MODERN LIVING

HOW TO DECORATE WITH STYLE

CLAIRE BINGHAM

teNeues

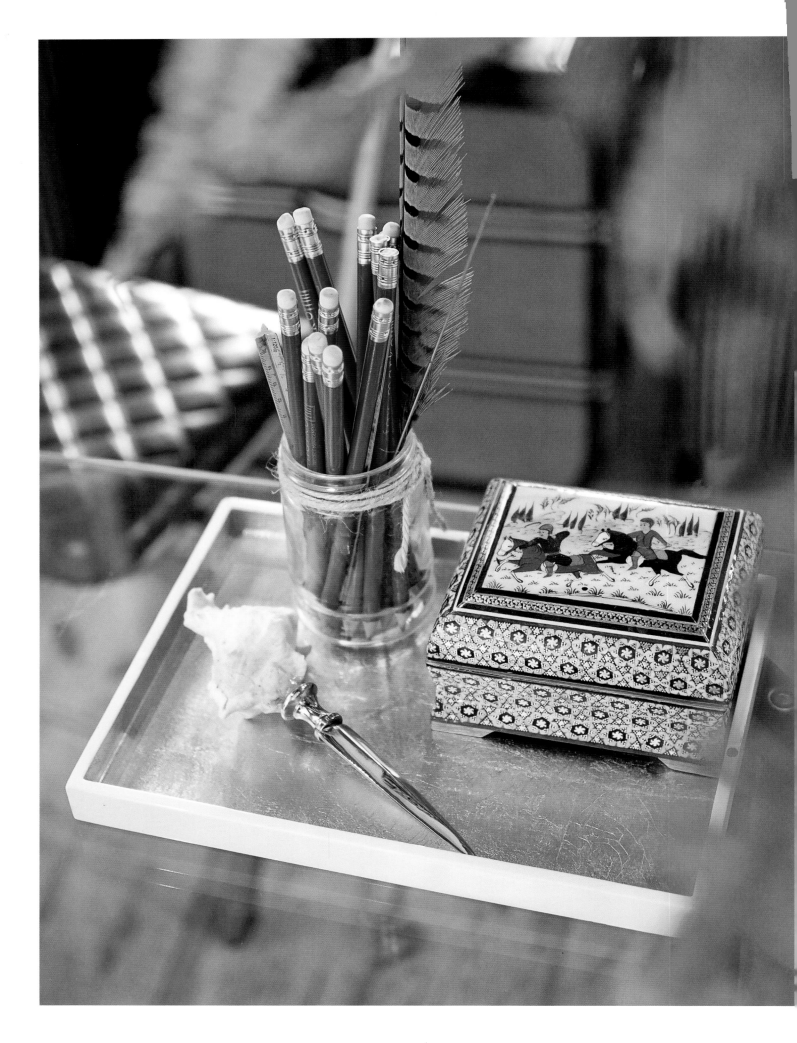

CONTENTS

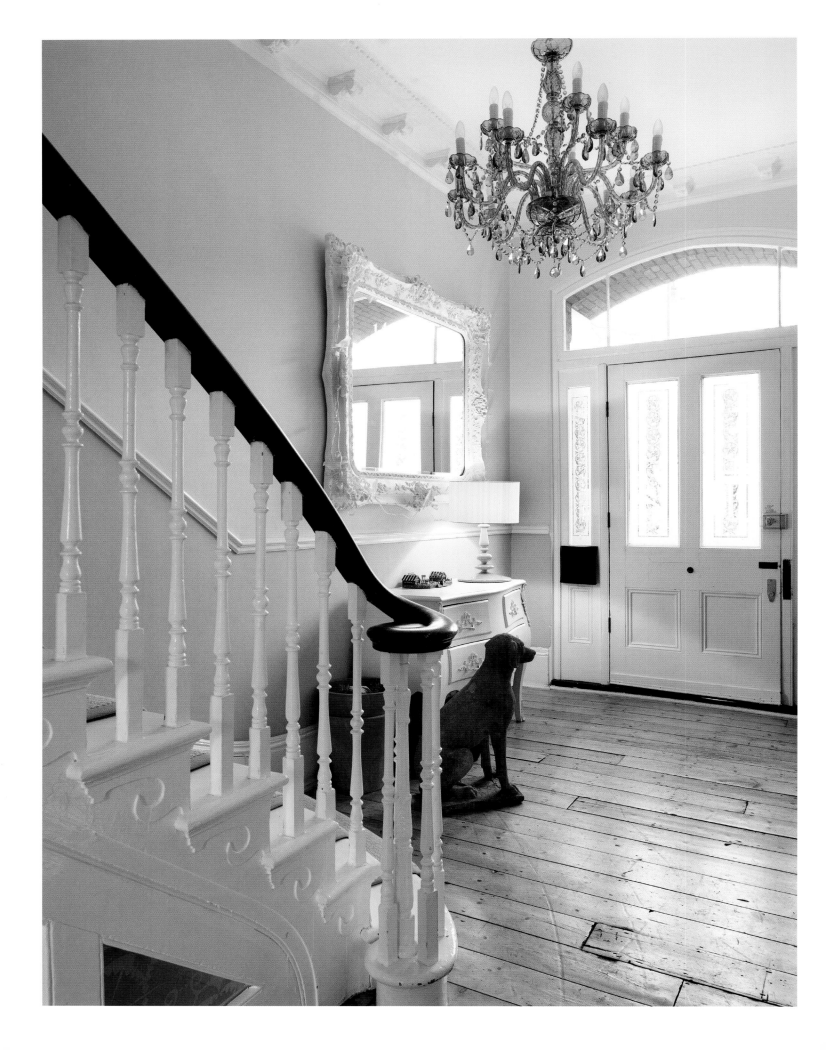

As an interiors journalist, I work every day looking at beautiful homes, other people's beautiful homes—up-to-the-minute interiors of the super glamourous to stylish places belonging to creative types. Over the years sneaking peeks around the homes of the hip and rich, I've seen all manner of takes on decorating, from people who like to live in clean, all-white architectural spaces to those who prefer the eye-popping, eclectic, and brilliantly madcap. There are no wrongs. I love them all. Underdressed or overdressed, the ones that stay with me the most are the interiors that are cut, colored and furnished to fit the personality of both the home and its owner. Think of it as in the way we get dressed. You choose a certain outfit according to where you're going and how you happen to feel. The same applies for interior decoration. It is an expression of style and personality. It is an extension of you.

In this book, I wanted to write about practical ideas and inspiration so should the decorating bug take hold, you are armed with the know-how to make the most of your space. Celebrating the decorating fever, this book shows you what to think about when making a room over and how to transform a dull space into something fantastic that you love.

Interior designers and stylists are trained problem solvers, skilled creatives and can edit a space to a tee. Part psychologist, part imagineer, they can visualize a room at different times of

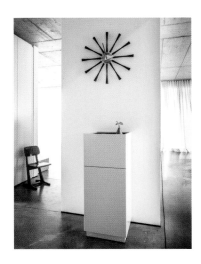

the year—how the light will fall in the living room during summer versus winter and how that will make you feel. They take time to predict how a space might be used on a daily basis, creating homes that are comfortable and make sense for the people that live in them.

What they know most of all is that there is a process to go through (they also have more opportunity to learn from their mistakes). Yes, you can devise a scheme based around a gorgeous new cushion, but it is best to think *less* about colors or details. Focus more on the mood and emotion, instead. Homes should make you happy. The aim is to make your interior work better for the way you live. It's useful to really take the time to determine what you want.

The sections of this book walk you through the house—room-by-room—giving steers from how to create a boutique hotel bedroom and choosing the right lighting to essential pointers on how to get started, and other useful ideas. There are also style lessons from our favorite interior design bloggers. Discover their Golden Rules of design and decorating rules to break.

Rules are there to be broken. If there is anything I've learned from nosing around other people's homes, it's that you should always do whatever makes you happy. Don't take decorating too seriously. If you want to paint a wall, paint it. It can always be repainted. It's your home, so express yourself but most of all, have fun.

BE HAPPY, IT DRIVES PEOPLE CRAZY

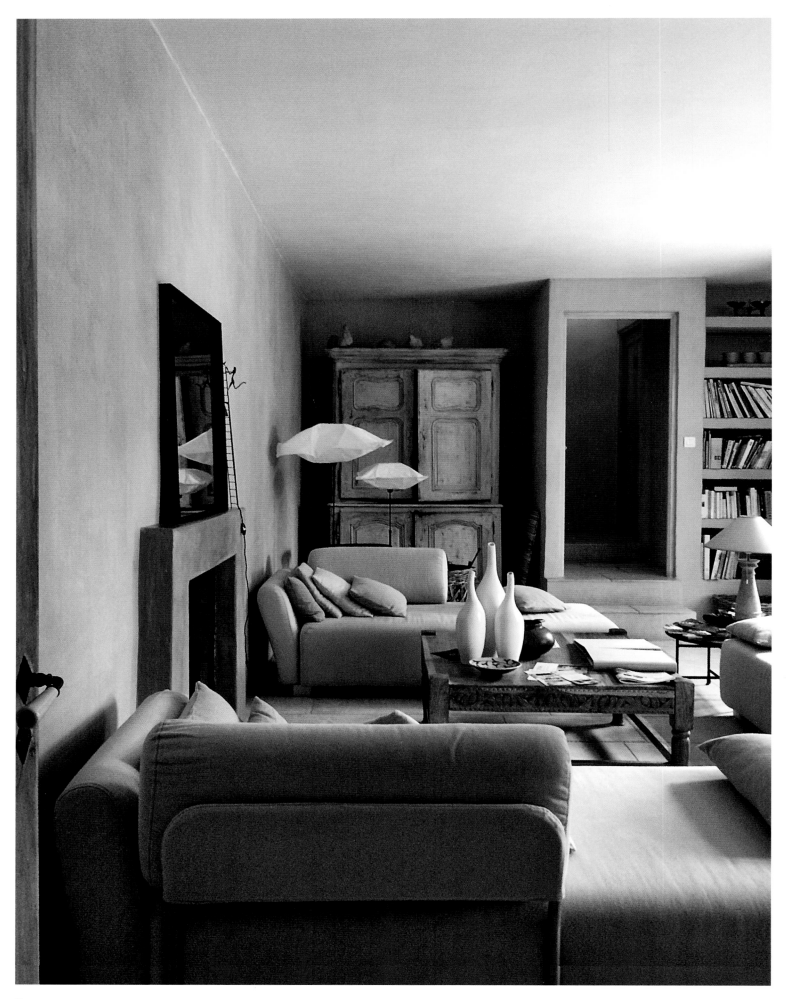

[DISCOVERING YOUR STYLE]

DISCOVERING YOUR STYLE—Or alternatively, finding the things that you love. The idea of putting your own stamp on a place is not something that happens overnight. Making small changes over time, rather than renovating all at once, will allow your space to grow with you—and will also avoid making expensive mistakes. In terms of committal, decorating is in fact, not at all like fashion. Let's face it—it's a lot easier to take back a spontaneously bought pair of jeans than trying to love an ill-fitting new kitchen or carpet. So take it slow. Research, gather samples, try things out, move things around—until you find what feels right and makes you smile. There is a logical side of planning a layout and seeing how things fit. Then there's the emotional side and capturing whatever feeling you're trying to evoke.

LOSE THE FEAR—Your home is a place that should reflect your personality and the way you and your family want to live. It's not about getting the "designer look" but more about achieving a balance between comfort, function and good looks. Comfort is number one. It's what makes everyday living a pleasure—because if something isn't comfortable, then it isn't going to be used. You choose clothes that you can throw on and feel amazing, well, the same applies to your home. With this in mind, don't be afraid to go with your gut. There are certain decorating tricks to getting

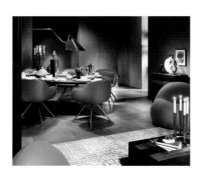

things right, but don't get lost in the details. Make plans. Big plans. But stay firm in your head: Do you love it? Is it comfortable? And beyond that, let things evolve.

DO YOUR HOMEWORK—Don't know your style? Not many people do. Like our moods, it is a multi-faceted thing. There is a path to discovery, however, that can help you analyze what you really, *really* like. Take time to research different interior styles. By familiarizing yourself with distinct looks, you will be able to easier identify what aspects make up a Scandi style or how to mix things up. Also consider the DNA of your home, deciding which elements you want to embrace—and which aspects you don't like. This knowledge will give you greater confidence to get started.

GATHER INSPIRATION—The fun bit! A visual reference is one of the most powerful tools you can have. Create a folder, a moodboard, a box, a sketchbook—whatever works for you—and start collecting things that you covet. Gather up images of any house crushes you have—from magazines, Pinterest, and Houzz—jotting down the things about them that you love. A common thread will hopefully begin to appear that will identify some small truths about your personality and, in turn, help to shape decorating decisions. For nice color combinations,

designers know that nature always works best. Take photographs of flowers, landscapes, or sea views for divine inspiration.

EDIT, EDIT, EDIT—Once you have gathered enough material, it's time to start the process of elimination. By all means, look at 1000 chairs, but it's important to narrow it down to just one. As Marie Kondo would say: keep only the things that spark true joy. Make that your motto. You will probably end up with a mix of different styles but who says you need to stick to one look? Some of the most beautiful homes borrow from all sorts of trends. My advice is to go for what you love—and when in doubt, don't. And whatever you're left with is a home that is uniquely you. Ta-dah.

STYLE CHECK LIST—A great way to understand what you like and why is to ask questions. Most designers have a number of questionnaires that they go over with their clients, so why not do the same? The list is endless but it helps to understand how we can improve our lives, our homes and our daily activities. Figure out how you use your home and the style will follow.

What styles do you like?

Which ones don't you like, and why?

What do you want to achieve in your newly designed home?

What is your biggest challenge?

Which colors and materials do you love?

Which color do you hate?

Do you like patterns?

Where do you spend most time?

Where do you relax?

Are you someone who likes to be warm or cool?

How do you like to spend your free time?

How much do you use your kitchen?

Do you entertain?

Are you messy or tidy?

How much storage do you need?

Do you prefer to have objects hidden or on show?

Do you have guests staying in your home?

Do you work at home?

Do you prefer high or low level lighting?

What's your favorite hotel?

What aspect of your life would you like to change?

What aspect of your home do you dislike?

NEW COUNTRY

One of the most appealing characteristics of this look is its tactile nature. A pairing of old and new, rough and smooth, natural and man-made: think woven cane baskets, glazed clay pots and time-worn wood surfaces whose sole decoration is its beautiful grain. Deliberately plain, it provides a gorgeous backdrop for all these artisanal, hand-crafted things. Colors are muted in grays, browns, and creams. Simple salvaged furniture is painted. What's brilliant about this casual style is that it adapts to any interior, whether you're modernizing a farmhouse or countrifying a city pad. It really does help to bring the outdoors in.

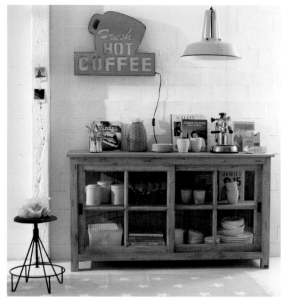

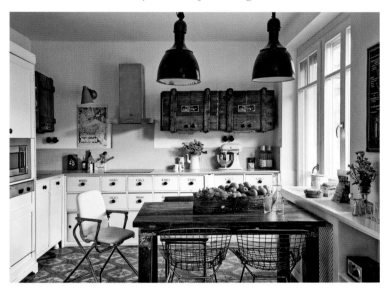

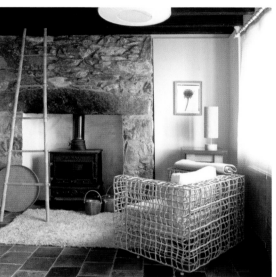

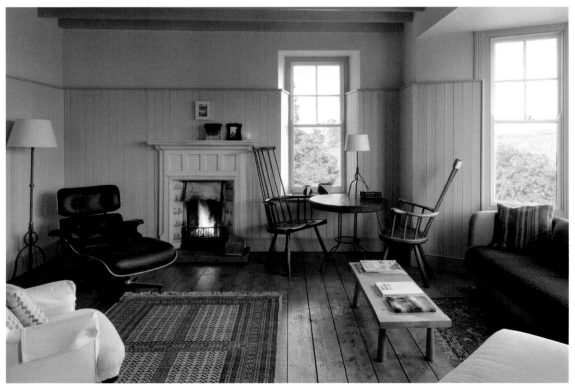

FUSION

Luxe travel meets hippy chic, this freestyle decoration is alive with global design influences and rich patterns. It is perfect for laid back and artistic individuals who love to travel and collect pieces along the way. Mix and match prints to your heart's content—as long as there is an underlying color to tie everything together, you'll be OK. Furniture is usually worn, either finds from flea markets or vintage pieces. The fabrics use vibrant colors in clashing ethnic patterns and an excess of accessories is a must! Berber rugs, painted tiles, crochet blankets, and pom-pom fun are all welcome here. And when it comes to floral, you can literally go all out.

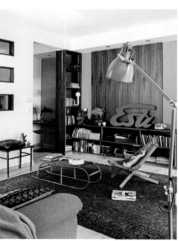

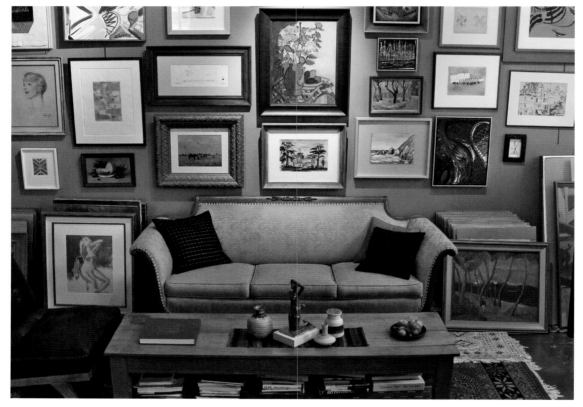

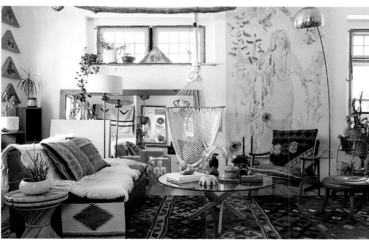

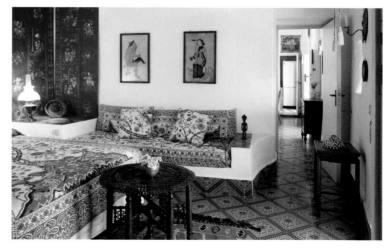

SCANDI

Unisex style, simple furniture and no-fuss accessories—let your taste for the minimal extend to your home. The key to Scandi chic is to choose well-made, design-led pieces that are intended to make daily life a pleasure. Light is fundamental. Windows are kept bare or dressed with transparent voiles to allow for as much light as possible. For the real purists, think white-on-white: white floors and white walls—with a bit of attitude in metallic or black. For a warmer style, combine dusky pastel tones with natural textures such as light oak, linen, and wool. The result? A gentle, soothing space that is as inviting as it is effortlessly cool.

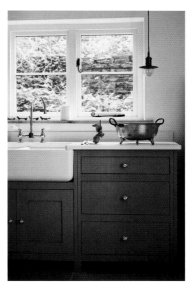

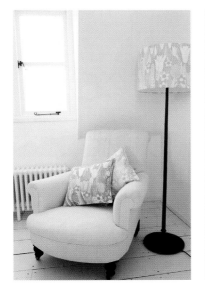

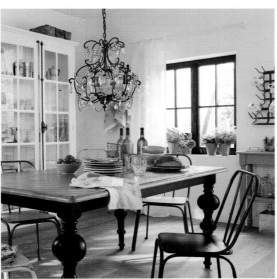

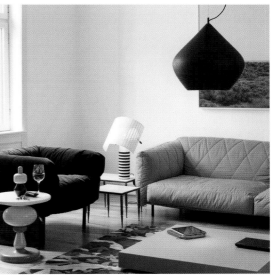

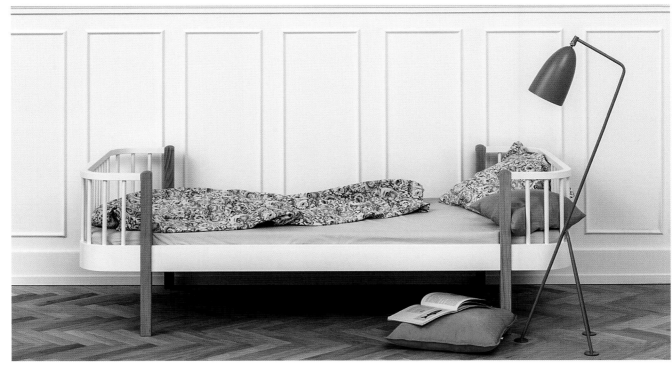

MID-CENTURY MODERN

For fans of the *Mad Men* aesthetic, this retro, tailored style begins with the architect-designed home. Think single-story glass houses in California with a squareish design. To recreate the Modernist magic in the real world, choose homeware from the Fifties and Sixties: furniture, ceramics, rugs, and lighting—in a palette of earthy tones. From Danish leggy pieces to geometric prints and nature-inspired textiles, designers to lust after include Charles and Ray Eames, Robin and Lucienne Day and George Nelson... no Modernist home is without them.

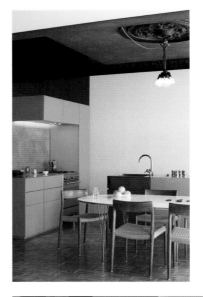

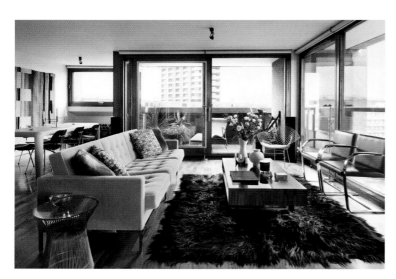

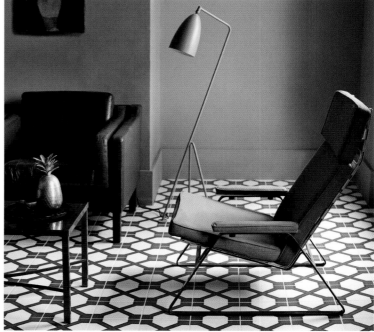

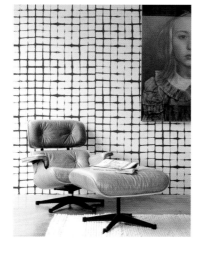

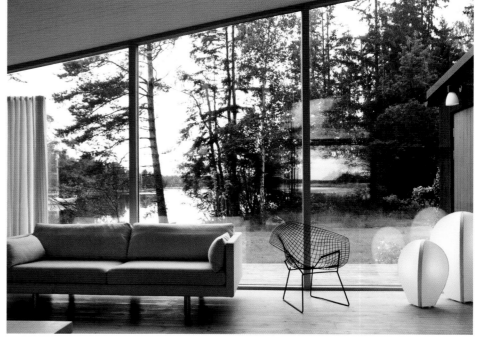

MINIMAL

This style is about the simplicity of the square. A fresh-faced Nineties-look pioneered by architect Claudio Silvestrin and fashion designer Calvin Klein, it is sleek and stylishly pure. There's no clutter. Like, literally, none. No door handles, no switches. Handles are replaced with slim ledges and rooms are shaped around invisible, built-in storage painted shades of white and grey. Smooth lacquer finishes keeps furniture cutting-edge but classy. In this case, it's not how much space you've got—it's what you do with it that counts. Enter with a busy mind—and the busyness slowly goes.

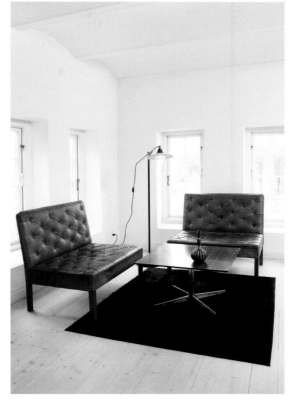

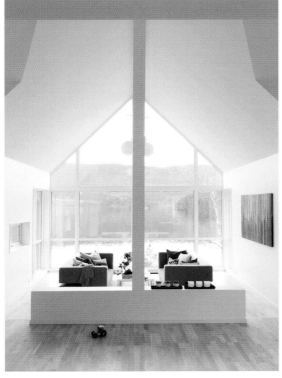

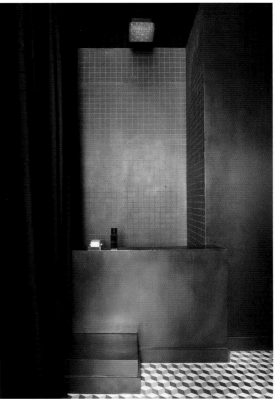

BOUTIQUE HOTEL

Luxurious details and a rich color palette spell contemporary glamour for this five-star look. There is a strong sense of materials in marble, brass, and velvet. Everything about it feels indulgent and beautiful to touch. The key here is to start with a statement piece of design. A graphic patterned rug or stunning piece of art will anchor the room and add drama to the space. A neutral palette on the walls allows the tactile furniture and shimmering accessories to take center stage. It's a fabulous place to relax.

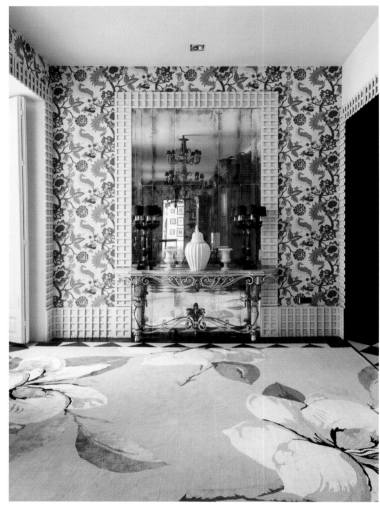

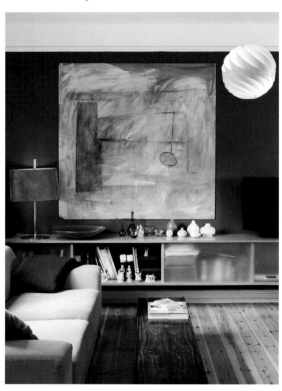

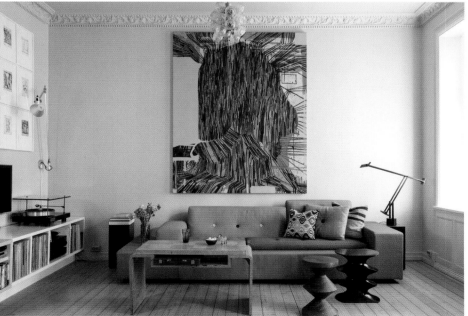

INDUSTRIAL

Warehouse-style, open space, and neutral colors create an uncluttered look that makes a feature of smooth materials (metals, concrete, glass) versus textured brick and wood—the knottier and more gnarled, the better. It is warmer and less polished than its earlier New York loft-style days. Burnished or raw metals such as copper and bronze have crept into this contemporary, utilitarian design, and gritty details such as filament-bulb lighting are key.

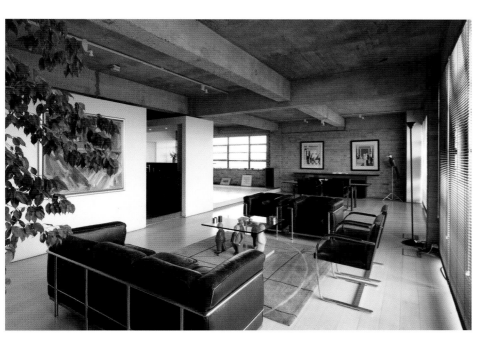

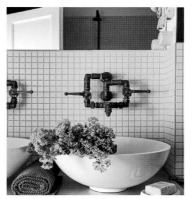

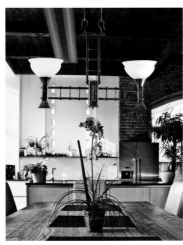

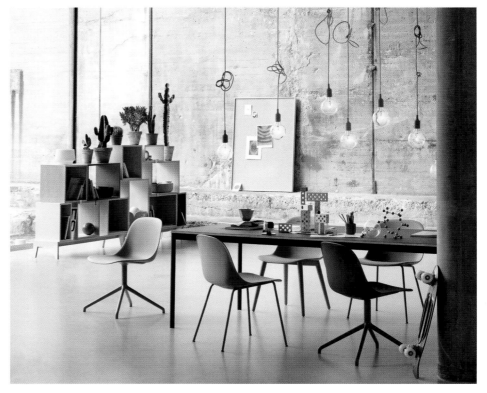

HOW TO CREATE
YOUR OWN MOODBOARD BY FAY MARKO

Creating a moodboard is an essential part of completing any interior design project successfully. It is a visual connection to what you are trying to achieve and will give you a sense of direction. It will help you avoid big mistakes and make thoughtful decisions. I prefer to do a separate moodboard for every room because I like to define as many details as possible, but this is up to you.

START by getting a black or white A2 size (42.0 x 59.4 cm or 16.5 x 23.4 in) foam board. It's much easier to work on a clean background. Personally, I prefer black, because I tend to use off-white

tones, and a white background can be deceiving. CHOOSE 2 or 3 images from your inspiration board, box, or file that represent the overall feel of the room and pin them on your moodboard. Forget about the small details for the moment and focus on the bigger picture. Make sure you include one picture (or item) that shows your color inspiration.

FIRST, choose the colors and/or materials for the bigger surfaces in the room, such as walls and floors. Are you going dark or light? Are you using wallpaper or paint? Will you go for wooden floor or carpet? Once you have decided, add a big piece of each sample to the board. The larger the surface of the material, the bigger the sample should be. Don't worry if they take up a lot of space on your board. You will layer all the other finishes on top, so parts of your wall/floor samples will end up being covered.

CONTINUE by selecting fabrics based on your color inspiration. Pick as many as you like, pin them on your board, and think about how you will

use them. Again, try to start with the bigger items, such as curtains and furniture, and then move on to cushions, throws, and other soft furnishings.

THE NEXT thing to add is materials for detail items: the piping for your cushions, a piece of the metal from the coffee table base, a stain sample for the dining sideboard. If you do not have samples of everything, print a photo and add it to your board instead!

ONCE you have finished picking materials, move on to selecting furniture and accessories. Pin a photo of the armchair, the coffee table, your favorite lamp, the rug you are dreaming of, etc. and keep editing until you are happy with the outcome.

You should now have a complete image of the room, how it should feel and look. Consider how your existing furniture will fit into that look and think of ways to adapt pieces where possible. You could re-upholster your dining chairs, distress or paint a dresser, or buy new shades for your bedside lamps. You will be surprised by the transformation you can achieve by making small changes.

Fay Marko, Interior Designer, London

TIP

To achieve a common theme throughout the house without every room looking identical, use the same materials and colors, but apply them to different areas. For example, if you have oak parquet floors in your living area, but you don't want to use wood for the kitchen floor, add oak shelving or go for oak barstools. Similarly, choose your kitchen tile based on a color you have in your living room walls or fabrics.

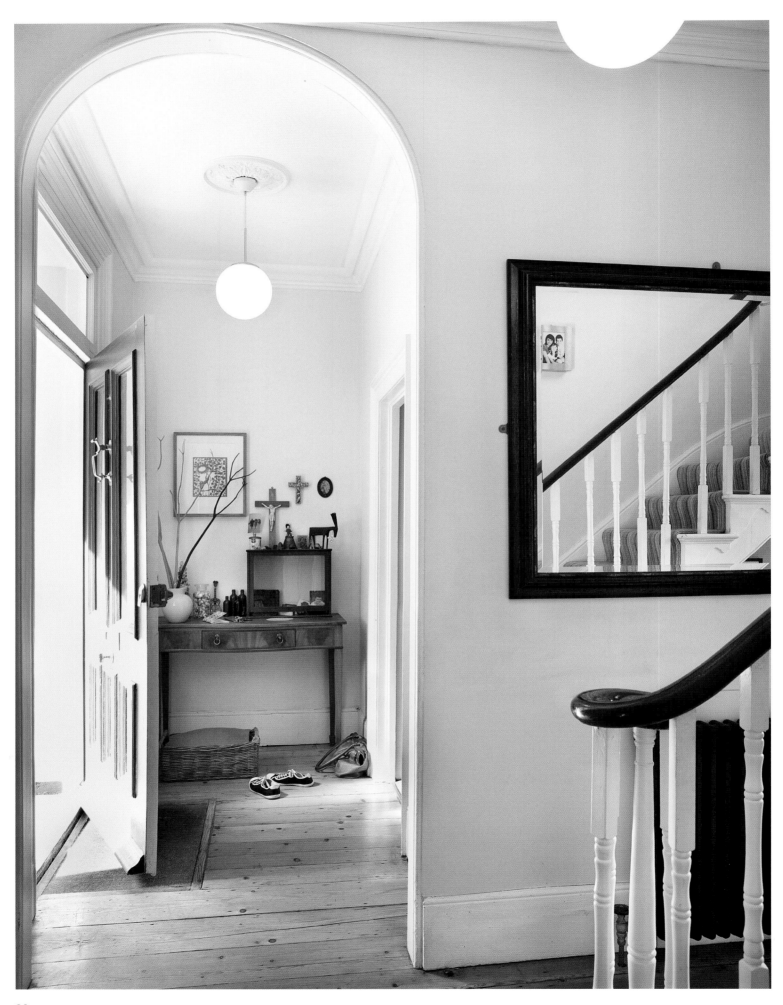

Home, sweet home. I like to think of the hallway as a house's hello. It greets you as you close the door on the outside world and is a constant that underpins everything. Isn't it a pity that its decoration is often left until last? Granted, it is not a room that you actually sit down in and spend any amount of time. It's a walk-through. But if you think about it, you do walk through it quite a lot. Dress from the feet up. Decorate your hall.

Me, I like a hallway to be a palette-cleansing space that, like a picture frame, presents every room. In entrances, you are looking for something with a bit of longevity—not just in terms of style but also physically lasting a little bit longer. With those high ceilings and tricky banisters, it's not a room you want to do again any time soon.

The power of paint goes a long way. When using color, I like to paint the entire wall—from architrave to skirting—in the same shade. Use different finishes for depth instead. It is subtle but the mix of extra glossy to completely matte will give a variety of sheens and will change with the light at different times of day. Textured, paintable wall coverings are also a great way to bring some pattern to a flat wall. To create a two-tone color-blocked wall, select one dominant and one subordinate shade (the light color doesn't have to be at the top). A split of half and half

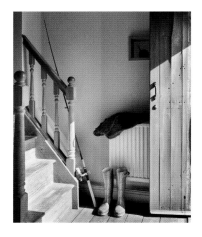

works well. For a sharp stripe between the two colors, use a spirit level, a water-soluble pencil and low-tack masking tape that can be carefully peeled off. And don't default to white. Gray is an effective color in a hall. It will always look modern and if combined with warm wood, should never feel cold.

In a monochrome scheme, rather than sticking to a white staircase with a natural wood banister, consider painting the stairs matte black. Just for a change. The key to getting the look right is a question of proportions. Balance the black with dark light fittings and door fixtures. The effect will give the hallway a contemporary but more masculine edge.

Good design should always make things easier. Hallways are notoriously tricky to keep tidy and require good storage. I'm a firm believer in baskets. They are ideal for flinging sandals, trainers and kids shoes (one basket per person—I don't like to share). A bench and seat combo is doubly handy for providing something to sit on while you lace your neatly stowed shoes. Also make use of any nook or corner under the stairs for hanging coats. Hooks positioned at your child's height will encourage them to get involved too (think positive). It's also worthwhile to fix some good lighting above your shoe and coat station. In a dark hallway, you need to be able to see what you're doing—

and it will help to find those bottom-of-the-bag door keys, too.

A long, slim shelf is also a favorite. Slender enough to drop keys, store mail and prop up a picture, it will tidy up a narrow space.

Once all the other stuff is done, move your eyes to the floor. Choose something you love and that will last. A carpet runner up the stairs is a great space smartener. Opt for a neutral, toe-friendly texture but bind the edges in a favorite standout shade. Bright pink or tangerine, this is the perfect place to add a bit of color. And think how happy it will make you every time you walk up the stairs.

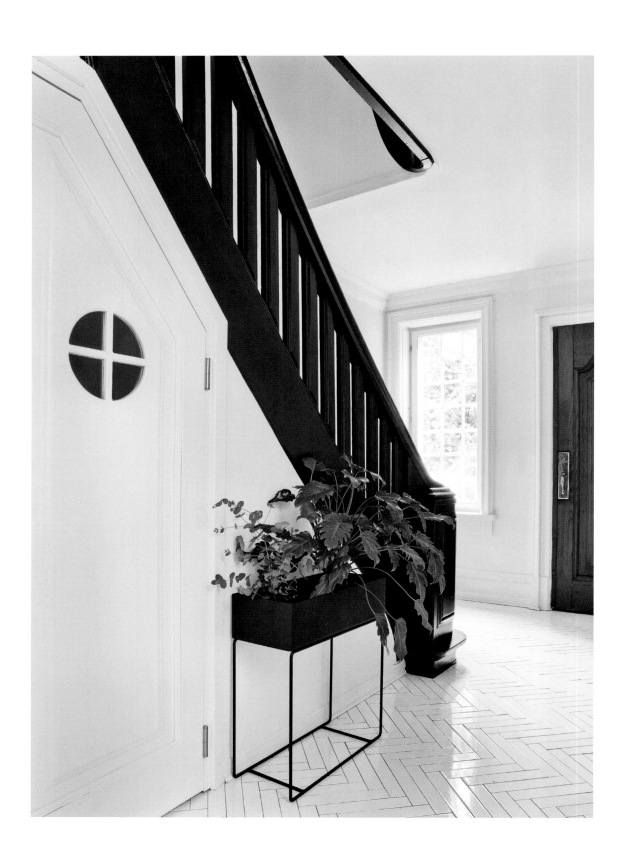

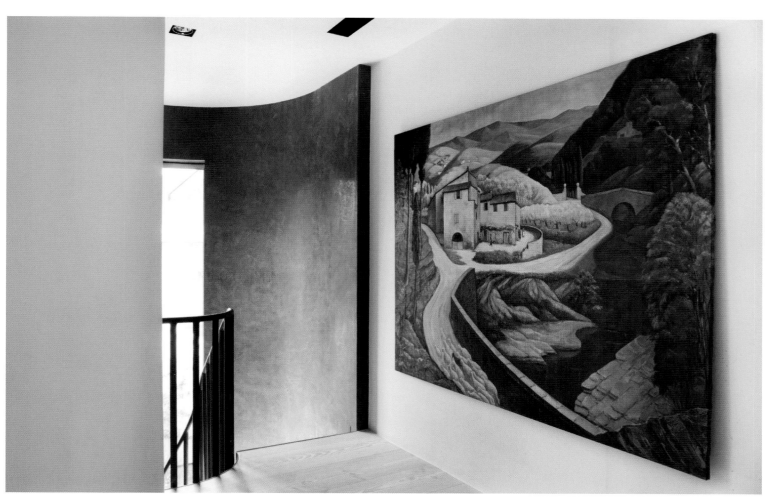

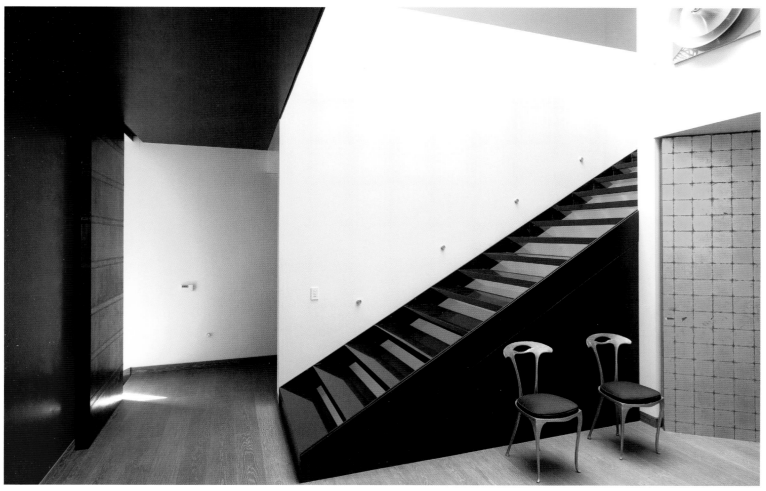

RIGHT Black is a powerful smartener in the hallway. Deliberately dark, it contrasts with white walls and makes a feature of the stairs.

BELOW In place of art, mobiles make good use of fabulous ceiling heights.

BOTTOM It's a brave decorating move but paint hallways bright, where you would naturally use white. It's cheering to have your favorite color the first and last thing you see.

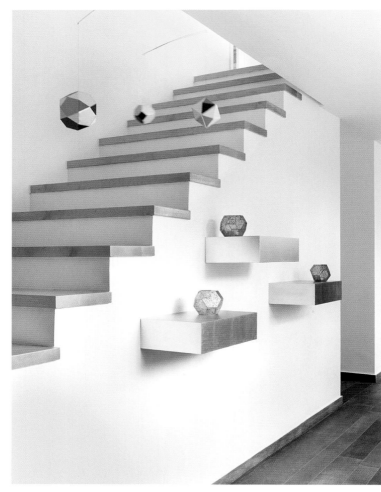

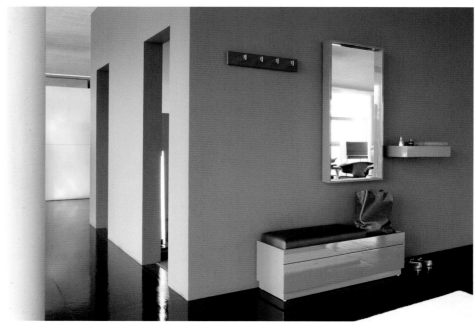

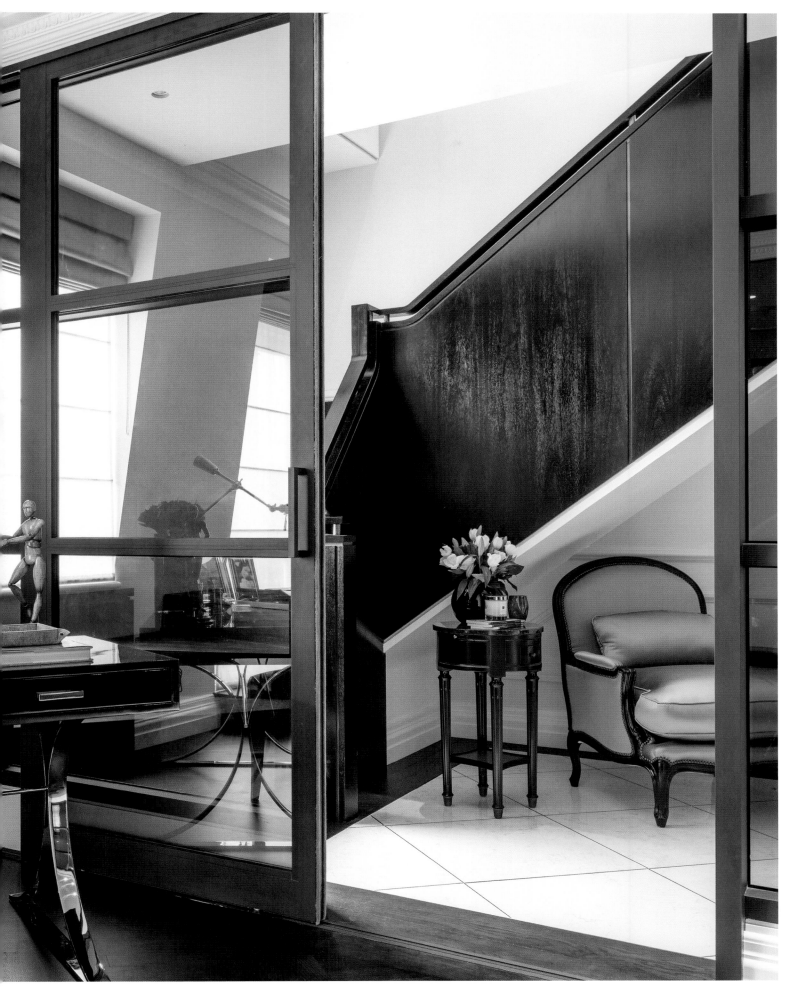

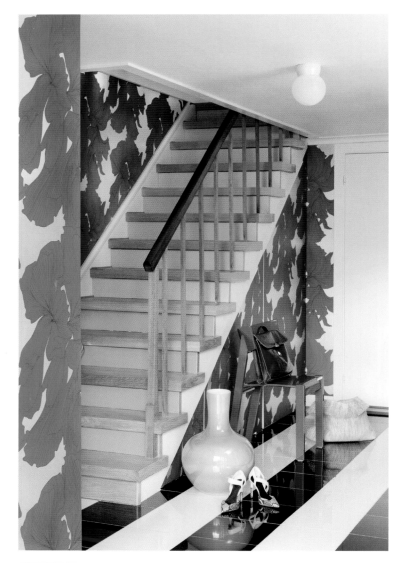

LEFT Wallpaper appeals to print enthusiasts. An eye-popping use of print and color, the emerald green floral complements the candy pink stairs.
BELOW LEFT When you can't deny a building's historic DNA, accent your home's timeless feel with heritage-inspired prints.
BELOW Create digitally printed photo murals using your choice of image for a uniquely patterned wall.
RIGHT If you're renting a property, large panels of wallpaper hung on the walls and door provide an instant (but detachable) pattern fix.

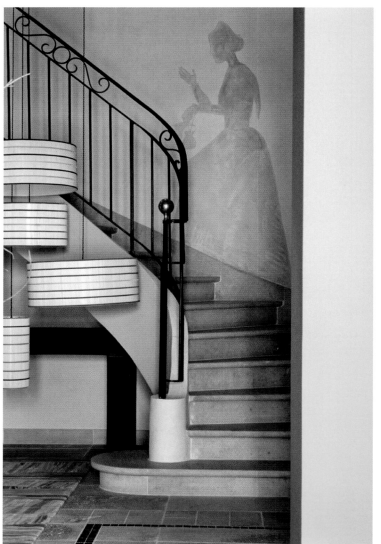

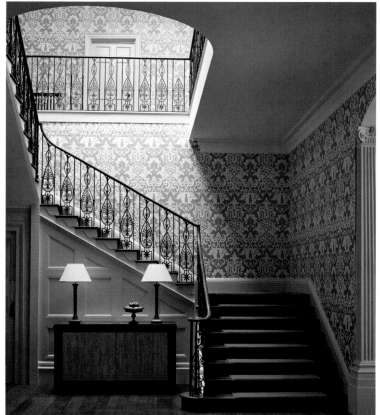

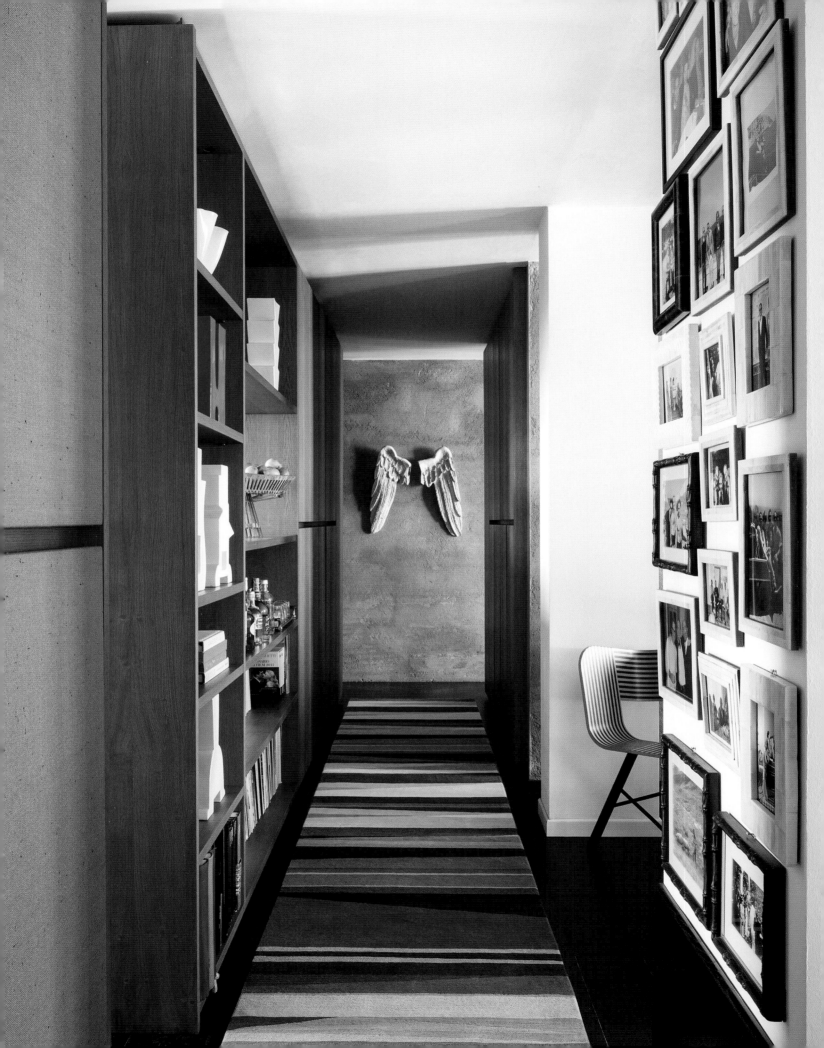

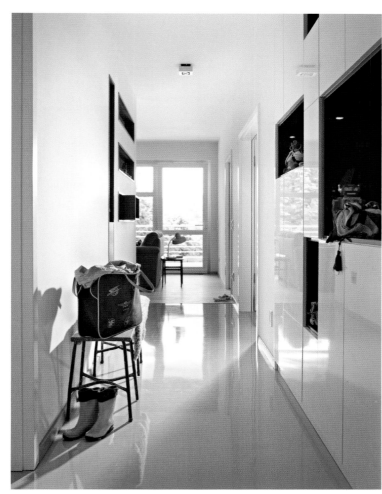

FAR LEFT To incentivize your gallery wall, pull out your fondest color photographs and frame them in a mix of black and white surrounds.

LEFT Built-in cabinets keep a hallway tidy. Opt for concealed finger-pull door fronts for a seamless style.

BELOW A striped runner carpet provides the main pop of color in this elegant space. Mix neutral colors with favorite brighter shades.

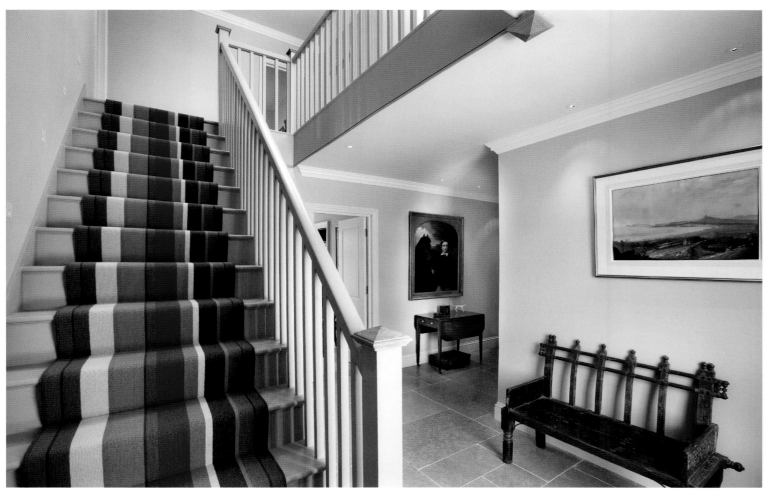

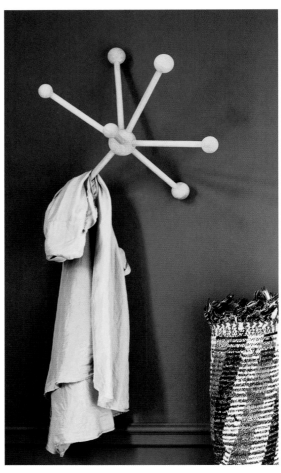

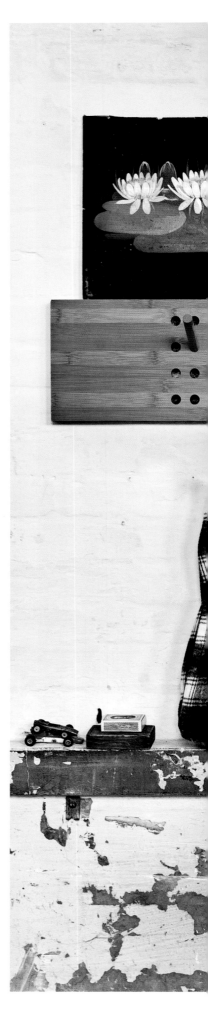

BELOW Your decoration is always in your hands. Coordinate a bright pendant shade with a matching upholstered stool.
BELOW LEFT Shaker-style pegs are my far out favorite for practical, understated style.
RIGHT Never before have coat hooks been so versatile and considered. This graphic Scoreboard design by a Danish design brand has moveable pegs fit for multi-purpose needs.

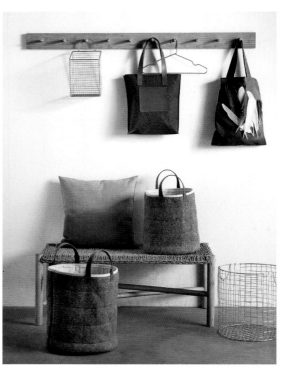

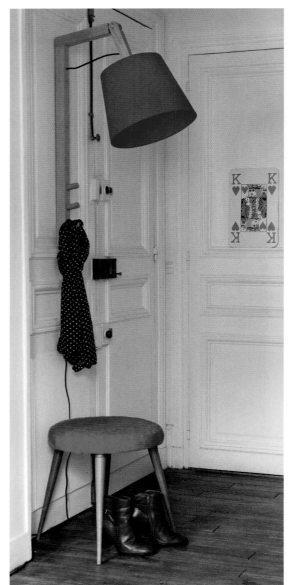

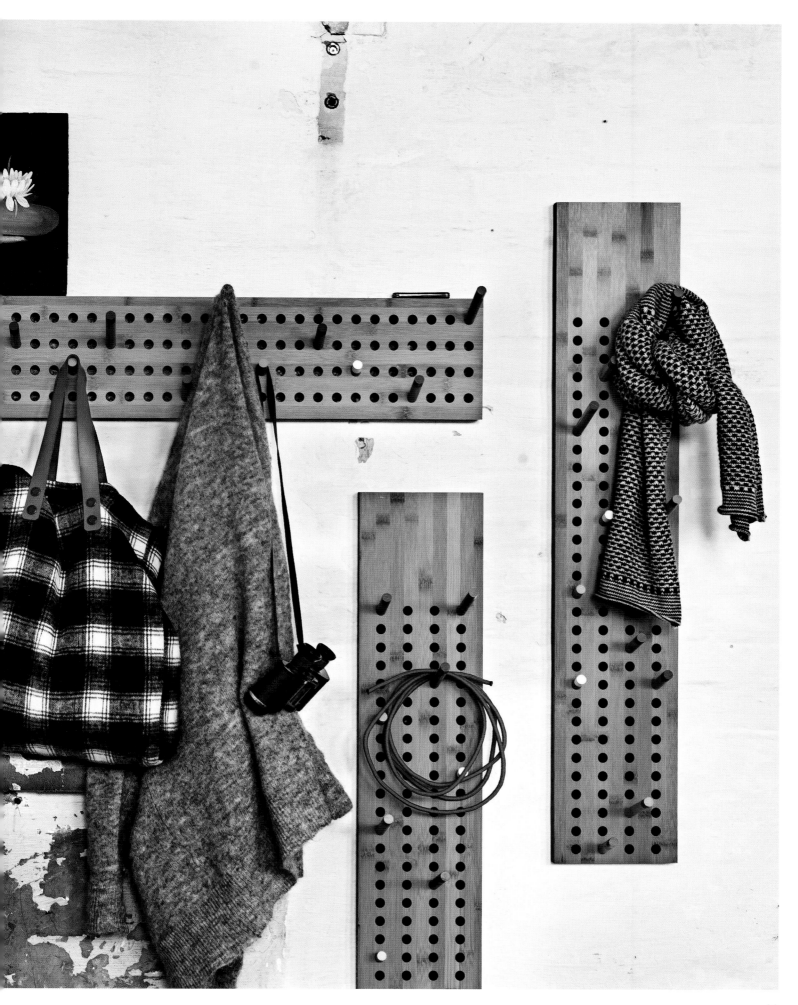

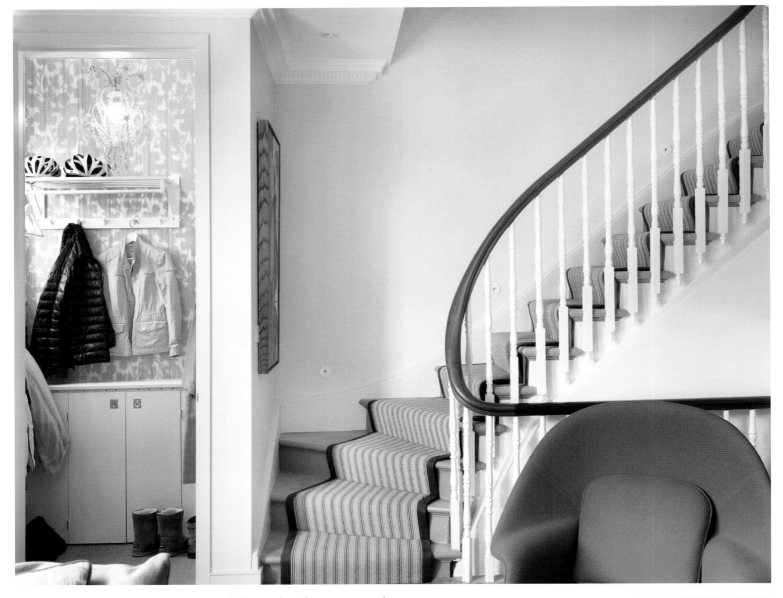

ABOVE AND RIGHT Keep hallways tidy with a smart coat rail or stand. Bags benefit from a dedicated hanging area, fixed at an easy-grab height. For coats, try updating a vintage wooden coat stand with a spritz of fluoro paint. The slim lines will also look handsome in black. However, if your outerwear demands more disciplined storage, look to modular wardrobes as a multi-tasking solution instead.

HOW TO MAKE VERTICAL STORAGE

When space is tight, nothing beats a bit of vertical storage. Keeping the floor free from clutter, walls can create room for storage that may otherwise be impossible to accommodate. Repurposing old drawers are a cute way to make shelves. They can be fixed on their side down at ground level and used as a place to stack shoes or mounted in a frame at console height. Coat hooks can also be easily homemade using door or drawer knobs instead. Simply replace the existing screws with hanger bolts to fix directly to the wall without the need of a backboard. A long, slim shelf is also a favorite.

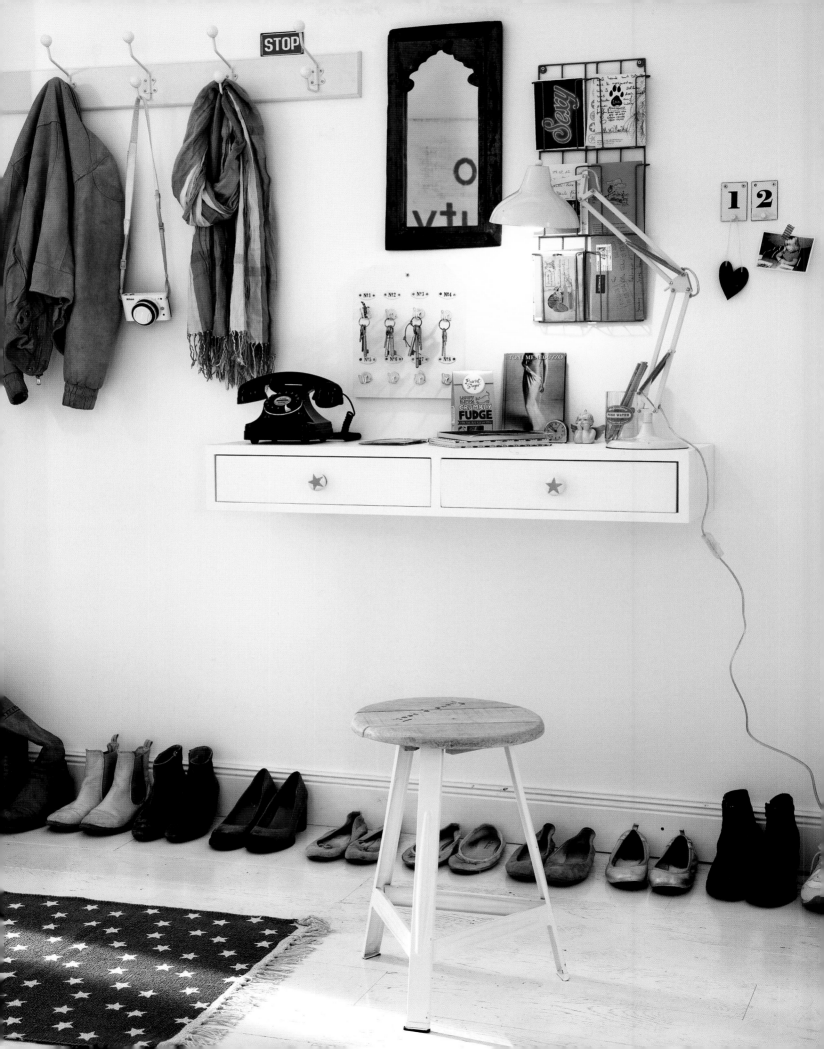

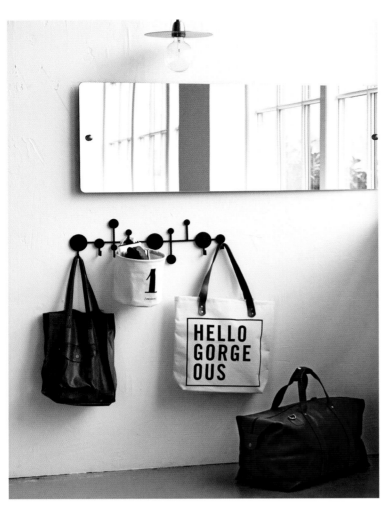
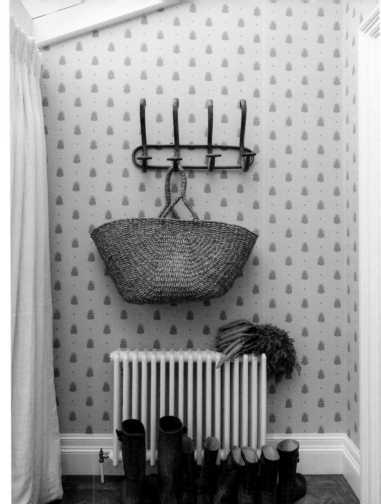
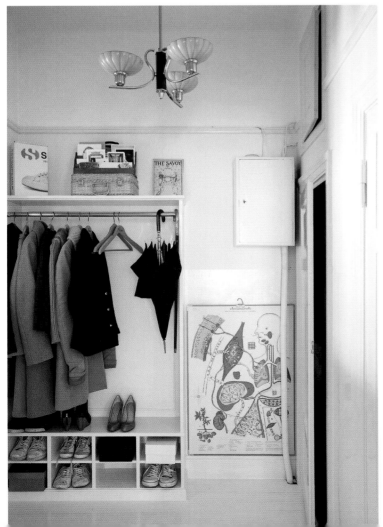
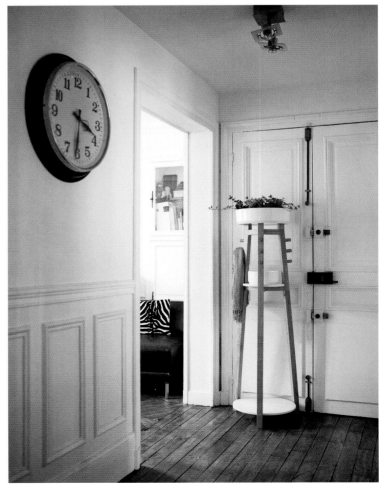

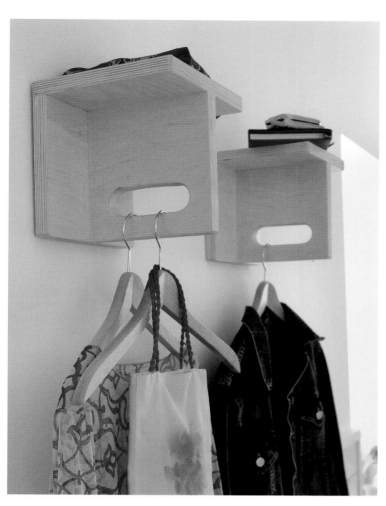

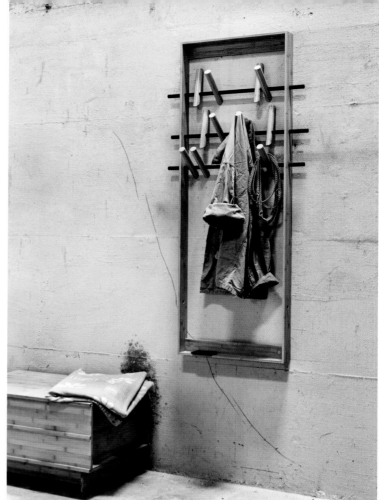

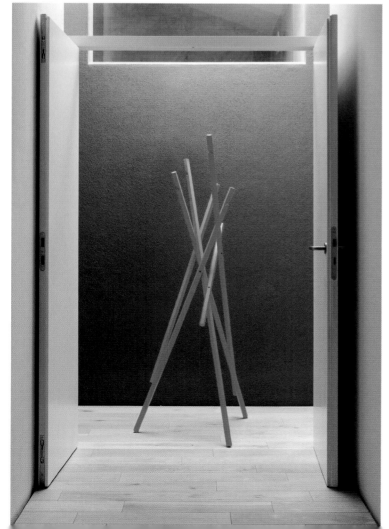

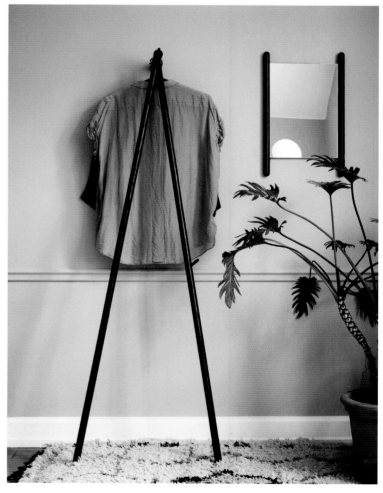

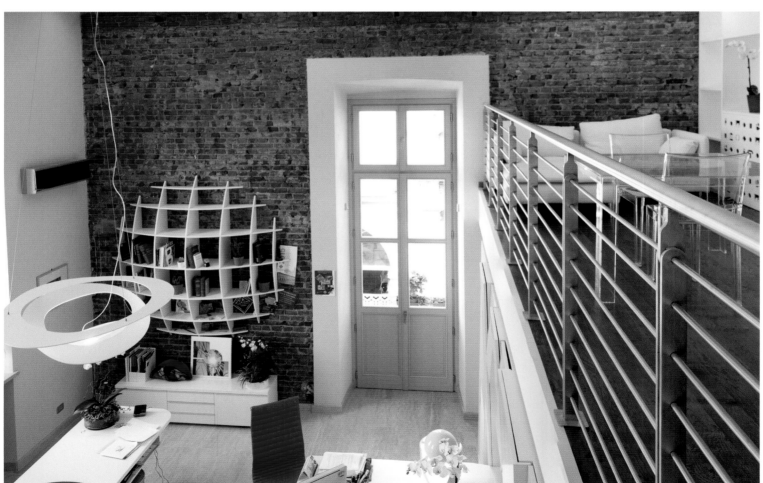

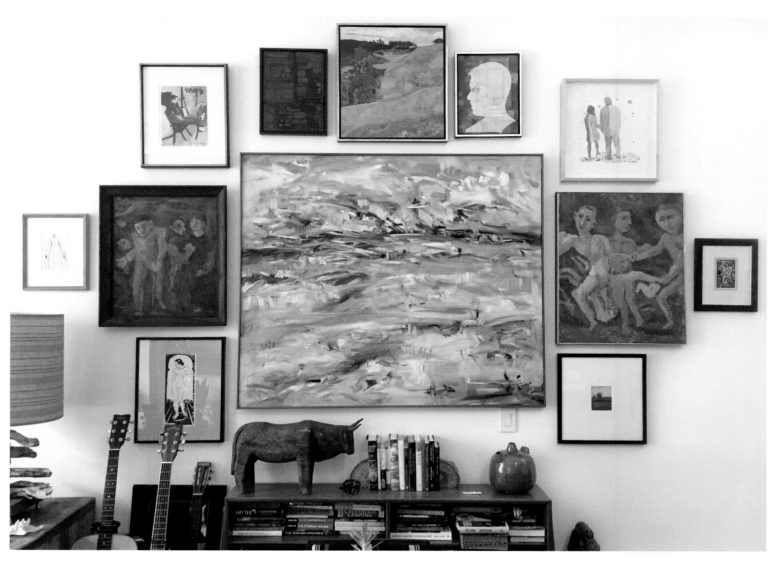

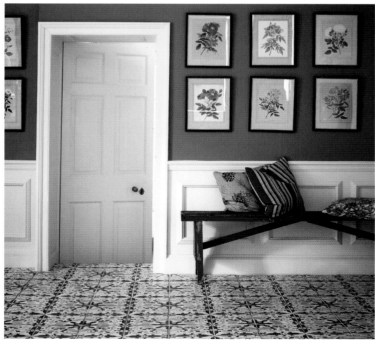

TOP LEFT Whether your hallway is supersized or skinny, if you put a mirror in it, you're guaranteed to double the space.
LEFT A snazzy bookshelf will add character as well as storage.
ABOVE Picture frame vignettes always feel more grounded if they are clustered above a console, desk or chair.

HOW TO DECORATE THAT EMPTY WALL

First of all, don't sweat it. In the hallway, less is more, and there are plenty of opportunities to display your favorite things elsewhere. While there's an abiding perception that photographs should be zigzagged up the stairs, it's difficult to get this right—plus the frames always end up lopsided. Instead, go big. One supersized artwork or an impressive picture wall in the hallway will add instant grandeur. The trick to displaying pictures en masse is to start with one central, focal piece with all the other frames sloping down on either side. The central picture doesn't have to be the favorite – just the biggest. The general idea is to move from large to small as you move outwards. To get it right, cut out the shapes of each frame in paper and position until you are happy and your walls are full.

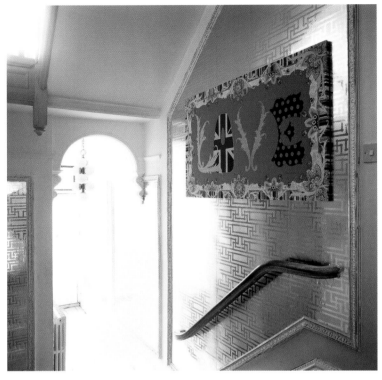

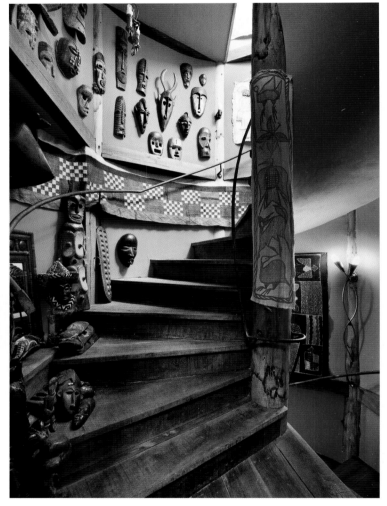

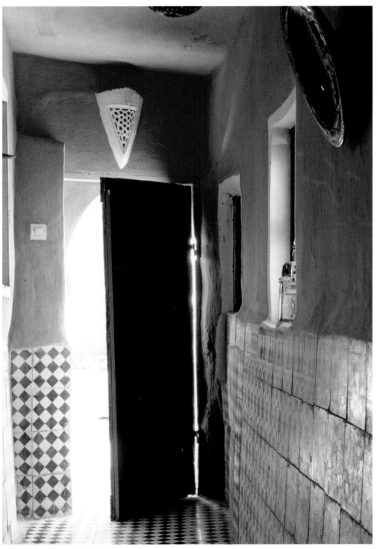

ABOVE LEFT Antique and modern are at play here with wall-mounted rugs and inset silver wallpaper panels.

LEFT A tiled floor and walls will bring the Moroccan souk to your door.

ABOVE Allow your personality to fill every corner by displaying collections on the wall.

RIGHT Hallways are a place to play out decoration fantasies. If a landscape is a step too far, create a pretty tree with potato-printed cherry blossoms.

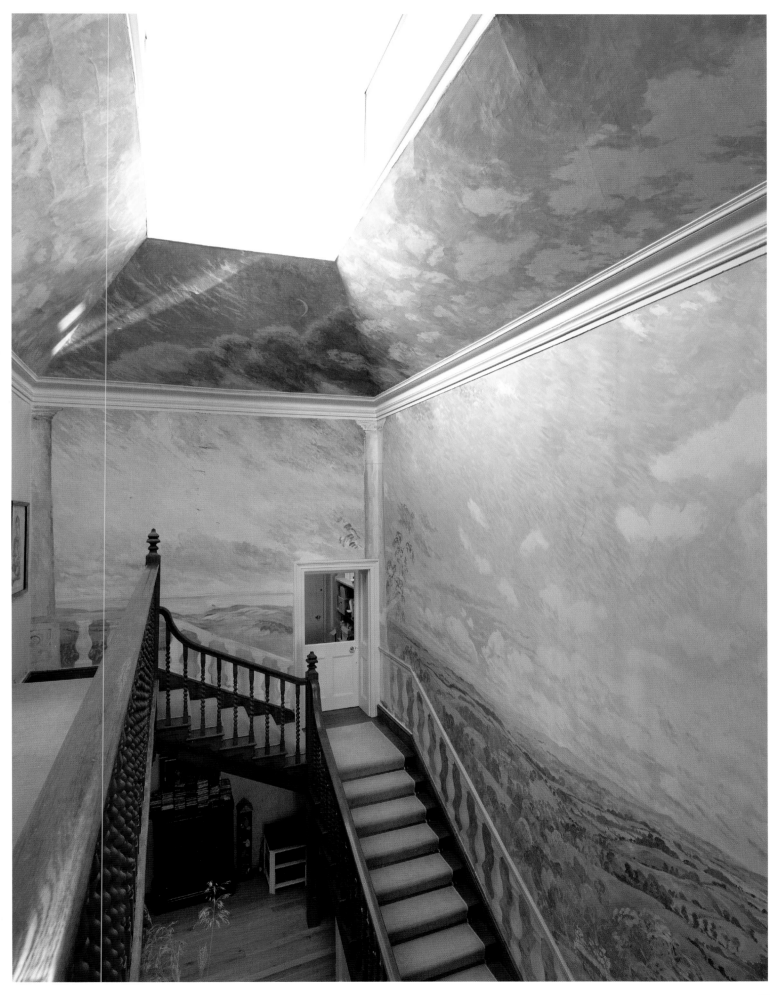

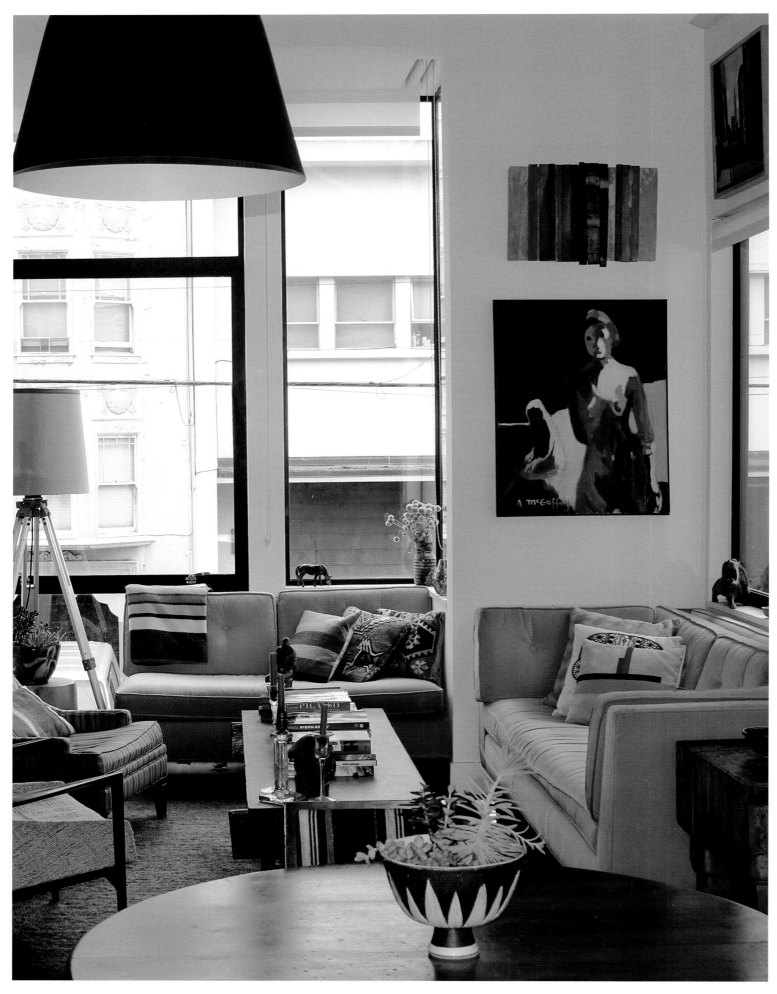

Lounge… It says it all in the word. A place for relaxing, evening lazing, and curling up on a comfy sofa with cup of tea in hand, it is one of the most-loved rooms in the home. It is also the room that most visitors get to see—so it is a focus in more ways than one.

There are many small changes you can make to your living room without going all out. For an instant lift, try brightening up your ceiling with a fresh coat of paint. A high-gloss white will bounce light around and makes for a surprising change from matte. A neat idea for gathering up clutter is to store glassware, books and ornaments in a glass-fronted cabinet instead of built-in shelves—this is also handy whenever you come to move. And to make a living room feel extra homey, super-soft sheepskin or a snug new throw looks beautiful thrown over a sofa or chair. It's the design equivalent of a warm embrace and gives a good, valid reason to treat yourself to a new blanket. What's not to love?

Creating a new room from scratch is, however, entirely different. So where to begin? My modus operandi goes like this: a clear idea, clever structure and strong character. Just like a page-turning book. For my living room at home, the idea was pretty well formed. I knew I wanted to create a dramatic yet serene feel, so I started with a moody blue. To get the color just right, I painted

swatches on each wall to see how the shade changed at different times of the day.

Next comes structure. Start putting down everything that's in your head about what storage, lighting, and seating you need. Who else uses the room? How do you spend your time here? Do you want your DVDs, kids' toys, and other miscellaneous stuff on show or hidden away? Then draw up where these key pieces might go, as this is likely to affect the furniture you choose. Add lighting to a reading spot or dark corner, wherever it is most useful. What to do with the TV? A love-hate affair, the flat screen shouldn't be an accidental focal point in the room. A trick to blend it in is to place the television against a darkened wall. An alcove painted in a shadowy shade (don't feel the need to paint the opposite alcove too) will immediately take the attention away. You could go a step further and make this alcove your picture wall. A combination of artwork and photographs will take the focus away from a solitary screen.

Finally, we get to give the room its character. If you're buying a new sofa—high-backed or bed-like—select your favorite style and then think about the fabric (not forgetting to make sure it fits). Reupholstering a vintage sofa in a tactile velvet or burlap is a designer's trick to creating a unique piece. Linen slip covers keep a look casual and family-friendly, while a neutral sofa is the

equivalent of a little black dress: always stylish and can be dressed in an accent color that you happen to be into at the time. On to curtains: do you want them clipped above the floor? This cut suits a modern retro style really well. For high-octane glamour, go for draped. Prop oversized artwork on the floor to keep the room feeling relaxed—same goes for mirrors. A frame-free and minimal mirror looks really effective against a period marble fire surround. When it comes to space-saving and versatile design, you can't do better than occasional tables that can be easily tucked away, and a glass coffee table maximizes light.

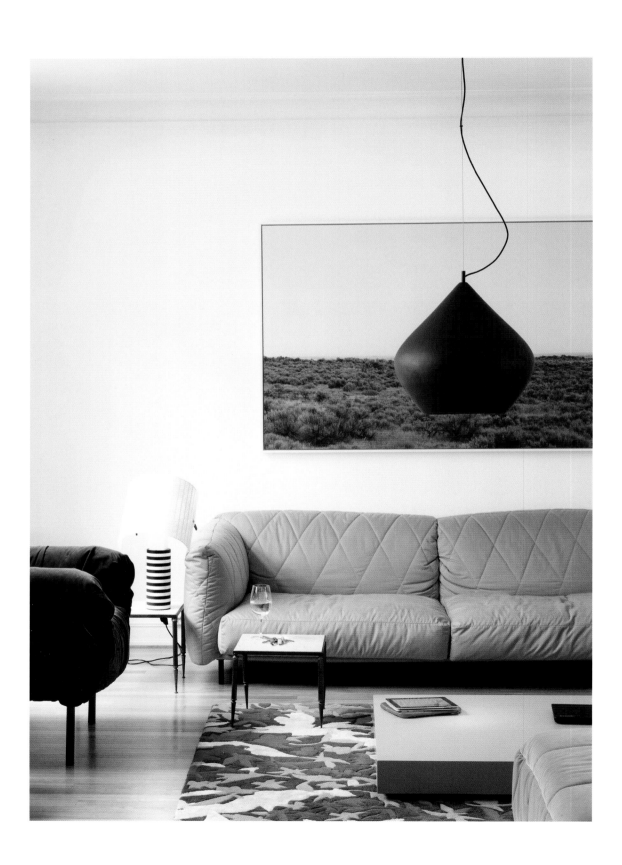

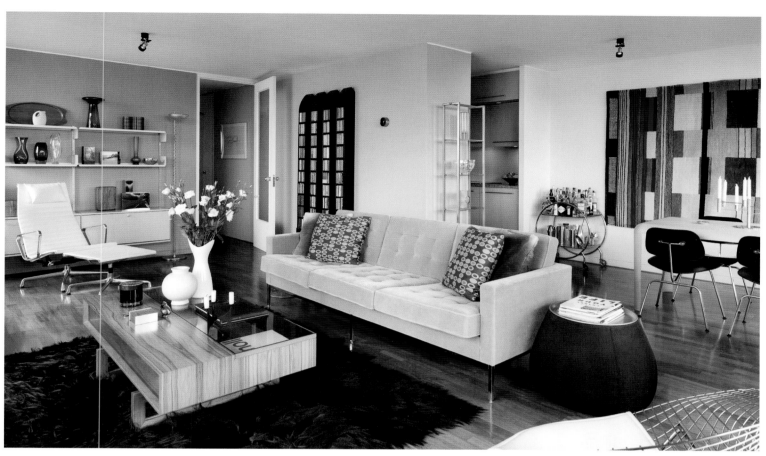

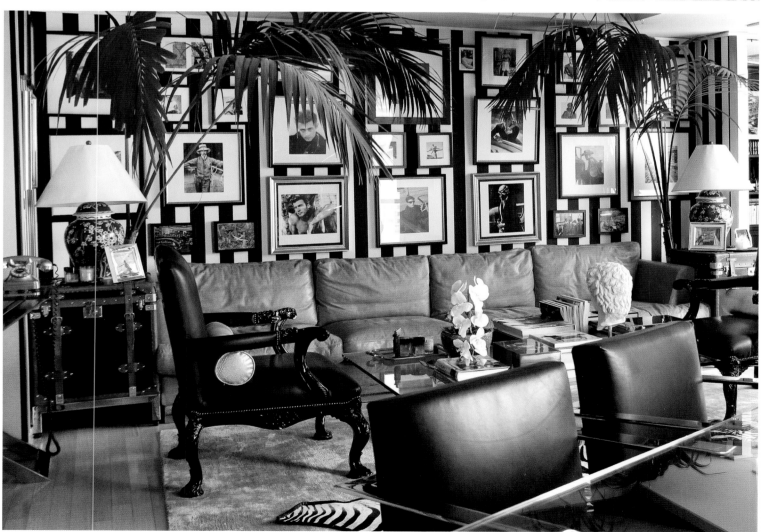

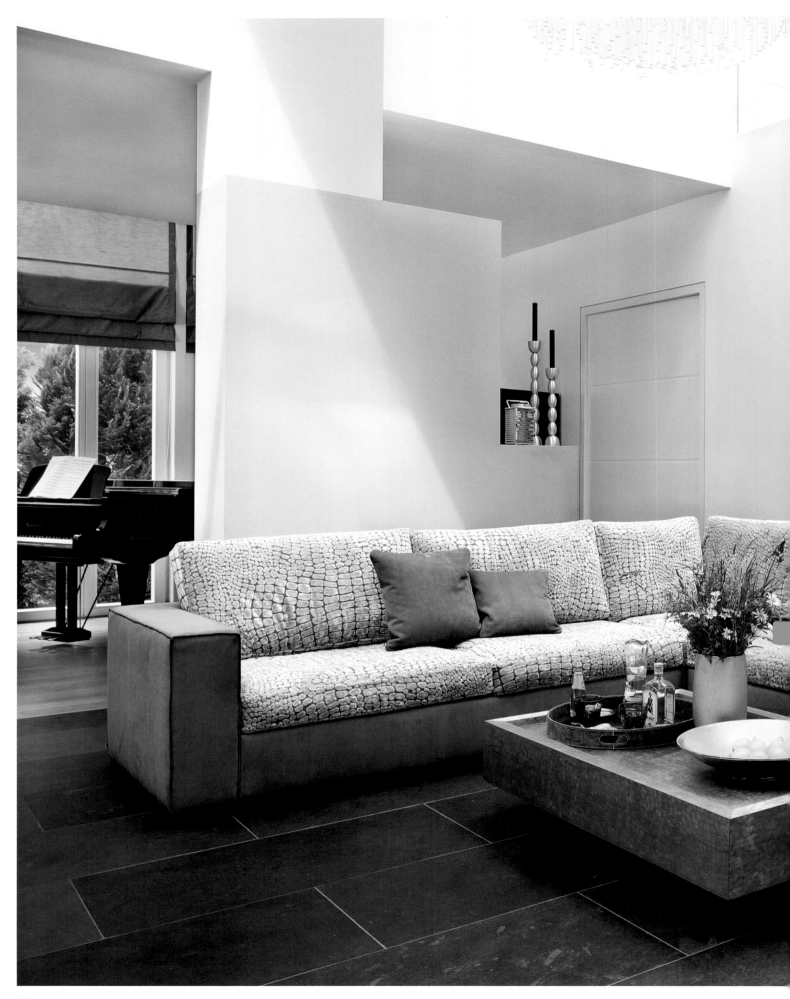

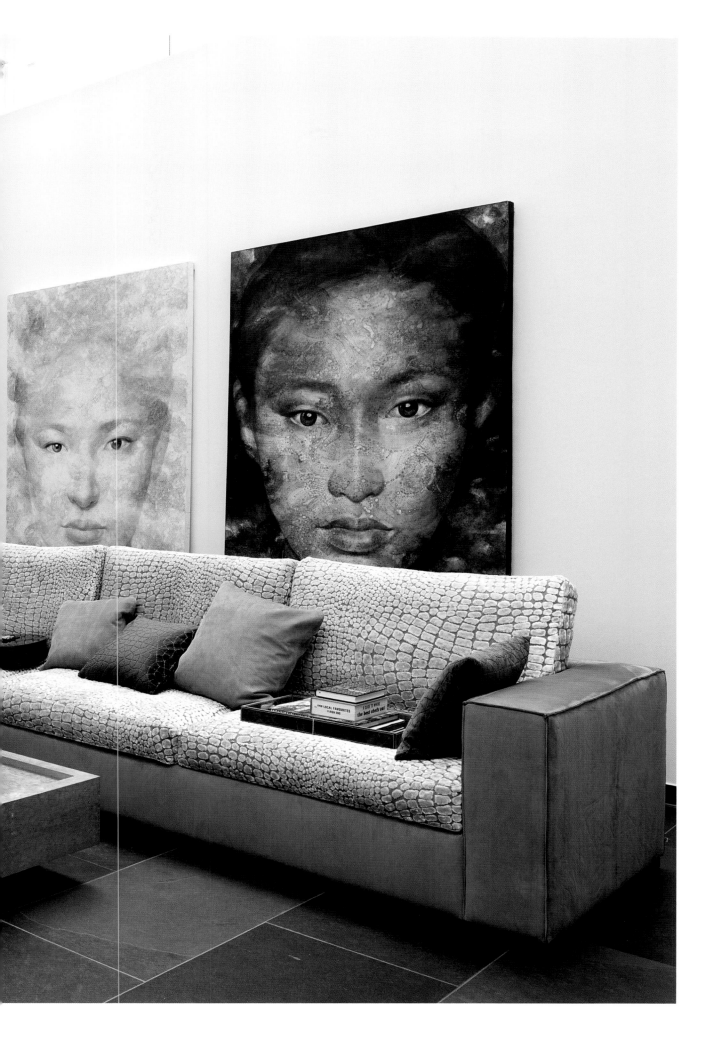

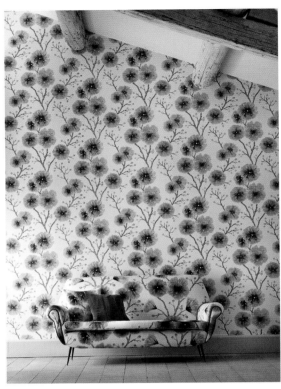

PAGE 46 While a quilted sofa oozes comfort, a beautiful patterned rug and blue armchair add color to a natural scheme.
PAGE 47 A gallery wall can be used to distract from a television or introduce old-Hollywood glamour to a dramatic black and white décor. A uniform frame creates smart coherence.
PAGE 48 This look favors classic luxe materials—velvet, stone, suede—and a neutral color palette.
BELOW Give an old sofa a new lease on life in a floral fabric or update with a casual collection of slouchy cushions and throws.

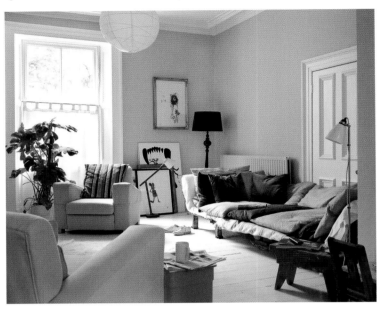

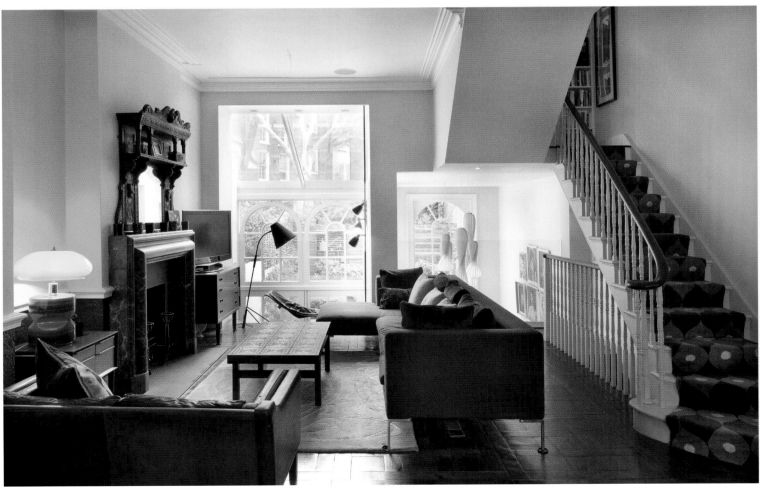

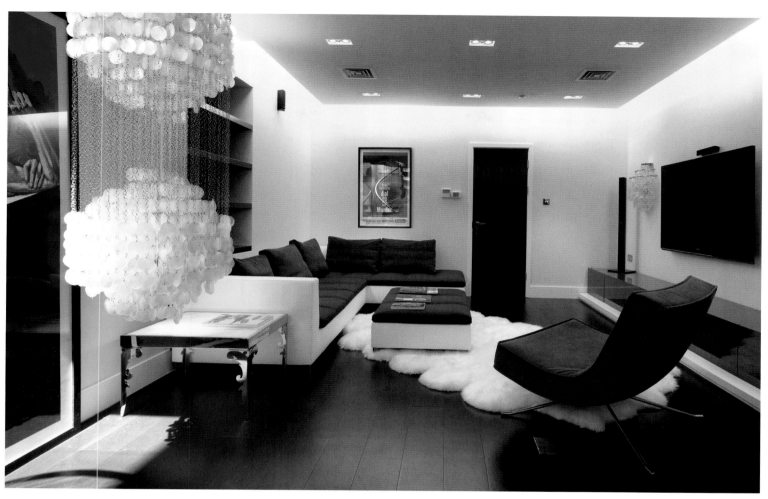

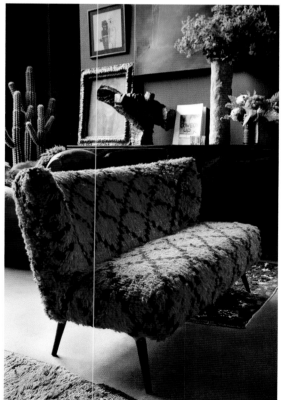

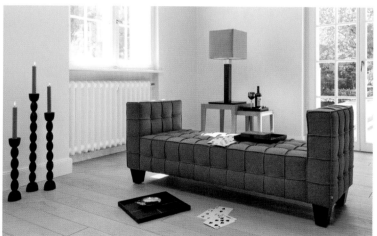

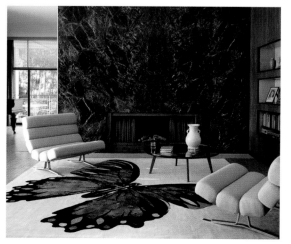

ABOVE Drama in a living room comes in many guises. Sleek and stylized, this formal look is all about the funky sofa and chairs centered on a coffee table.

FAR LEFT Interior designer Abigail Ahern is the queen of creating a theatrical space. Here, she has upholstered a small sofa in feisty red wool, which stands out dramatically against the chocolate-colored walls.

LEFT Wallpaper is an old faithful for delivering character to a space. For easy opulence, fake it with a richly veined marble pattern rather than a damask print.

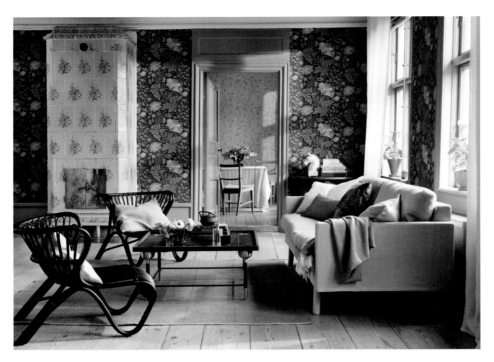

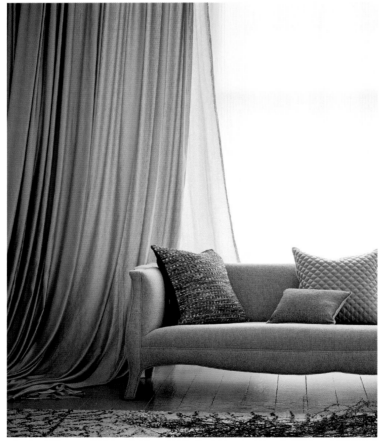

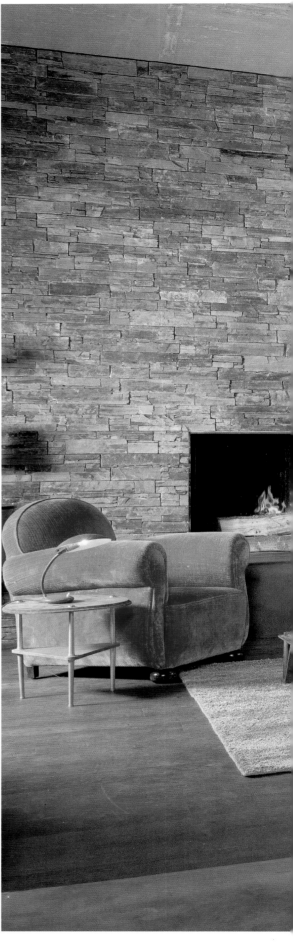

TOP LEFT Living in the country doesn't have to mean a traditional look. Here, a modern boxy sofa is paired with sinuous bentwood chairs—and there's not a spot of tweed in sight.
ABOVE Nothing says luxury like a swag and drape. Let curtains fall onto the floor to create this lavish style.
RIGHT A velvet-covered armchair or sofa goes a long way to adding a touch of luxe. Combine with a chic leather stool in a muted gray and a silky shag pile rug.

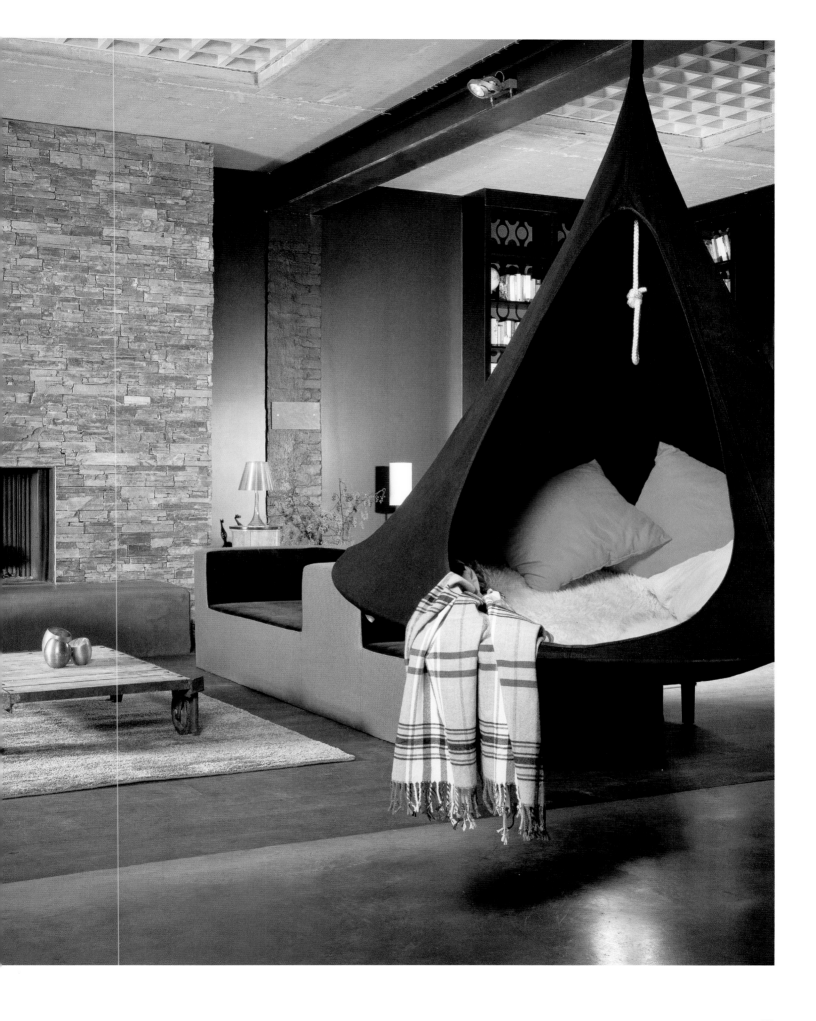

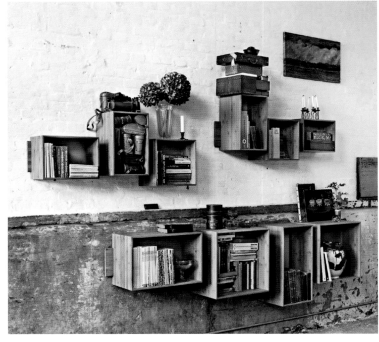

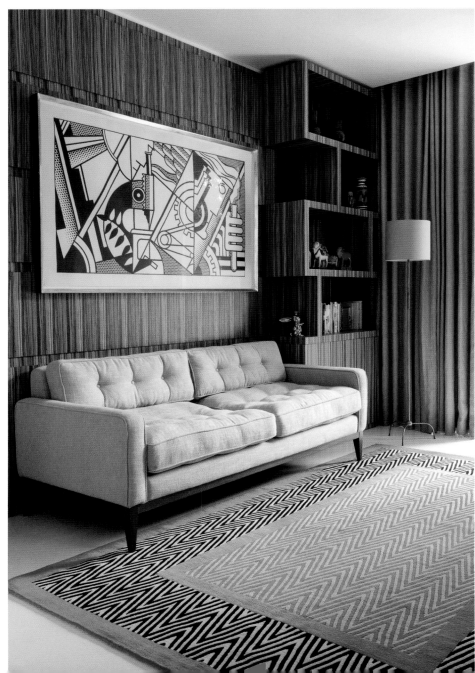

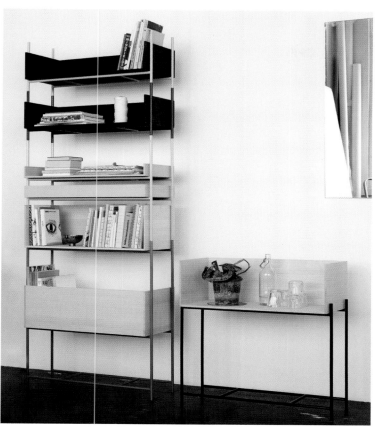

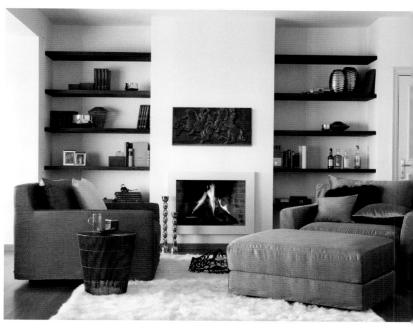

THIS PAGE Shelves and bookcases are a crucial part of any living room, providing functional storage and keeping a space clutter-free. Alcoves are a natural solution for custom-made shelves. Bookcases with a slim profile will take up less visual space in a room, plus will fit with any style of room.

OPPOSITE Bookshelves don't need to cover an entire wall. Here, clusters of boxes are fixed to the wall, creating little nooks for books and accessories.

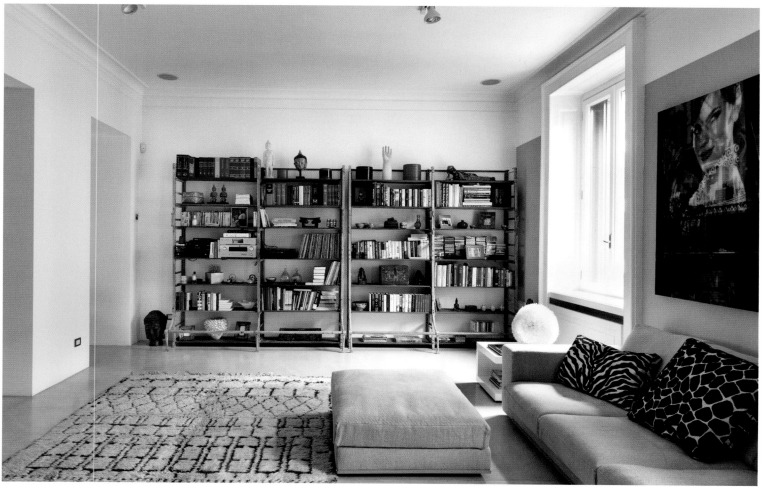

LEARNING HOW TO LAYER

Adding the stylist's touch to your home can be tricky to master. Part experience, part instinct, an interior stylist can feel their way around a space, grouping objects and strewing cushions with ease. However, there are some style hacks you can borrow to prettify a room.

#1 Contrast old + new, rough + smooth. Offsetting classic styles with contemporary pieces, rough textured ceramics with glossy glazes works really well.

#2 Rather than putting bits and bobs everywhere, organize your favorite ornaments into style and color categories, grouping them in odd numbers.

#3 Think 3-D. Stand back and look at the volumes in the room to make sure each piece of furniture is balanced and there are no gaps.

#4 A touch of black will instantly ground a room and make it feel cooler.

#5 Rugs are great for adding a tactile element. Use them as a pathway, mix and match, overlap.

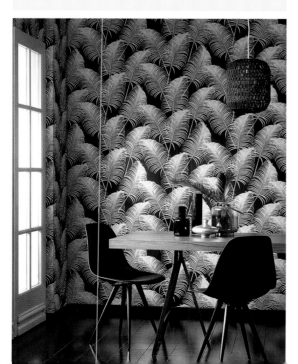

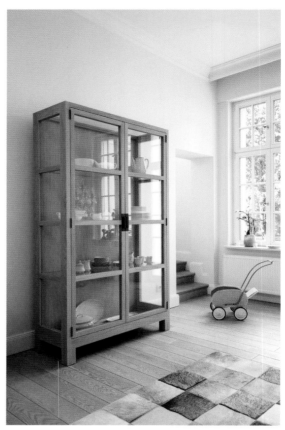

THIS PAGE A dark-painted bookcase makes a feature of colorful book covers and patterned boxes, while a simple, glass-fronted cabinet in blonde wood forms an elegant display of white ceramics.

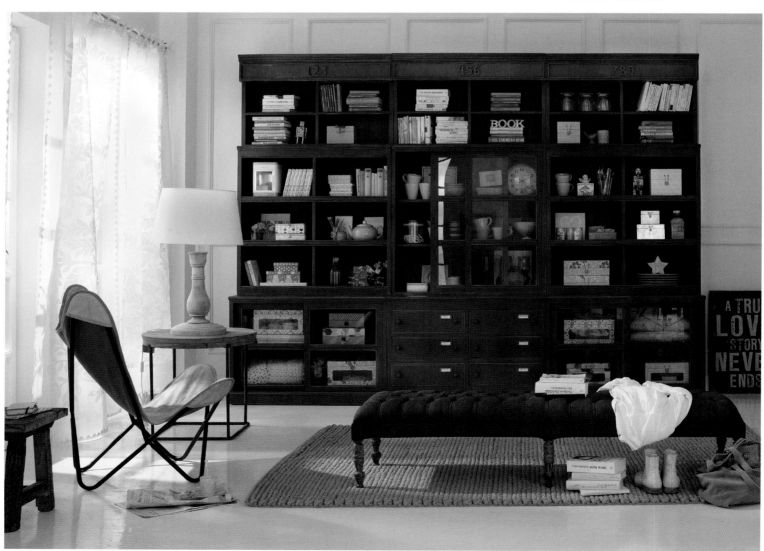

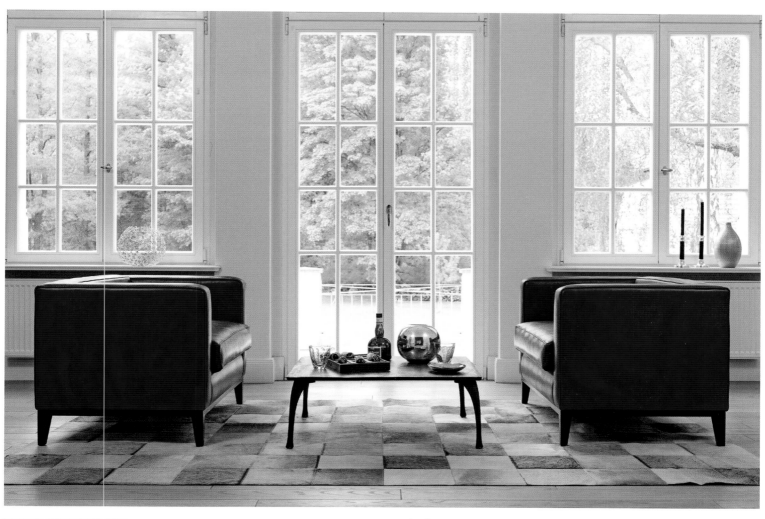

Think of grouping items in threes for a considered, put-together look, for example: a chair, floor lamp, and picture; a sofa, coffee table, and rug.

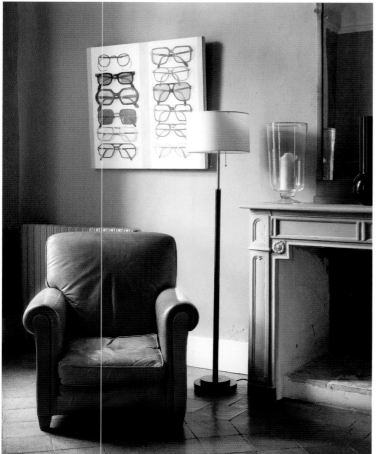

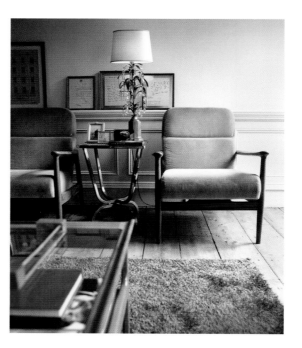

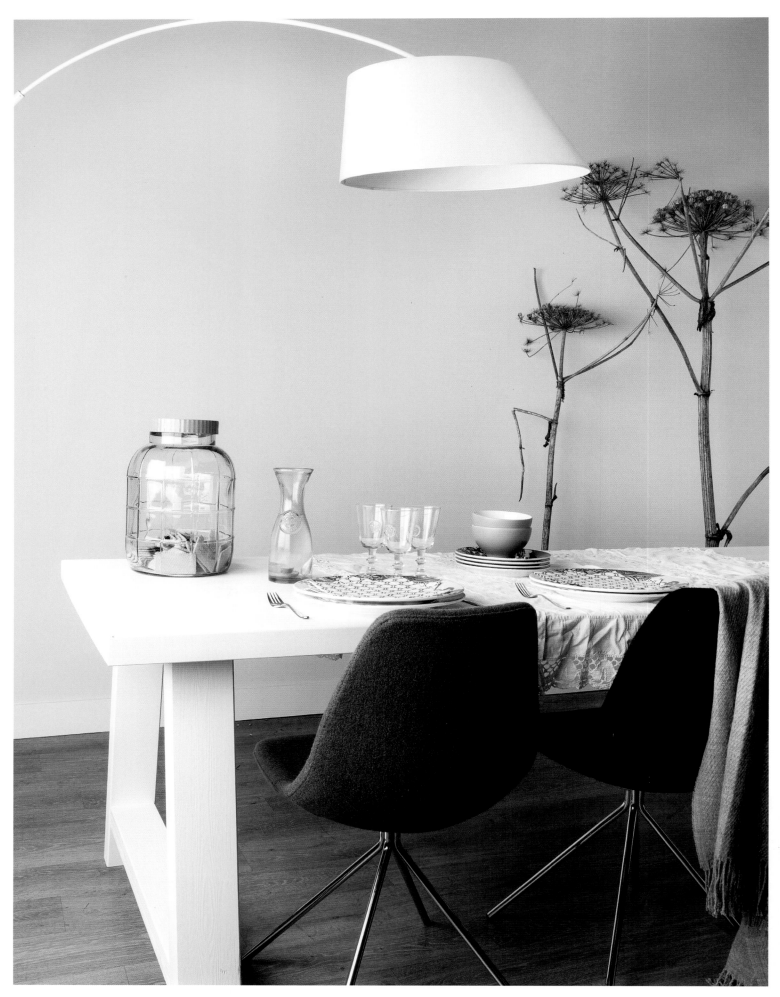

DINING ROOMS

Family life can present challenges when it comes to decorating a home. Case in point: the dining room. In today's time- and spatially-challenged world, multi-functional spaces have become the norm. Who has the luxury of having a dedicated "good" room? Unless you are a regular host, the days of the formal dining room are gone. More than likely, the kitchen and dining room are morphed to create a wonderful, useful, versatile, hardworking, and fun space, where everyone can be together and an array of activities can be done. It is a place to eat, entertain, work, and play. But there is a heck of a lot to think about in its design.

I say, keep it simple and low-maintenance. Easy-to-sweep floors and wipe-down surfaces should be your reference point. Go for a light and airy scheme. If I'm using my dining room to work during the day and hang out on weekends, a white space is a nicer place to be. A smart idea that works really well in a shared kitchen and dining room is to paint one section of the wall as a chalkboard. Pale wood furniture stands out against the flat, slate color and it is as handy for jotting lists as it is for keeping the kids entertained. If you prefer an all-white room, to stop it becoming too one-dimensional, offset it with a single piece of furniture that is bright and cheery. We always want to encourage sunshine in rooms.

Much like the character of the space, dining room furniture works best when it is

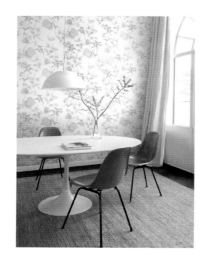

versatile. Display cabinets and sideboards are back in favor as storage for plates and glassware. It makes setting the table a cinch and keeps you out of the way of any hostile cook. Fixing cupboard doors on the reverse side of a kitchen island is a space-saving alternative too. On the subject of tableware, try not to obsess about being too matchy-matchy. When in doubt, think French. There's nothing wrong with a mixture of glasses on the table. Different styles and colors look beautiful together and small tumblers work as well for wine as they do for water. If you stick to classic colors for crockery, i.e. white, then you can amass various styles, but they will always look good together. You can't beat classic beauty.

For your furniture need-to-know, everything revolves around the dining table. It sounds obvious, but choose a table that works for the shape and size of your space. Less dominant than wood, a glass-topped table will maximize light and improve visual flow in a room—so this is good for busy interiors. When it comes to space-saving and versatile design, I like a round dining table. They are saviors in a small space as they are ideal for tight corners and flexible when it comes to seating options. As the boundary between kitchen and dining spaces blur, an extending dining table is a heavenly match, as it can be used for anything, so great for families who live life to the fullest. To create more space, use a bench on one side that

can be tucked underneath. Bentwood chairs are my go-to for all occasions and room sizes. They are lightweight, easy to move, easy to clean, and don't have solid space-absorbing backs.

As the dining table has become a statement piece, it deserves a statement light above it—something with a wow factor—especially so in open-plan areas, because as rooms are getting bigger, you need bigger fittings too. As a rule of thumb, the size of the dining table and the lamp above it go hand-in-hand. Also, the shape should echo the table itself—a round for a round, an oval for an oval.

#1 Work out where you want your table. Like, really work it out, as the corresponding light fitting is less of a moveable feast.

#2 Things look good in pairs. Giant pendants positioned side-by-side over a dining table give grandeur as well as illumination.

#3 Hang it low. A lamp positioned between 28" to 32" above the table is about the right height.

Get your dining table and lighting right and the rest of the decoration will sort itself out. Aim for warm, friendly and inviting and you can't go too wrong.

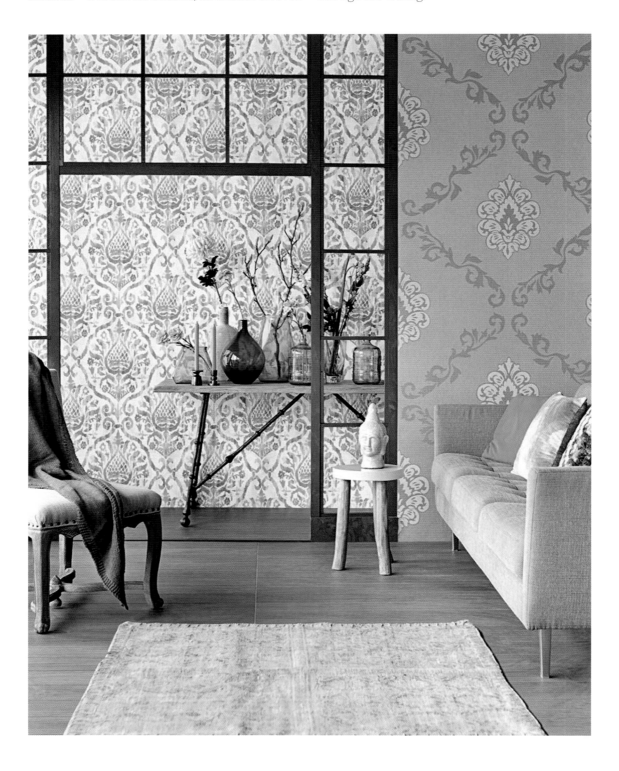

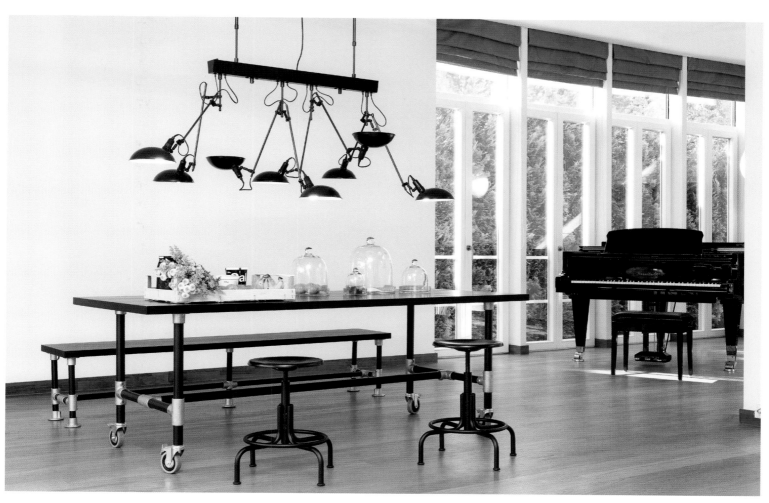

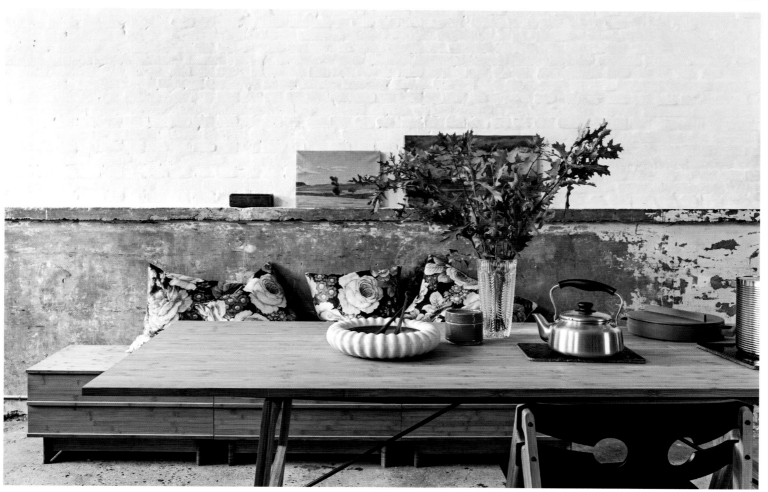

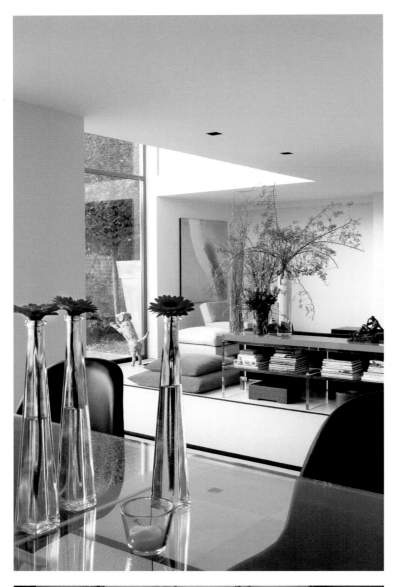

LEFT In a monochrome scheme, accents of blood orange make the room sing.
BELOW LEFT Yellow is such a welcoming color. In this white room, it looks fresh and inviting.
BELOW Orange is the happiest color, so ideal for a social space. This apricot shade is more forgiving than a saturated bright tone.
RIGHT The white walls and furniture anchor this zingy patterned rug in this dining room.

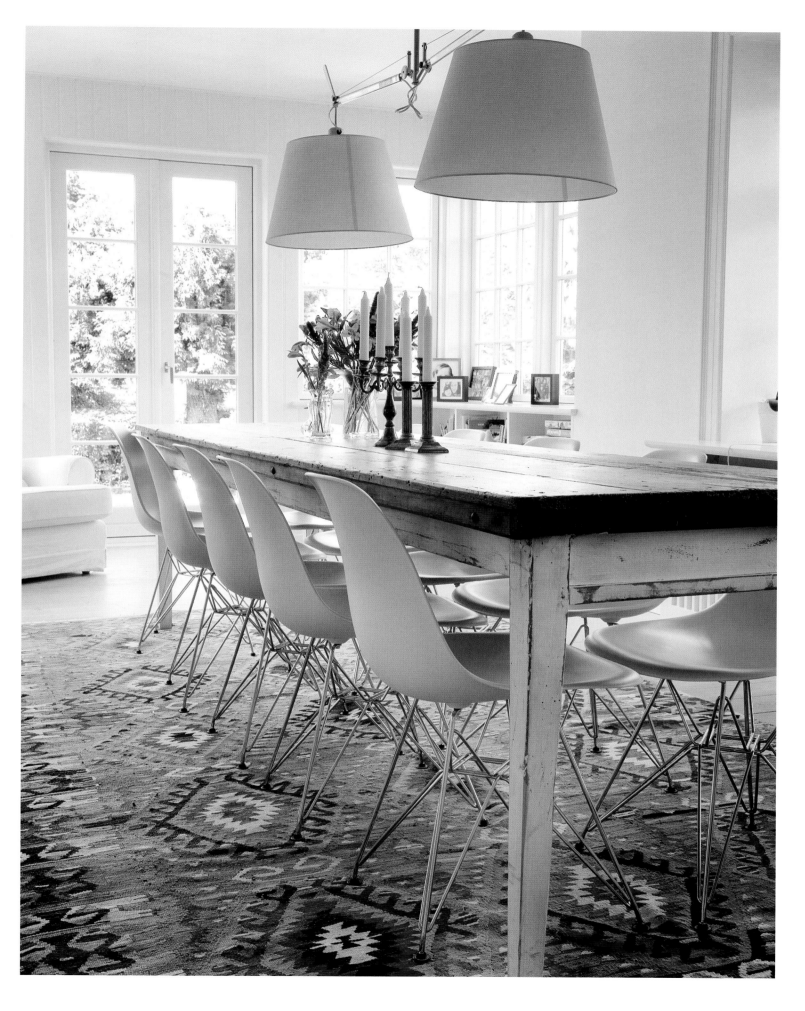

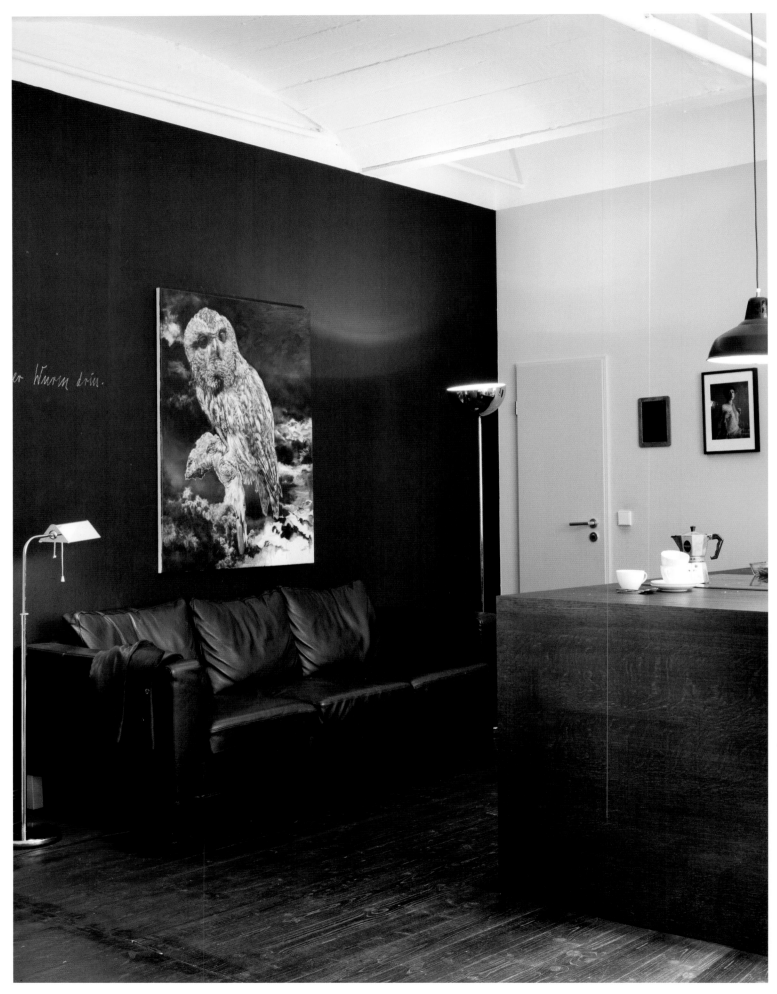

LEFT A matte-black wall sets off artwork, making it a focal point in the room.
ABOVE Wood and white: a classic Scandinavian-inspired dining room.
RIGHT When you're going all out for opulence, you don't have to stick to a white tablecloth. This paisley fabric matches the maximalist vibe.

HOW TO CREATE A CENTERPIECE

Never underestimate the transformative power of plants. Clear the work papers away, move the Play-Doh and put some flowers out. It doesn't need be anything lavish. A simple snowdrop in a terracotta pot or a bunch of tulips over flowing a vase can make an impact. Jam jars of all sizes, old food cans, and the glass holders from scented candles make pretty vessels for small displays. Wild flowers and cut flowers combined also create a nice contrast—just keep to a simple color scheme when picking them out. When choosing a vase, look for beautiful shapes and consider the color and scale of your table. And if you can't pick a color—go for glass.

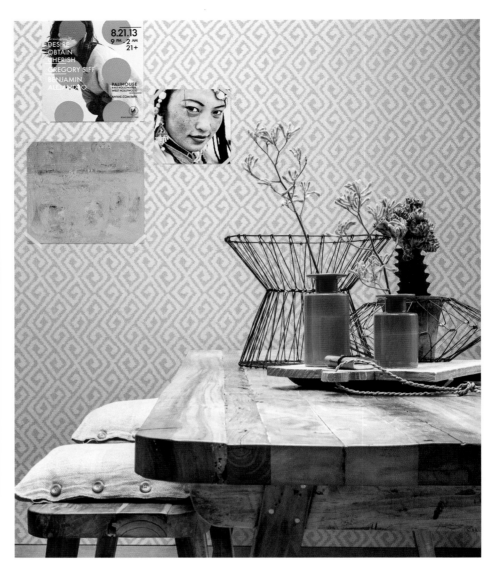

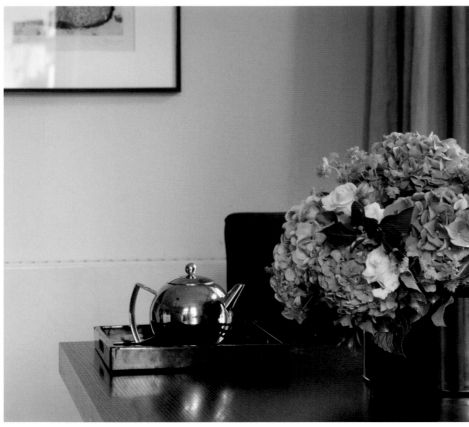

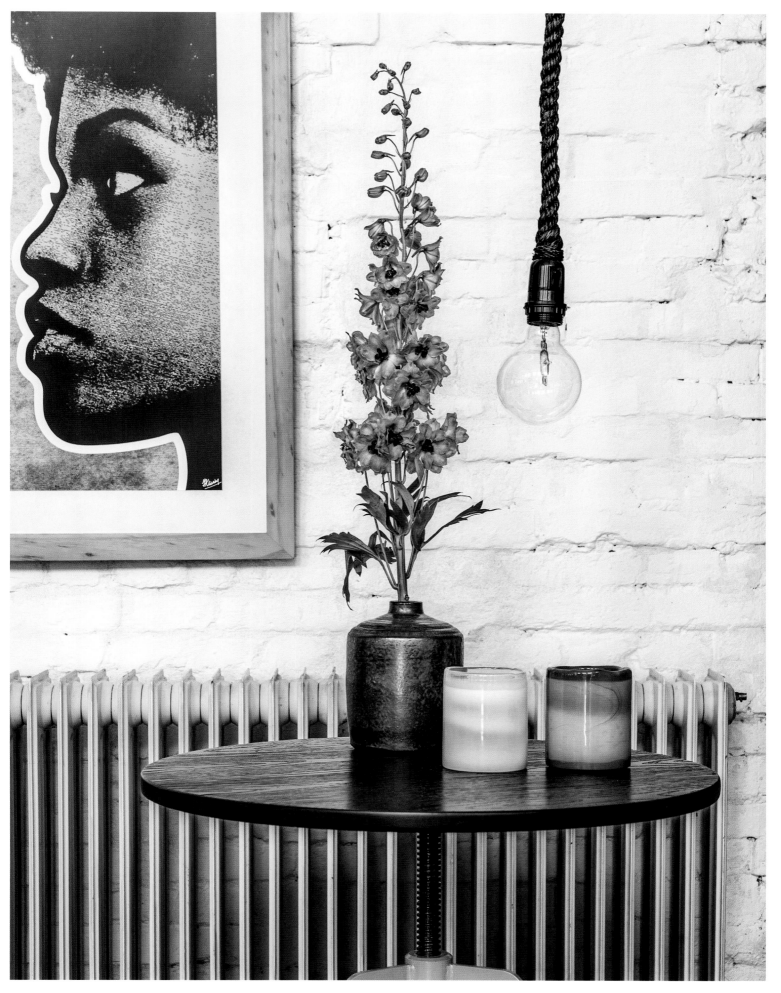

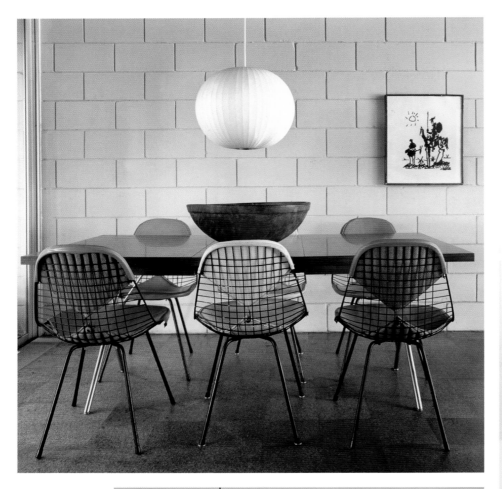

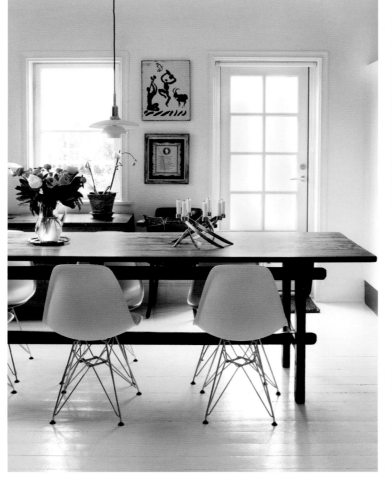

ABOVE LEFT For mid-century enthusiasts, this cork floor and white-painted cinder blocks complement the George Nelson Bubble Ball light and Eames wirework chairs.

ABOVE A small amount of black adds drama to this calm gray and white interior.

LEFT DSW chairs by Ray and Charles Eames contrast with this rustic dark timber table.

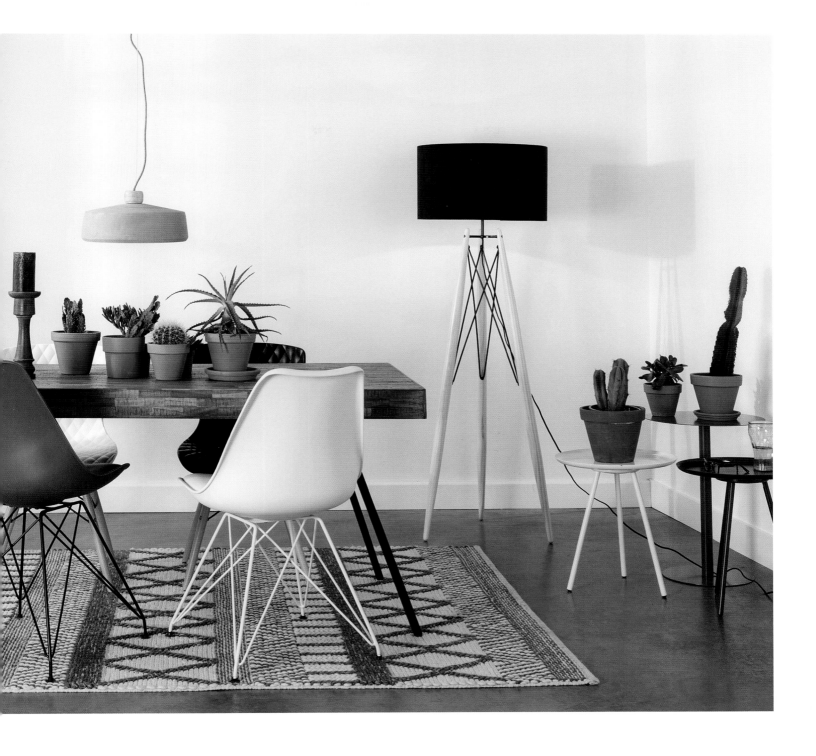

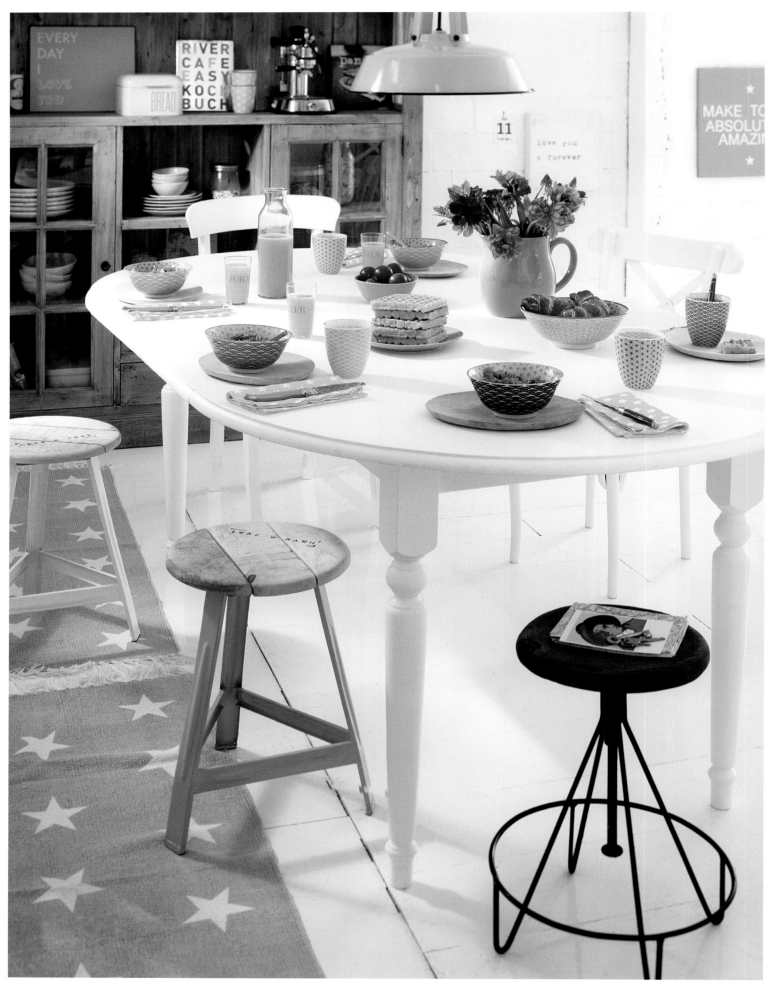

LEFT PAGE Bursts of color will breathe life into a white scheme. Focus on a single area—in this case, the floor—to keep the overall effect from looking too brash.
RIGHT You can't beat paint for an easy update. Here, turned wooden chairs are painted white and a bench is a gorgeous teal blue.
BELOW The organic warmth and character of wood will soften the coolness of a white kitchen diner.

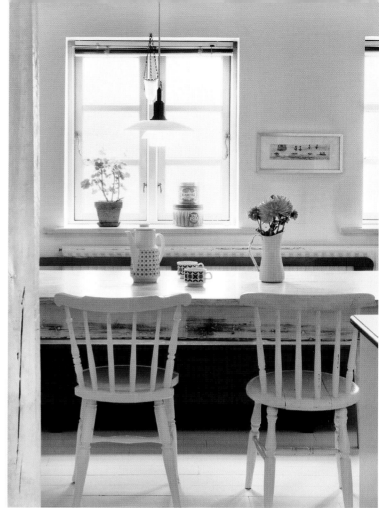

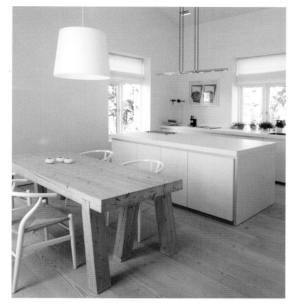

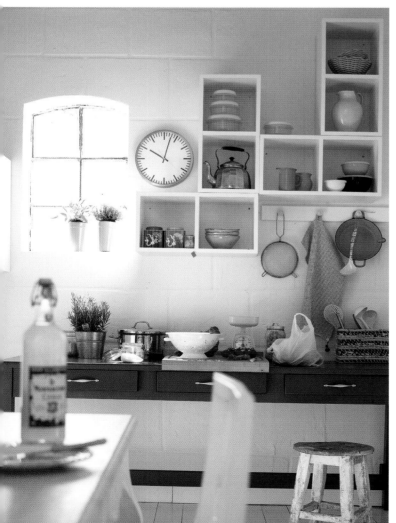

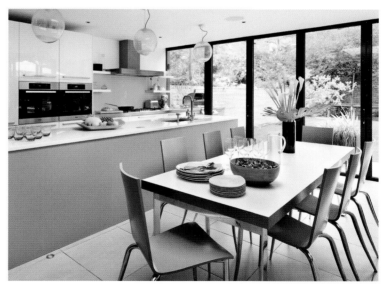

ABOVE Pink and green is a color combo made in heaven. Here, it enlivens the restrained color palette.
LEFT A rich blue-painted cabinet grounds this pretty white kitchen.

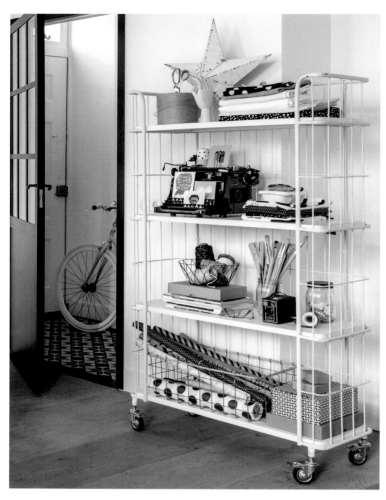

LEFT A moveable feast, this trolley is mounted on casters so it can be wheeled into a new position.
BELOW LEFT As interiors become more open-plan, a small sofa adds extra versatility.
BELOW This multi-function bench has concealed storage under the seat to stash away clutter.

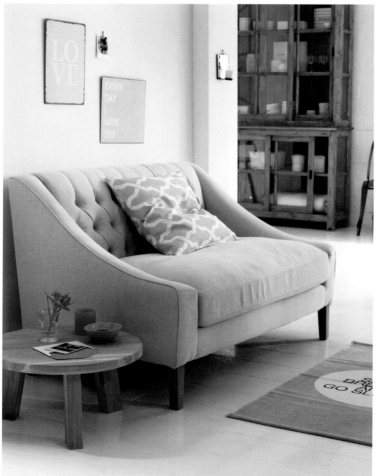

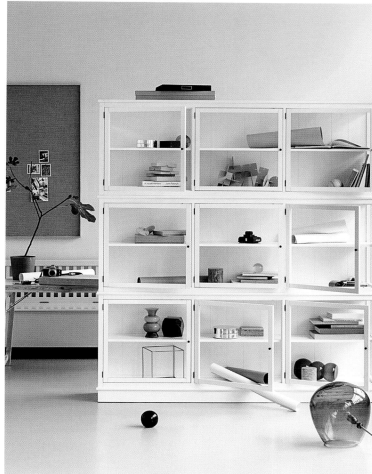

ABOVE This vintage sideboard keeps dinnerware out of sight.

ABOVE RIGHT A glass-fronted cabinet displays china and glassware.

RIGHT Wood, leather, and glossy white come together in this bright and airy space.

BELOW This beautiful metallic console adds a touch of luxe to a monochrome scheme.

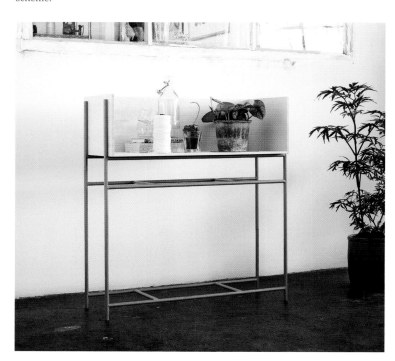

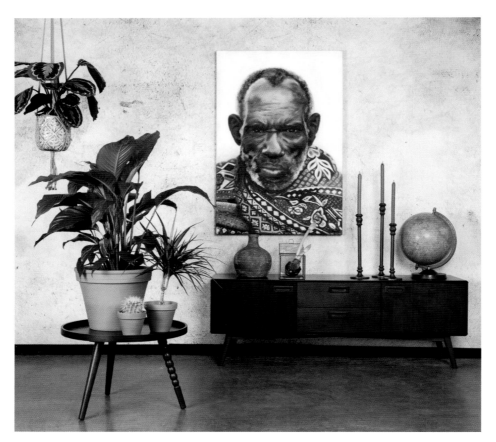

ABOVE Lush greenery adds drama and shape to a room.
RIGHT AND FAR RIGHT Vintage pieces add character to a home.

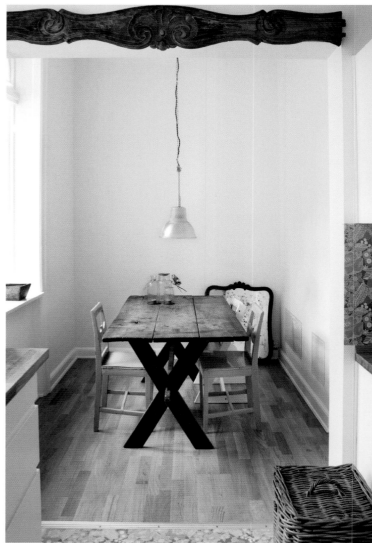

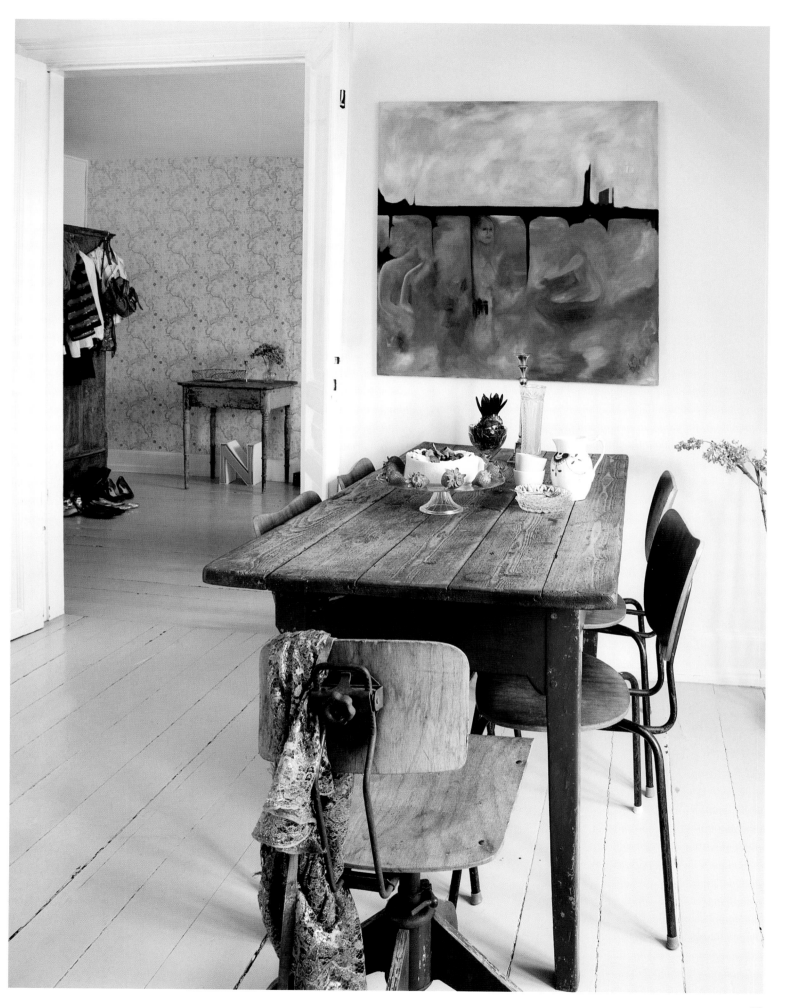

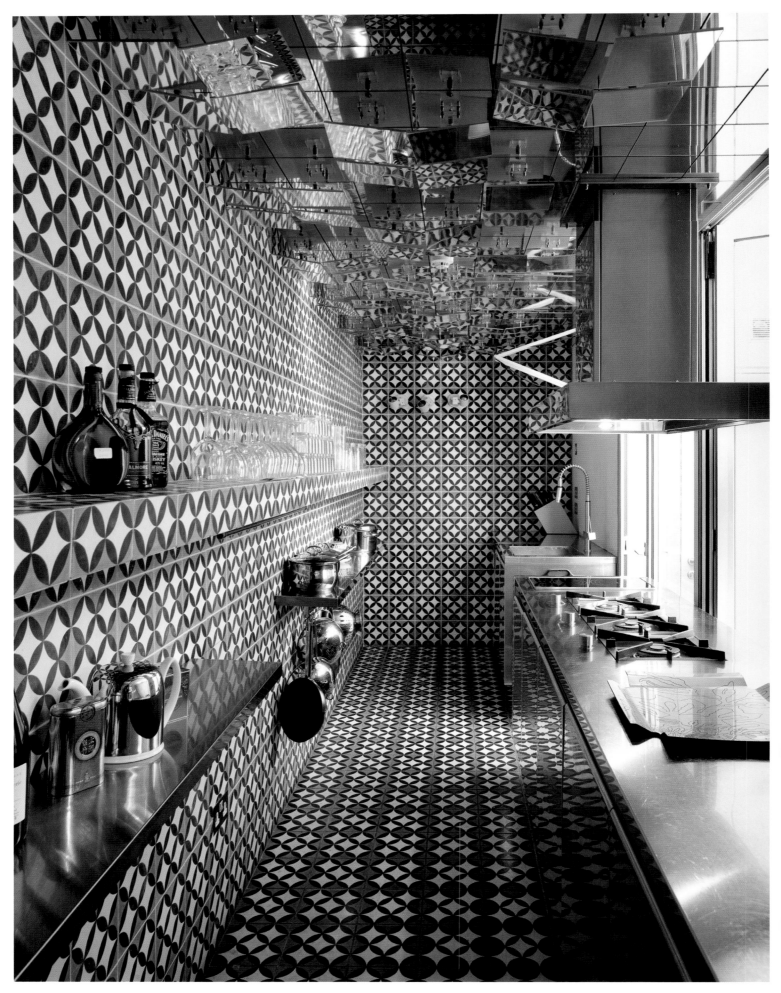

KITCHENS

Kitchens are one of most expensive rooms to renovate. They are also the place where we spend most of our time. But how do you plan the perfect kitchen? Can you update it without ripping it out and starting again? Yes, you can. A few cosmetic changes—new color scheme, new cupboard doors, new backsplash—and hey presto, you have a whole new look.

To create the perfect kitchen, think logistics first, looks second. Common sense and careful thought are the main requirements for designing a kitchen from scratch. Work out how you use it, how often and for what. This will help determine the layout and the type of furniture that is best for you. Freestanding or fitted, open or closed... What would suit the size and shape of your room? What would suit your personality? If you're a messy creature, tall cupboards where you can hide away clutter are probably better than open shelves. Tidy tribes may be able to get away with less storage space, however, know this: whatever you think you'll need, you'll require more.

With this in mind, great storage is key. In my experience, a combination of freestanding and fitted elements works really well. It gives flexibility for different rooms and also means you can arrange the kitchen according to your personal taste. For instance, an industrial, stainless steel unit looks really good against a chunky butcher's

block. Larders are having a moment, too. If you are lucky enough to have a walk-in pantry tucked into your period home, you have nothing but an asset on your hands. Save that, a capacious larder cupboard is invaluable for storing spices, cans, dry goods, and snacks. It means you can do away with your overhead cupboards and celebrate the wall space instead. Here you can hang cast-iron and copper pans to a sturdy pole. Or fix some modular, open shelves. These are especially useful as they you can add/change shelf heights as your kitchen grows. They also give an opportunity to put any prettier dishes or packaging on display.

In a bid to declutter worktops, trays are versatile and decorative storage, keeping tools and condiments neat and close-to-hand. If you have a spare section of wall in your kitchen, lean a ladder against it for some practical—and good-looking—vertical storage. All you need are some large S-hooks and you can use it to hang pots, herbs, and magazines. To create additional space in a small room, ditch the oven hood and fix a ceiling-mounted fan in its place.

Materials are the next consideration when refurbishing your kitchen. If there is one investment, make it your worktop. Not the place to cut corners, try and use materials that look good and stand the test of time. Natural materials will age beautifully, whereas mirrored and glossy surfaces will bounce light around a

room. Corian, marble, and brushed zinc are sexy choices, thanks to their super-sleek finish and their ability to stand up to wear and tear.

As in all rooms, the quickest way to transform any space is to use color. Just because it is a kitchen, it doesn't mean you can't have fun with paint. The floor is a good starting point, as it is a common thread throughout the house and will help to tie in the kitchen to the rest of the décor. Patterned encaustic tiles on the floor are an eye-catching update to a white scheme while adding a global, eclectic vibe. Arrange in an abstract pattern for maximum style points. If a discreet pop of color is more your thing, paint the insides of your cupboard or the back of open shelving in your favorite shade. A cobalt blue or a bright yellow will look amazing against a muted scheme. For small spaces, don't be afraid to go dark. The dark color will make the view the focal point, making any greenery really stand out. Like food, plants are good for the soul.

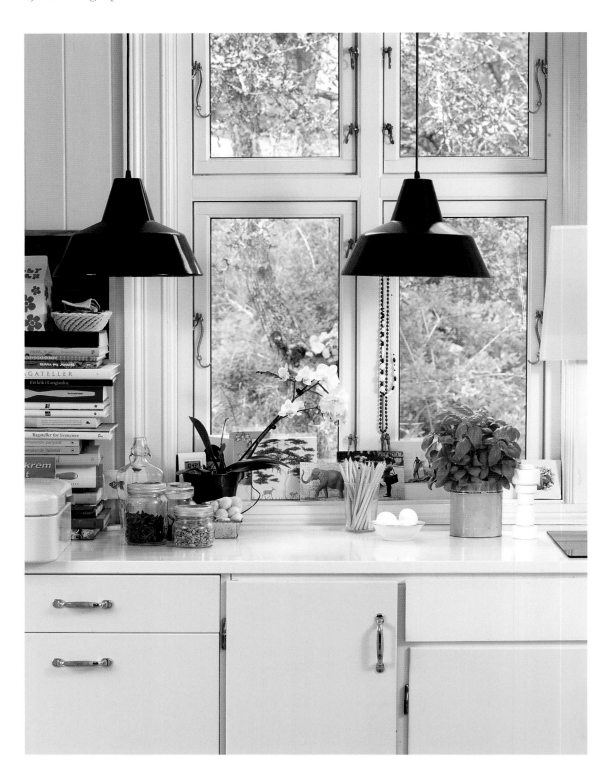

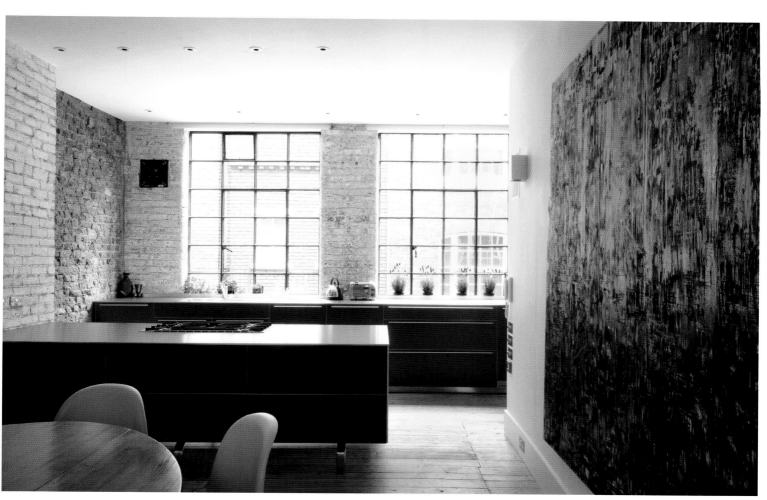

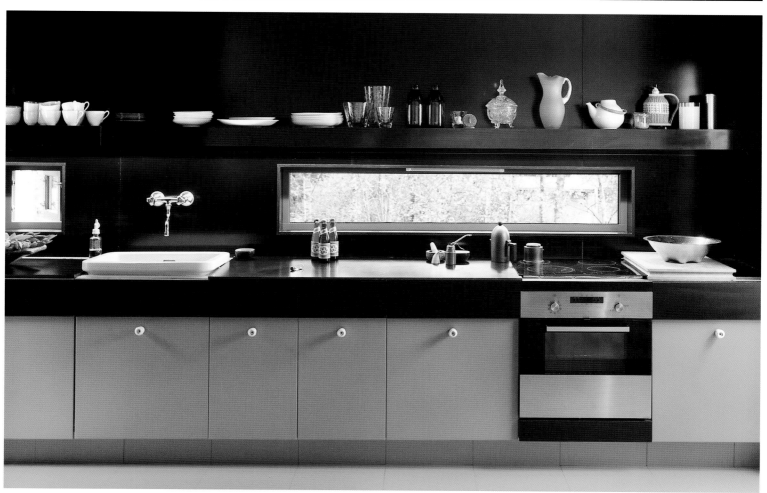

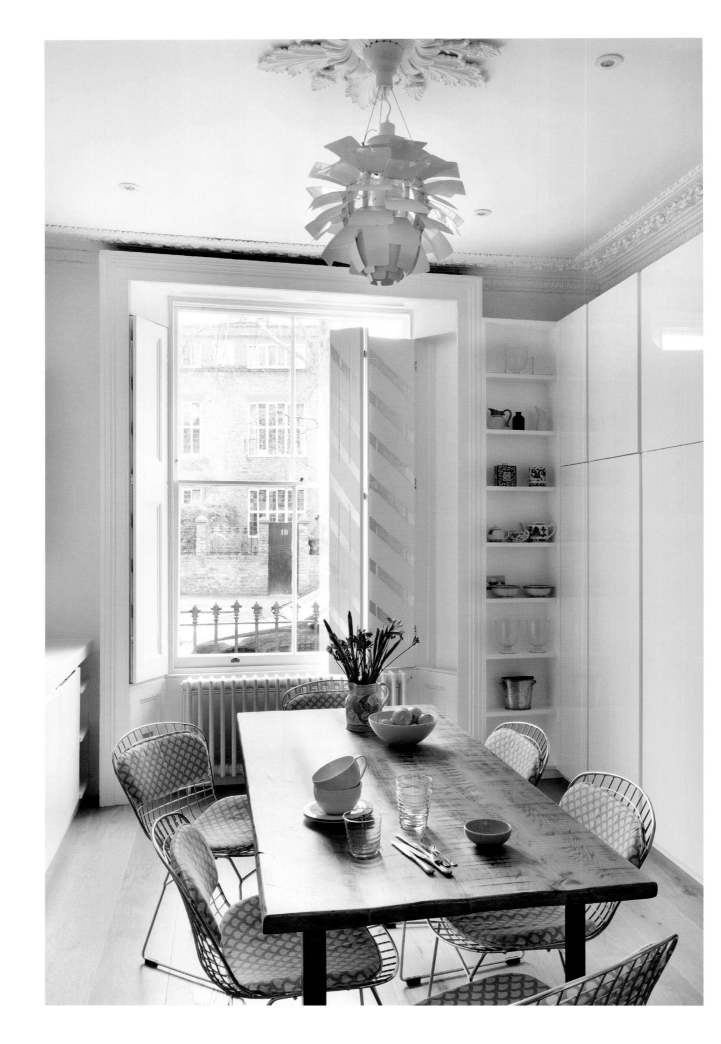

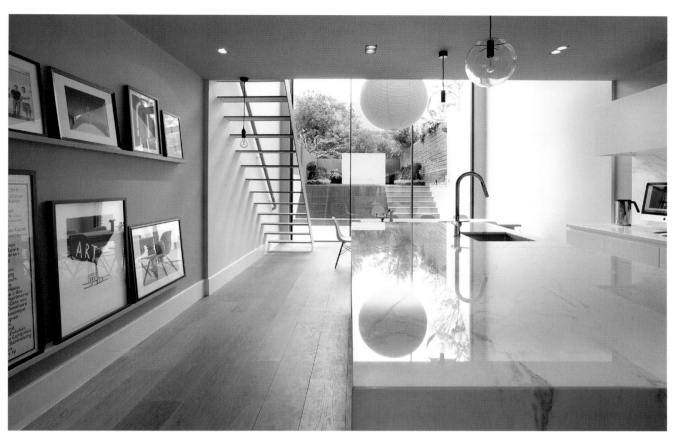

FAR LEFT Streamlined white cabinets hide away clutter, keeping the dining table and chandelier the main focal points.
ABOVE A slim shelf is used to display photographs and artwork in this sleek, open-plan interior.
LEFT Wirework racks and baskets are great for organising kitchen bits and bobs.

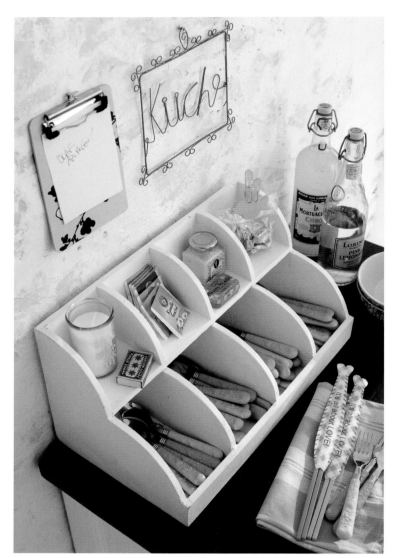

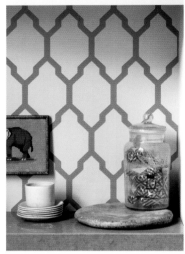

ABOVE RIGHT Here, wallpaper is used in the alcove to add pattern to a simple ceramic display.

RIGHT Embrace the unexpected with eye-catching color and pattern.

FAR RIGHT Not for the faint-hearted, this all-yellow kitchen is sunshine on a plate.

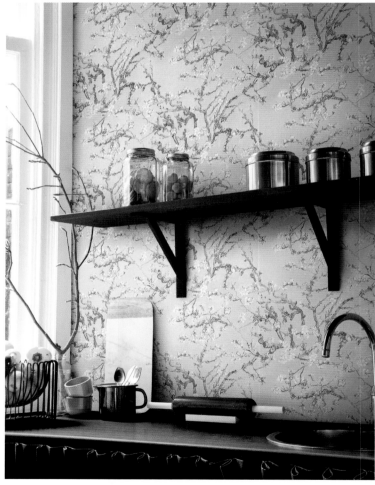

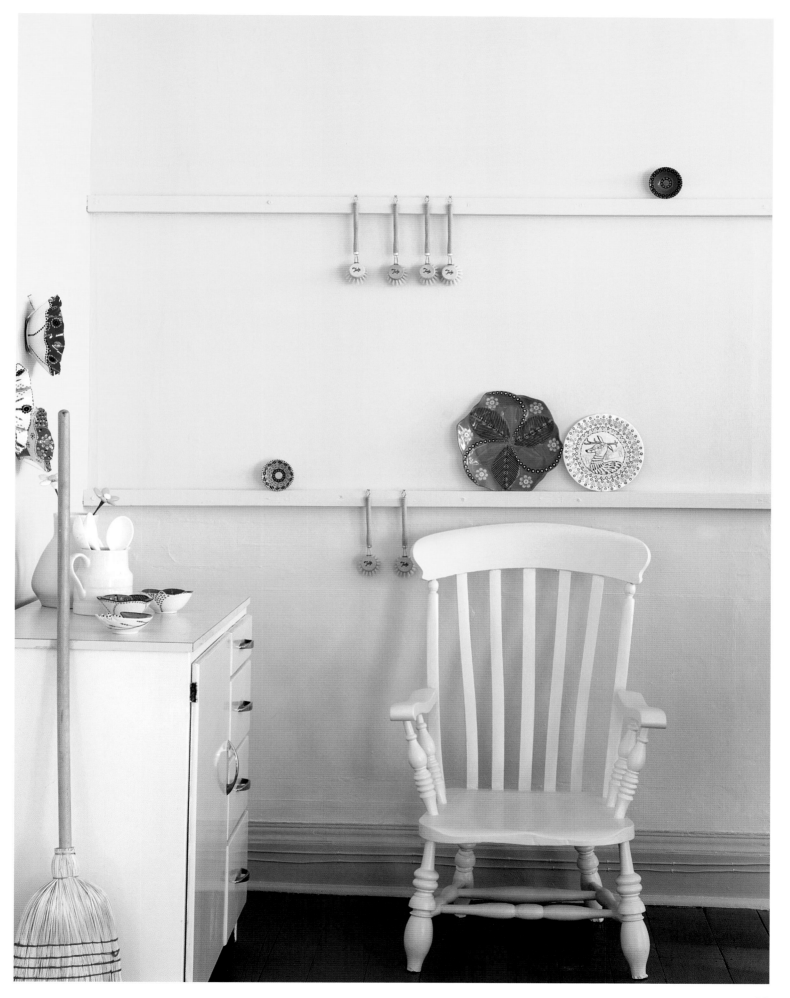

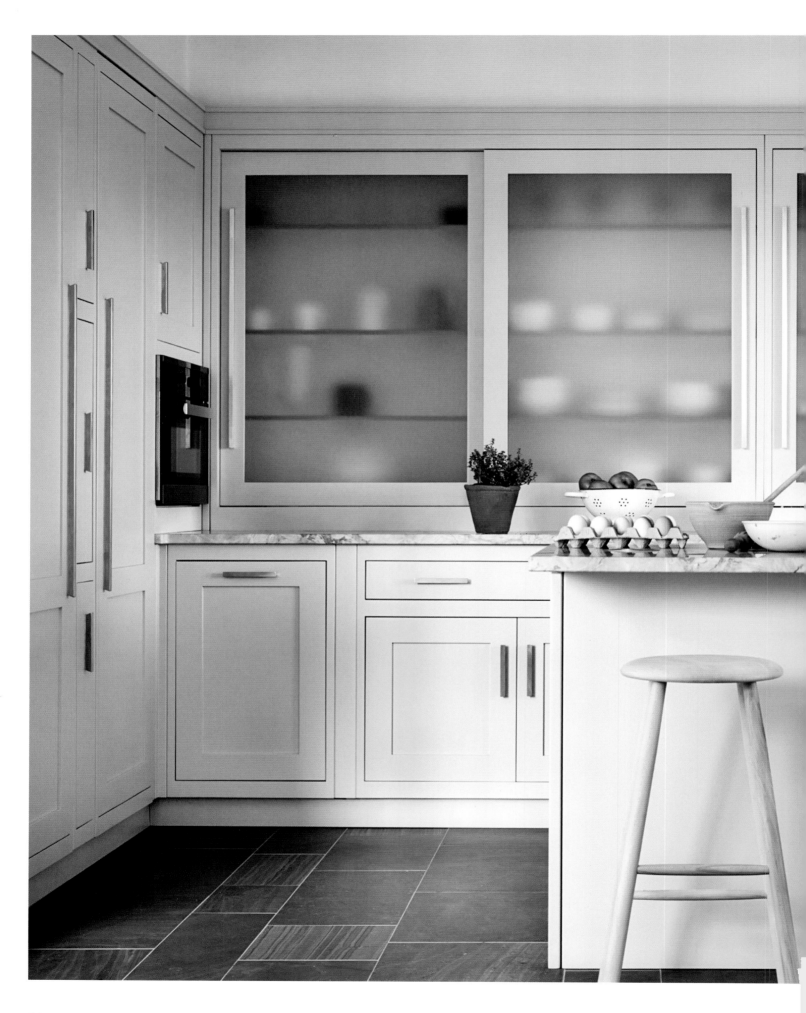

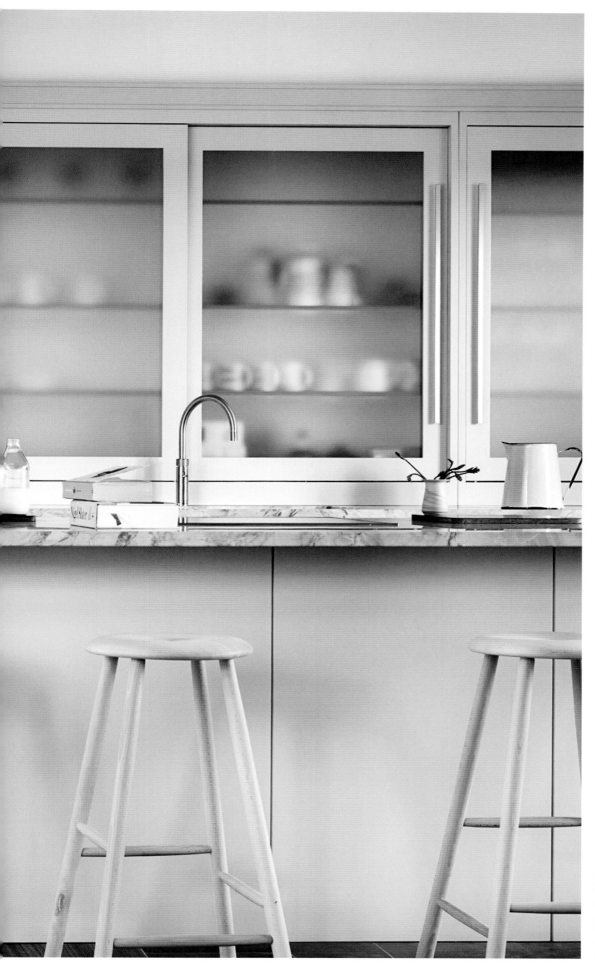

LEFT Beautiful craftsmanship, simple lines and traditional technique are the mainstay of this classic kitchen. A grained marble worksurface, slim brass handles and Scandinavian-inspired pale wood chairs prevent the kitchen from looking too stark.

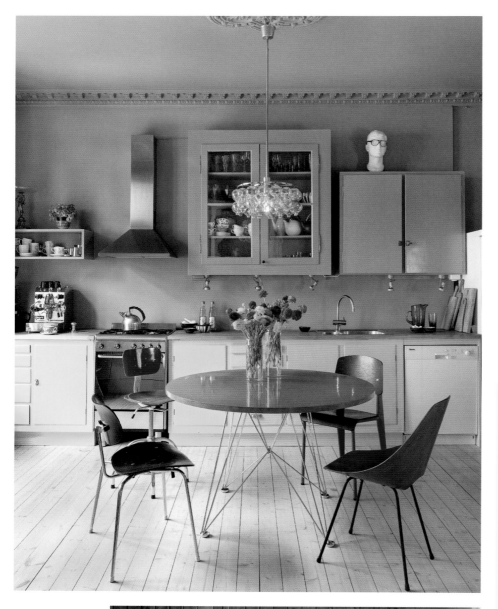

HOW TO UPDATE YOUR CABINETS

With a quick makeover of paint, you can transform old cabinets without getting new cupboards—and save thousands in the process too. A cool coat of charcoal will bring traditional-style base units bang up-to-date. The choice of color gives a contemporary twist and if paired with a rustic wooden worktop, really makes the most of the texture and grain. For added drama, I would paint the entire room in the same dark shade, but to keep things bright and beautiful, opt for white units on the upper half. New brass handles will give a hint of industrial styling while adding a bit more attitude to the look. Semi-gloss is a good choice for the finish, as it tends to be more durable than matte and easy to wipe clean. Prep work is crucial. First remove the door fronts from the units, sand back really well, and fill any holes from where the old door handles used to be. Add a coat of primer before spray painting the rest for a professional result. Brush strokes be gone!

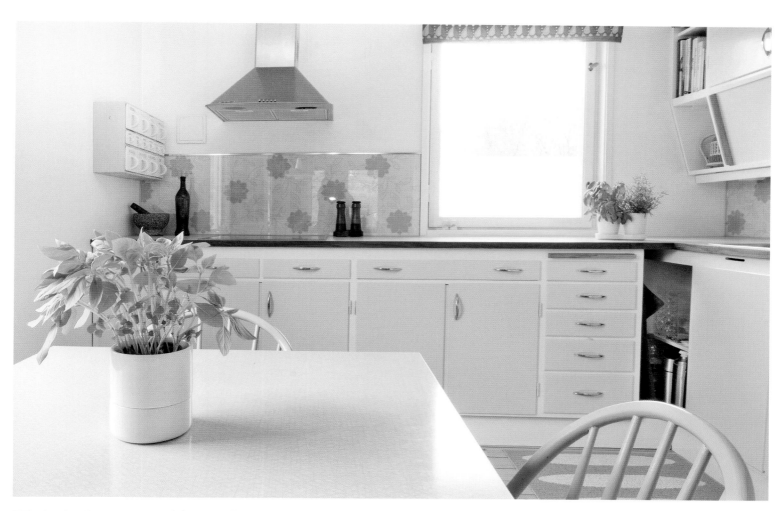

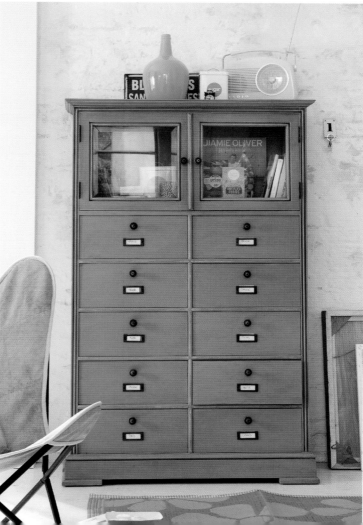

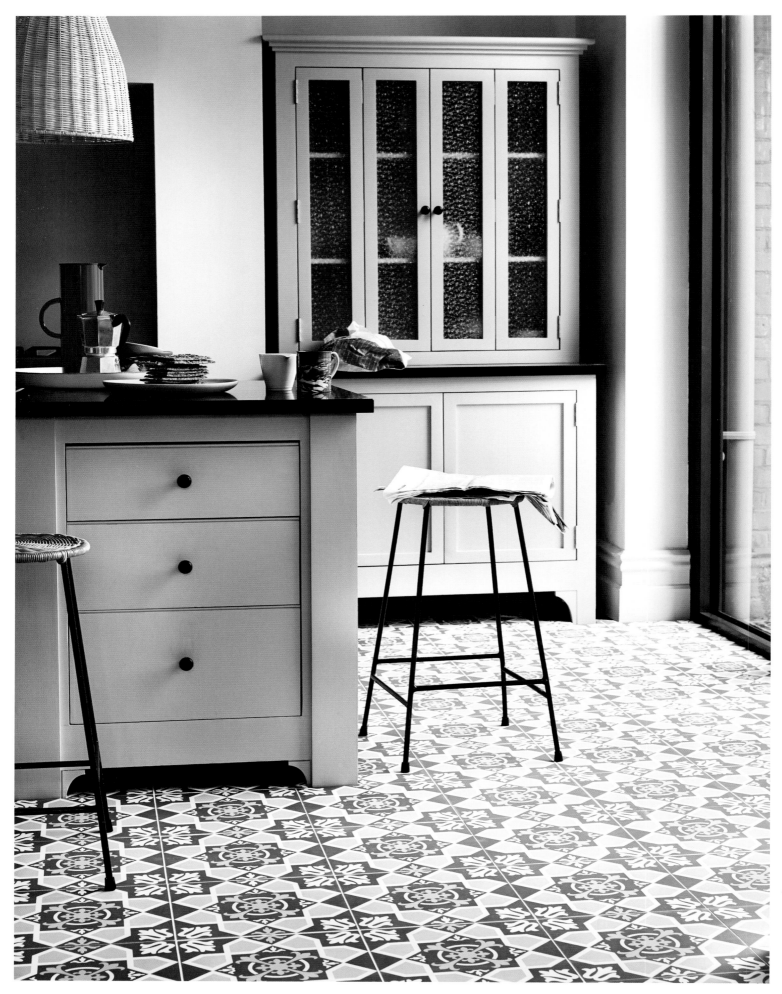

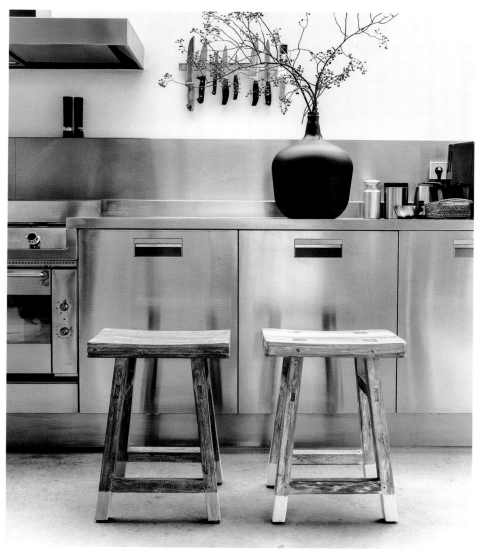

LEFT Encaustic tiles are an effective way to add punchy pattern to a simple kitchen.

ABOVE I love the contrast between these weathered timber stool and sleek stainless steel units.

RIGHT White bevelled tiles and a concrete worktop give this kitchen a clean, utilitarian vibe. Butchers blocks, bricks, and professional grade appliances will further the industrial style.

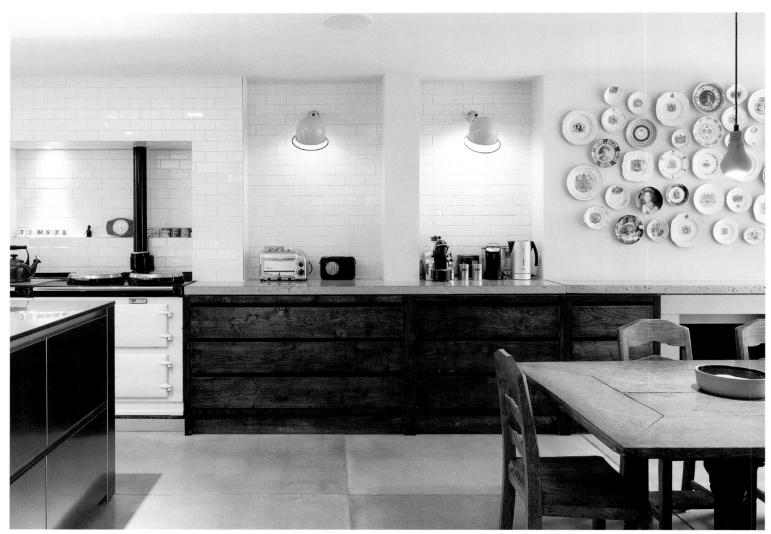

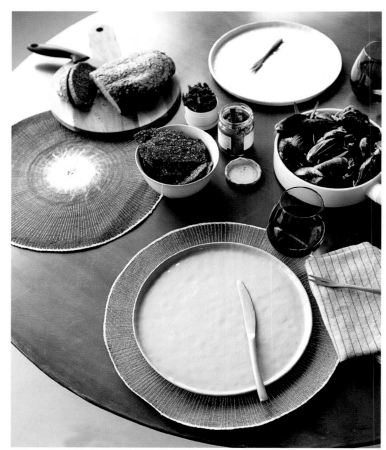

ABOVE Utterly charming, this traditional interior feels modern due to the casual mix of classic chairs.

LEFT ABOVE A cute idea for a feature wall in a kitchen diner is to hang decorative plates. Start in the middle and work your way out.

LEFT Chalky pastel tones and gray come together with beautiful glazes for a multi-layered approach to table setting.

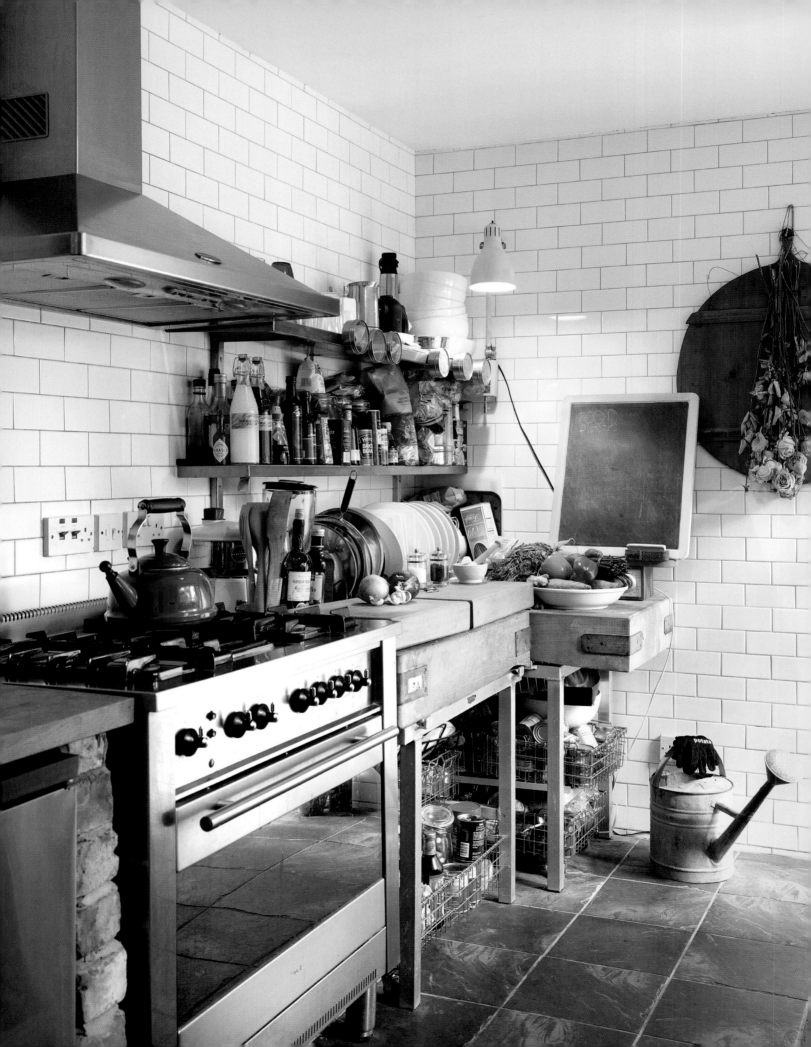

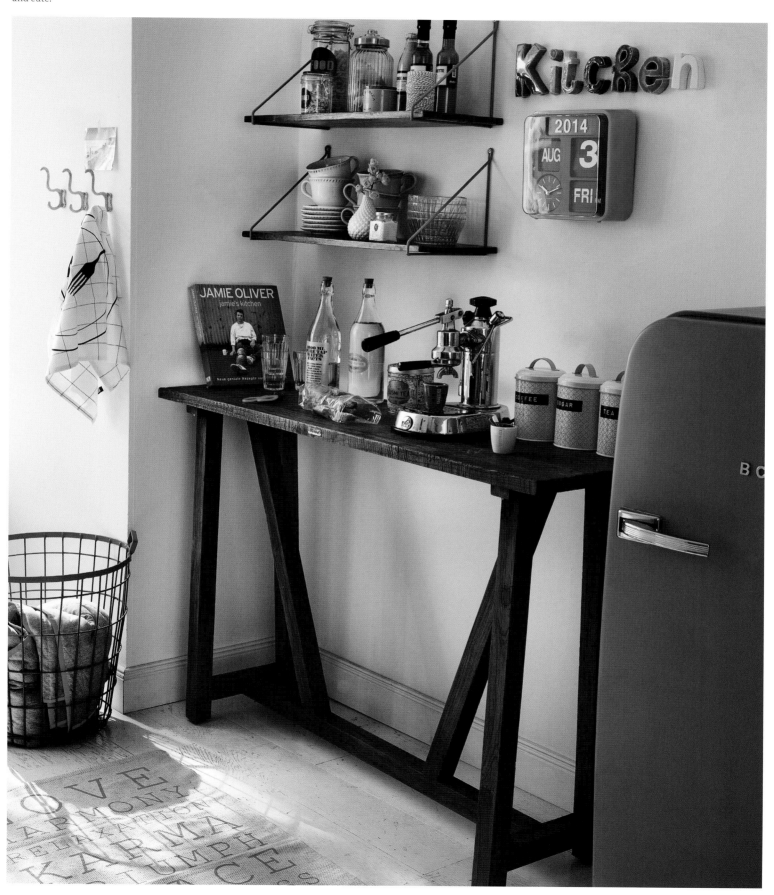

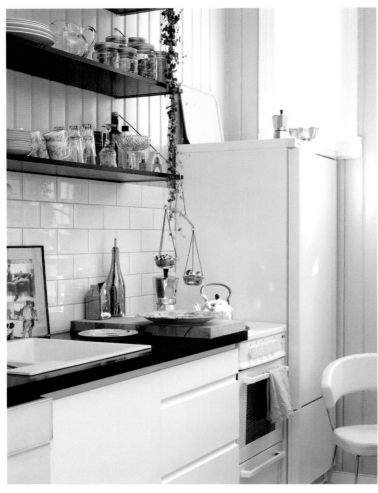

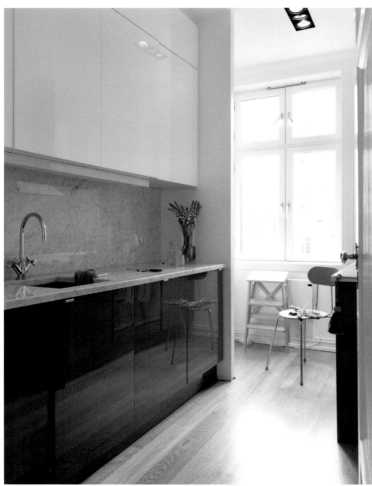

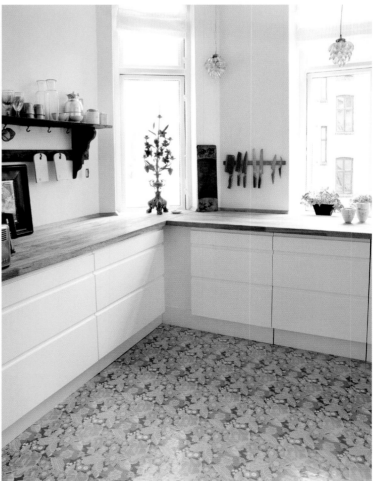

FAR LEFT This simple white kitchen is made striking with the timber worktop stained in a dark chocolate.

FAR LEFT BELOW Black and white is a classic. Use black at the base and white on top to make a small space to seem larger.

LEFT BELOW Lino is a practical and easy way to add playful pattern into a space. This 70s design avoids retro overload with the balance of modern white units and solid wood worktop.

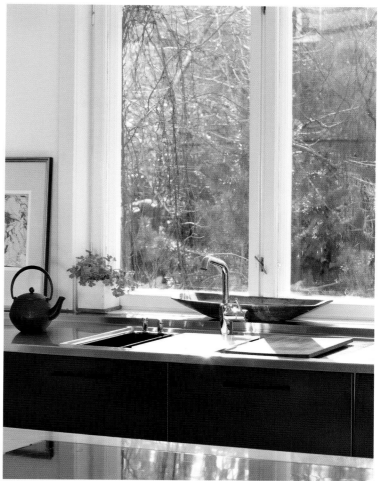

RIGHT This slim stone worktop and dark unit combo will suit any style or size space. Keep the walls white to keep the overall look light and bright.

BELOW In true Scandi vibe, this pared-back, uncluttered kitchen features open shelves and natural materials, such as wood against pale gray.

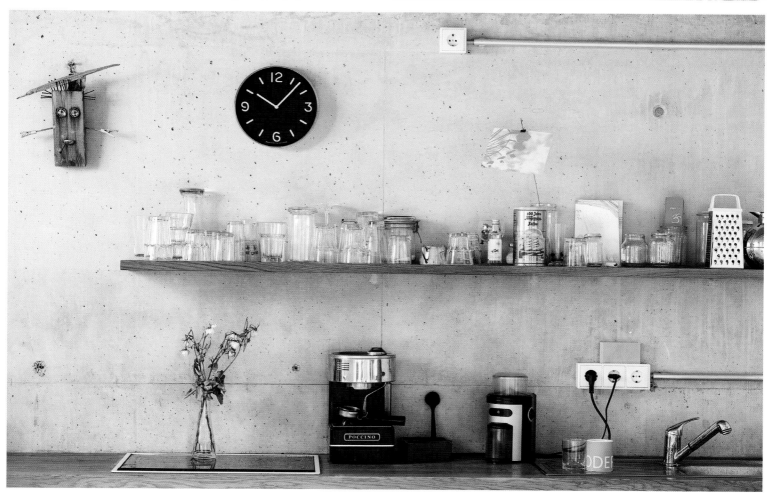

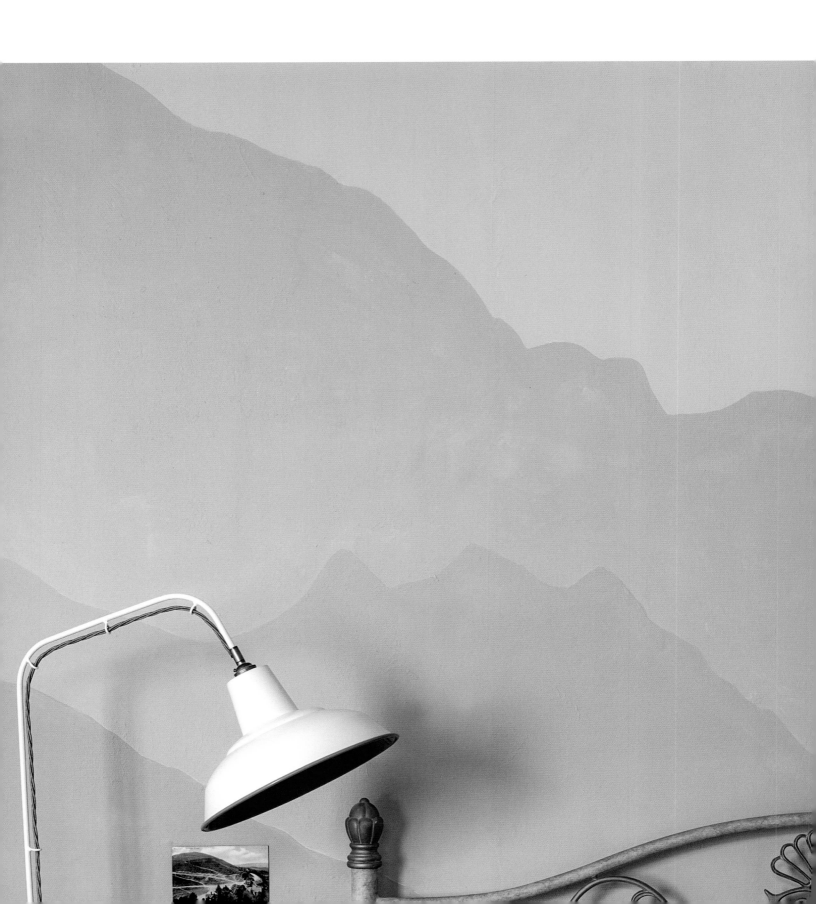

BEDROOMS

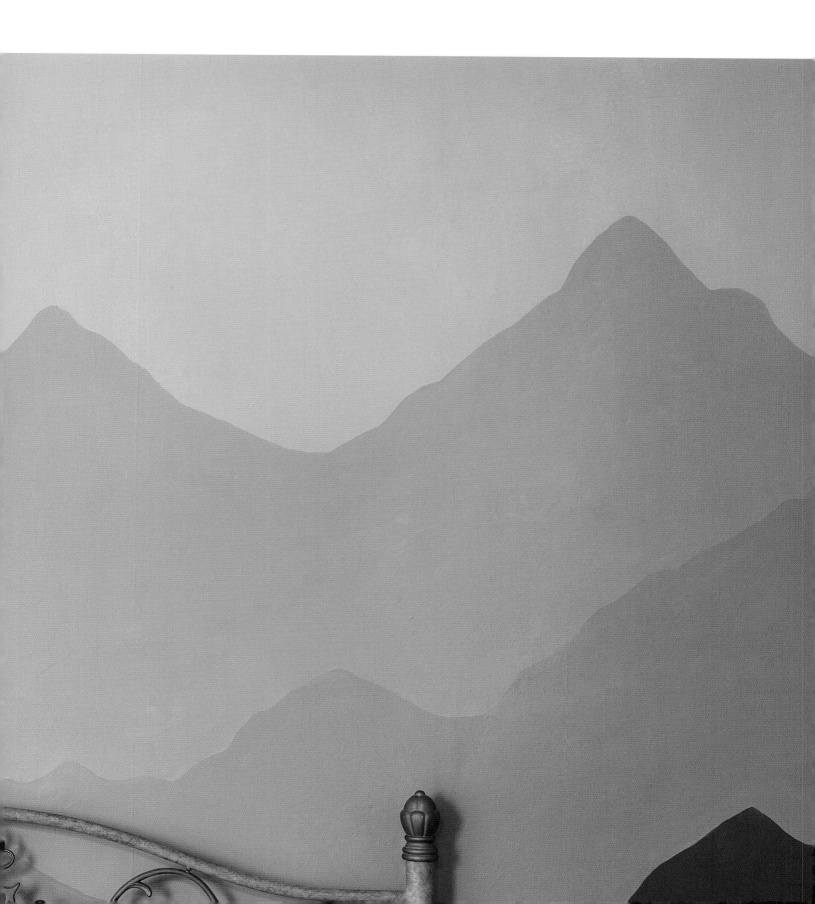

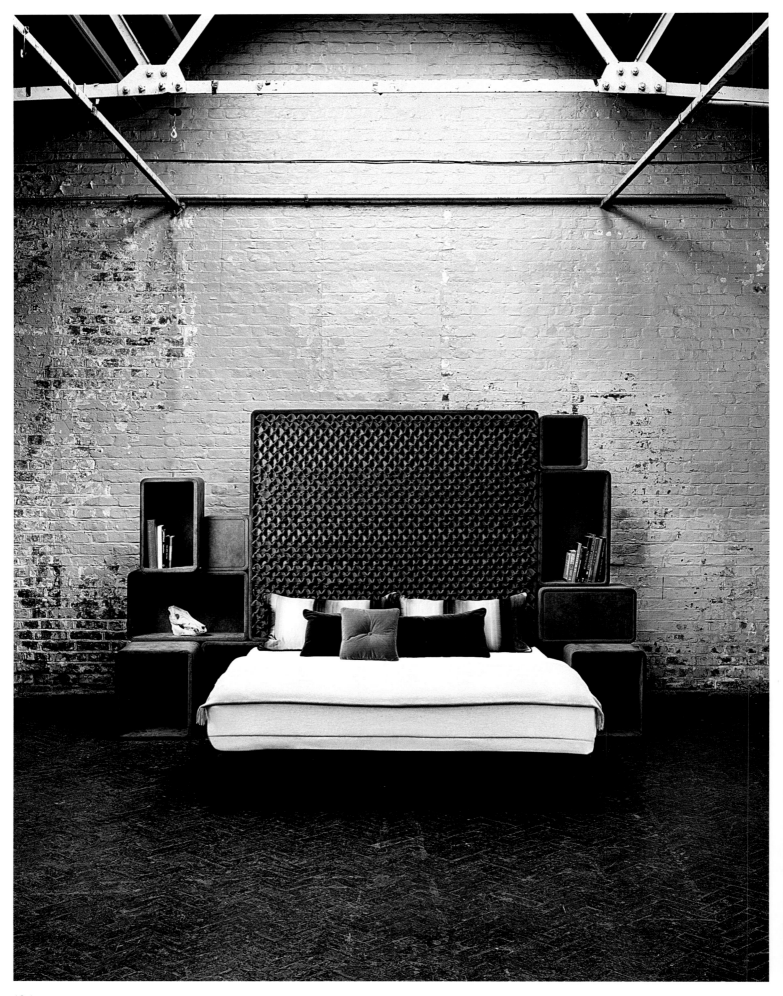

[BEDROOMS

Time for bed. It's not just your phone that needs recharging at the end of the day. We also need a space to replenish our own batteries. We need a hideaway—and a bit of peace. As our homes have become much more multi-purpose, there is ever more need for a comforting crash pad where we can unwind.

The key to creating an environment that speaks of intimacy and privacy is to choose colors and materials that please the senses without overloading them. Choose calm and restful tones here, exercising caution when adding patterns. As much as I love a large-scale floral, a full wall of blossoms can be overload. Use pattern as an accent instead—a reupholstered chair or headboard is a happy medium. A silky plush fitted carpet is ideal for an indulgent feeling bedroom and oversized frame-free mirrors help bounce light around.

Hotel suites are the perfect inspiration for decorating ideas. If you like a pale scheme, soft silver and white is elegant and soothing—as is a moody palette of charcoal gray, if you prefer it dark. Mixed with opulent accessories, this grown-up look is contemporary but laid-back. Blackout roller blinds will ensure a good night's sleep, whereas voile panels are perfect for creating a diffused light whilst retaining privacy. Make lace curtains your own by dying them in a favorite shade or dip dye voiles in indigo for a

modern ombré design. For a more unisex stance, I say, make flannel pyjamas your reference point. Stripes and checks are always in style.

Comfort comes first in the bedroom, so make your bed the priority. Go for extra wide and get the best mattress you can afford. To make your bed extra inviting, introduce an extra set of satin pillows to crisp white cotton linen and layer with velvet and wool throws. Natural materials, such as woven textiles and wood, add warmth. A floor standing lamp in the corner will add to the hotel vibe—as will a low-level easy chair if space allows (a wooden stool if not). The television is banned from my bedroom but if you *need* a TV, opt for a smaller screen that can be brought closer to the bed. Propped on an occasional table (go for a wide one that's about mattress height), you will be able to bring it forward and later, move it back against the wall. Wall lights save space by the bedside. An easy DIY is to wire a bronze or nickel-plate lamp holder with a colored fabric flex. Screw in a filament-bulb and you have an industrial-style bedside lamp to hang either side of the bed.

Ultimately, the bedroom is a place of rest, so if you want your bedroom to be a blissful sanctuary, there's no escaping it: you need to organize your wardrobe. Space is a precious commodity, but there are a few tricks to make items

easier to find. The first discipline is to edit. Clothes need to earn their keep. If you don't wear something, there is no point in holding on to it as it is only taking away space that could be used for new purchases. To save on space, opt for thin velvet hangers instead of chunky wooden ones. A seasonal sort-out is well worth the time. In summer, move your clothes around so your wardrobe is in holiday mode. Winter clothes can be stored in a vintage suitcase. Stacked up or down, these double as a handy tabletop. Flat shoes and accessories have a good home in a sliding bottom drawer. All lined up, it is easy to see them at a glance. Finally, learn from the fashion stores and hang your clothes by color, then by type. That way, it is easy to find what you're looking for—and it looks prettier too.

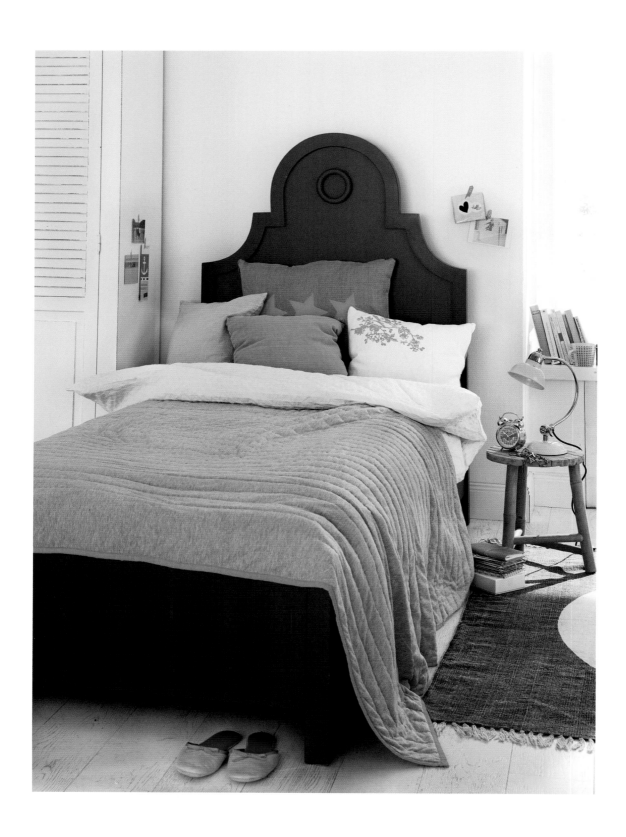

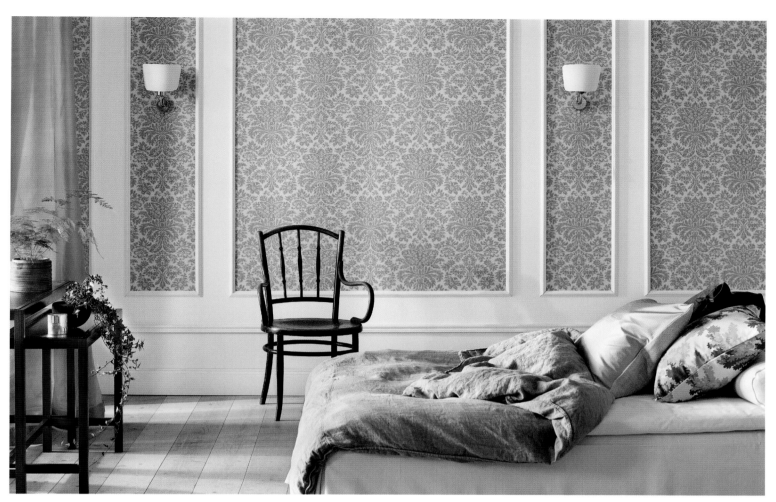

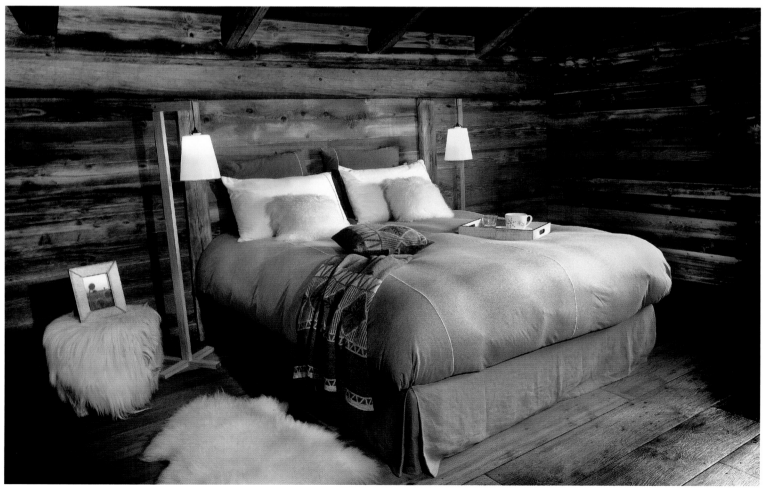

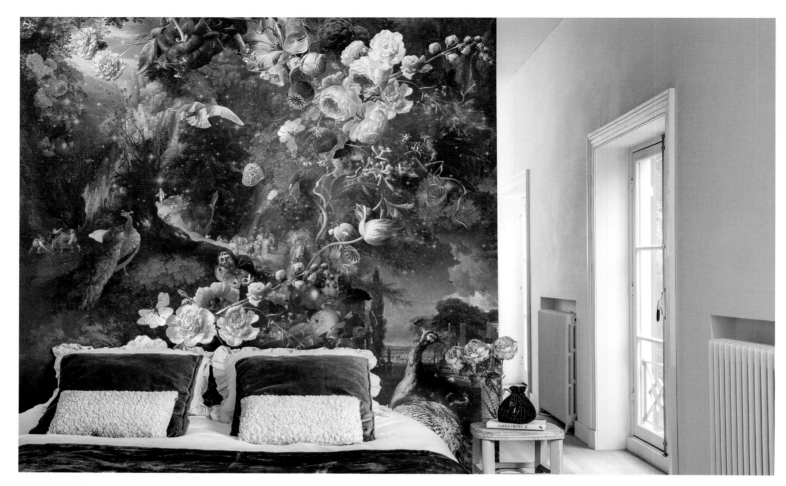

ABOVE Create your own scene-stealing wall with a magnificent mural inspired by a timeless classic.

LEFT Get pattern-happy with contrasting wallpaper, tiles, and textiles. To make it cohesive, stick to a similar colored base.

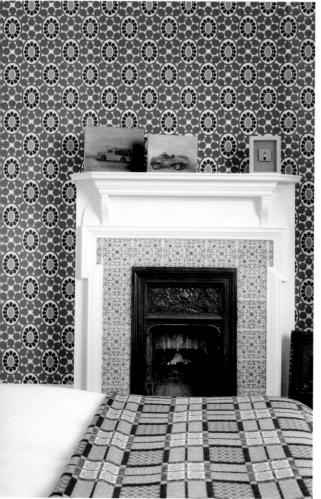

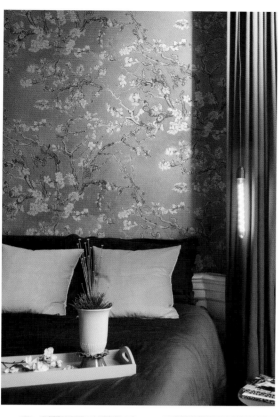

LEFT The jewel tones and Chinoiserie print create an extra decadent feel in this bedroom, with the emerald green grounded by the gray.

BOTTOM A supersized map is used as wallpaper.

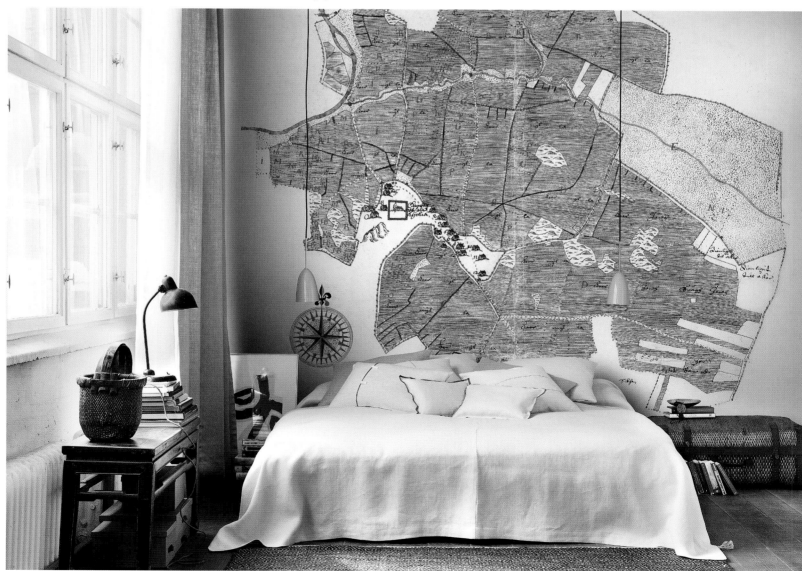

LEFT In this room, the bedding and lace panels have been dyed indigo and cerise. RIGHT Painted in white from head-to-toe, this serene bedroom is furnished with Moroccan blankets and a Louis Poulsen light.

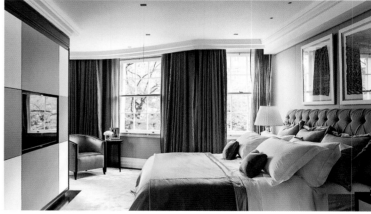

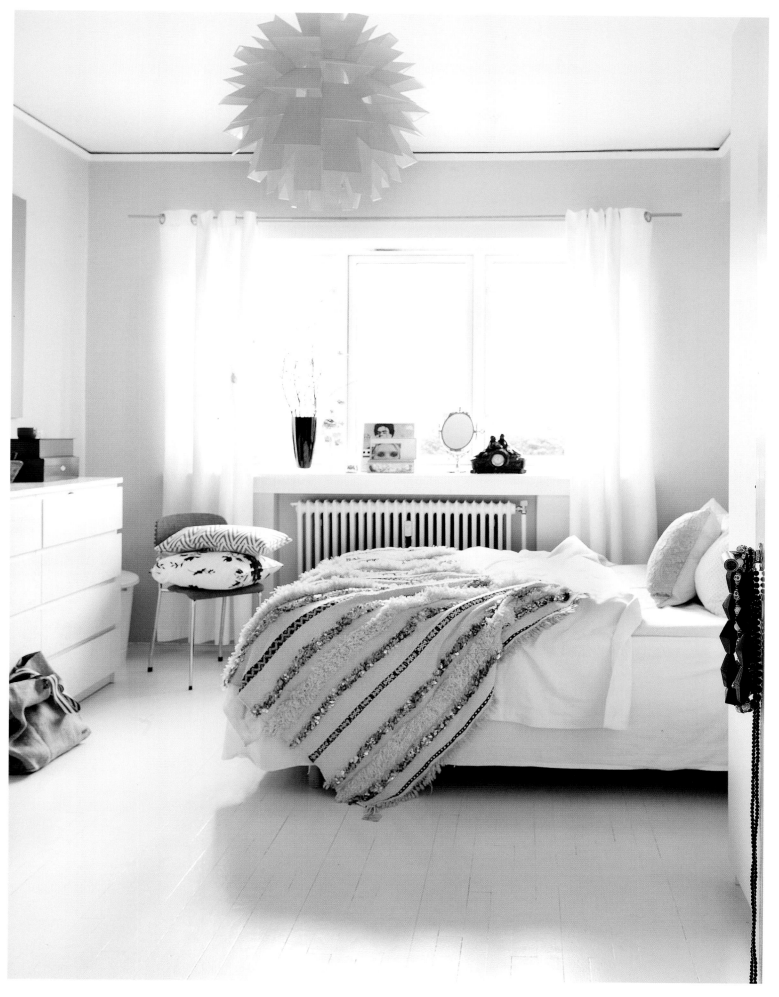

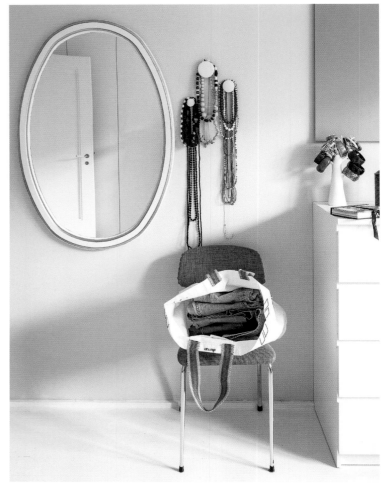

RIGHT Knobs are a brilliant way to keep jewelry. Not only practical, as everything is visible and easy to reach, the beads look decorative on the wall.

RIGHT BELOW Sheepskin rugs and timber walls give this bedroom a feeling of coziness.

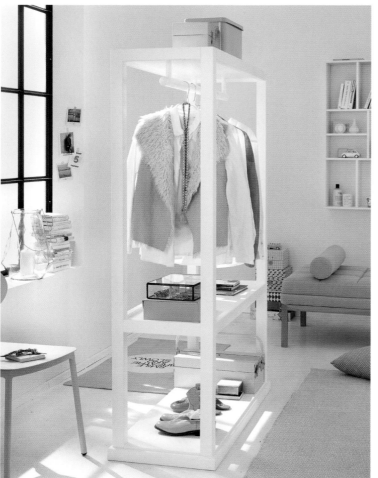

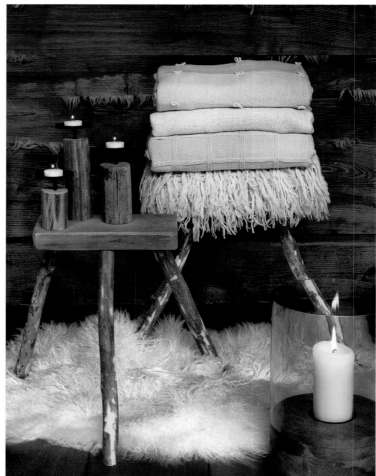

RIGHT Organize your bedroom with this useful folding screen. Handy in open-plan spaces, these "transparent" wardrobes make a feature of your clothes while dividing up a space.

RIGHT BELOW A vintage cheval mirror contrasts with the clean lines of the streamlined built-in wardrobes.

LEFT BELOW Vintage furniture and personal mementos add character to a home.

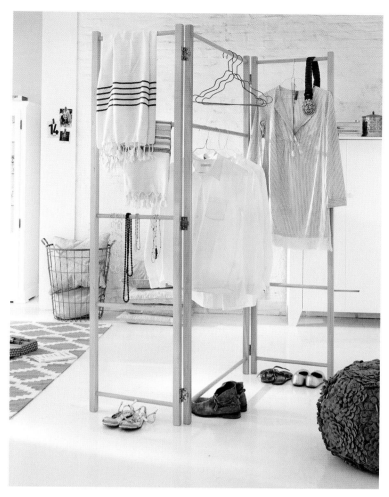

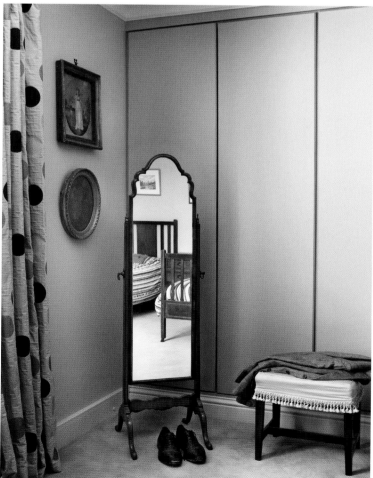

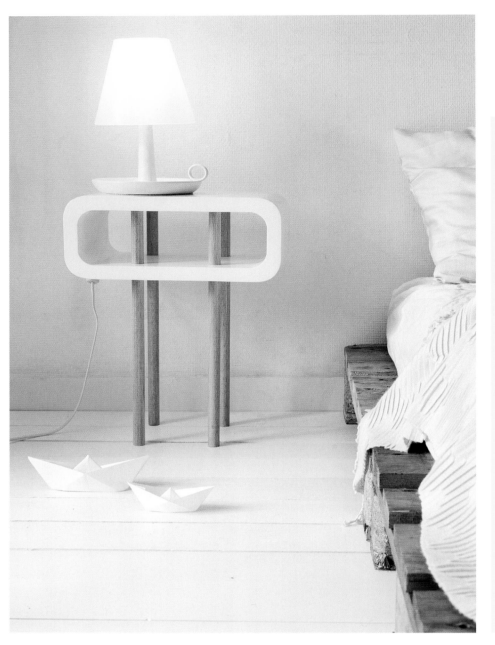

HOW TO MAKE A BEDSIDE TABLE

A beautiful bed is nothing without its side-kick. An essential landing pad for many things—phone, lamp, books, water—a bed-side table doesn't need to be a standard cabinet on four legs. Instead, pack more personality into your nightstand with these re-purposed ideas. A tripod or side table with a tulip base is an elegant choice if you don't have much clutter to hide, otherwise consider a vintage apple crate or cinder block, which will offer more storage scope. Upturned on their sides, they provide space to store books as well as a surface for your morning cuppa. Simple stools and compact chairs are good choices for tucking into small spaces. Upscale them in a chalky pastel or glossy bright paint.

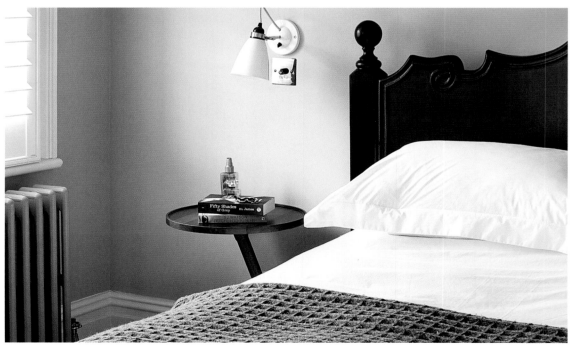

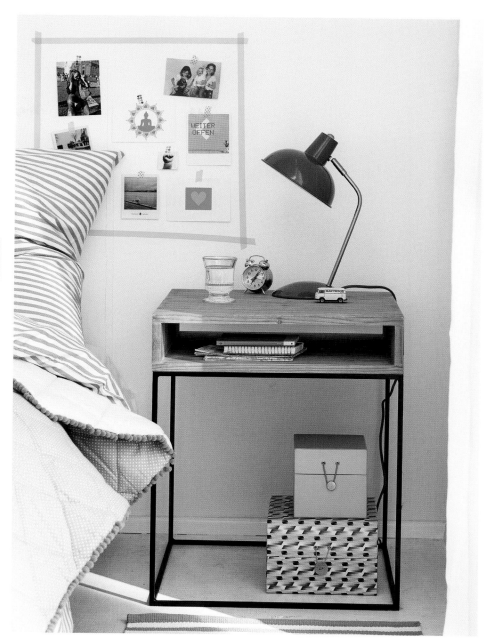

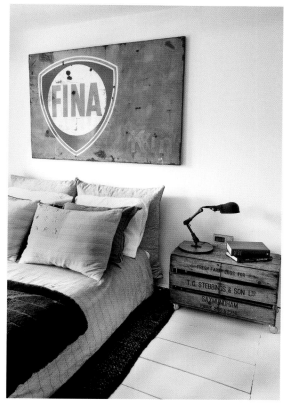

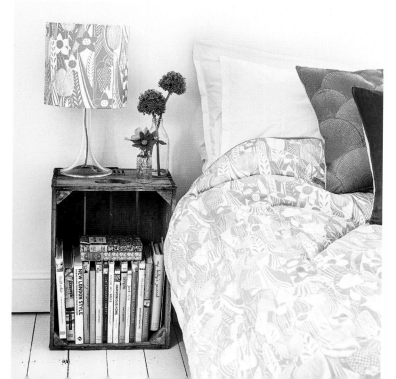

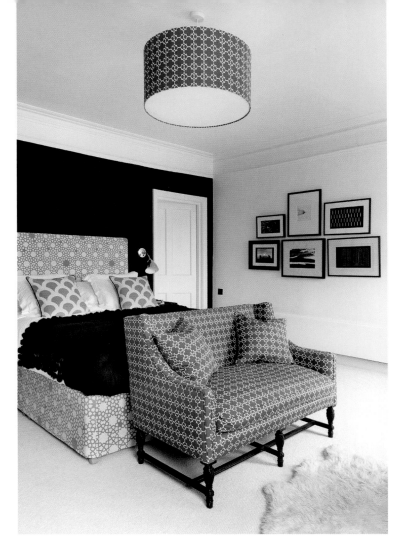

ABOVE Bold bright colors make a refreshing change from traditional whites and neutrals. Here, chartreuse-colored walls contrast brilliantly against the red embroidered bedspread. Peepholes have been cut through the dividing wall to create shelves.

RIGHT ABOVE Give a white room a boost of sunshine with flashes of color.

RIGHT AND LEFT BELOW A patterned rug is the perfect way to make a big difference in an otherwise simple scheme.

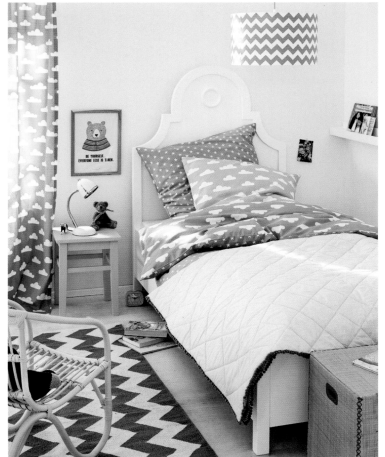

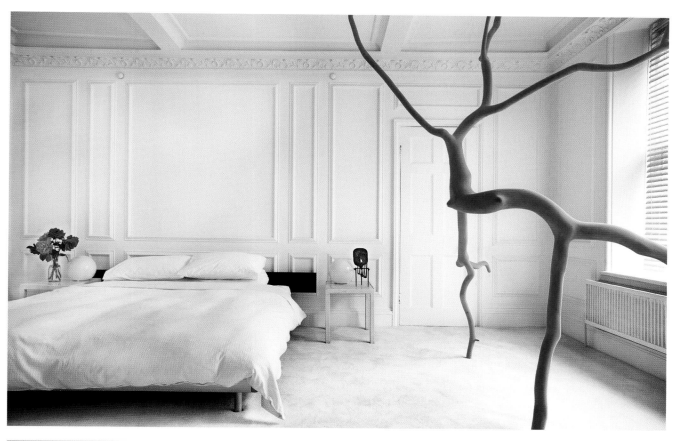

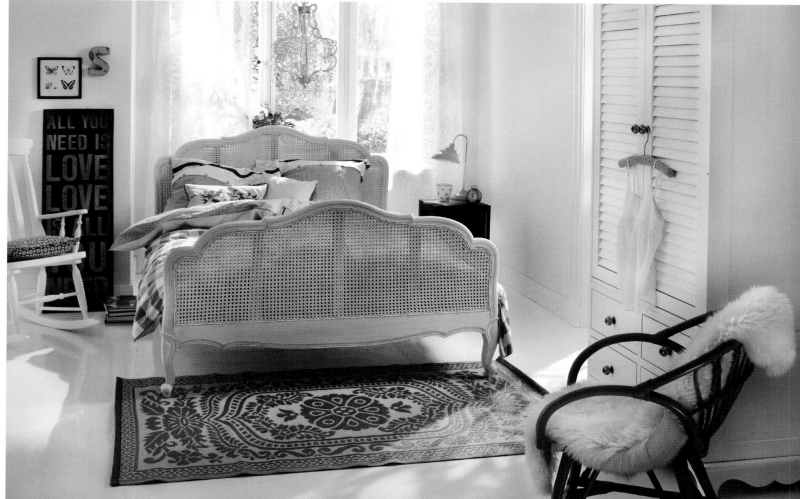

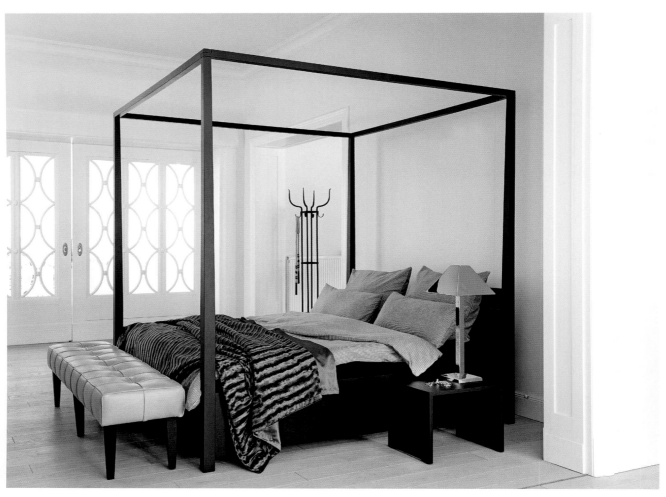

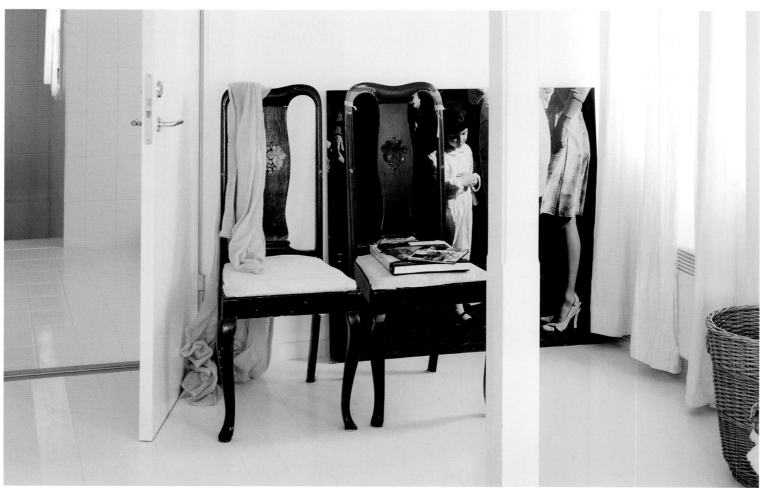

LEFT Combine Scandinavian and Japanese design with a minimalist four-poster bed. This look is all about the clean lines and monochrome color palette.
LEFT BELOW Simply furnished, the elegant silhouette of these black vintage chairs stands out against the white floor and walls.

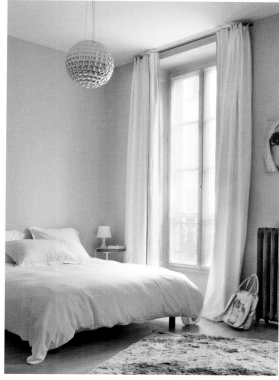

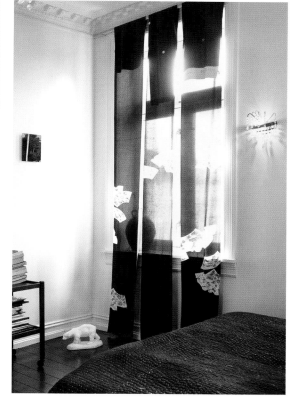

ABOVE The room's floaty peaceful atmosphere, is glammed up with a silky textural rug and silver pendant lamp.
LEFT Old, new, rough, smooth: mix and match eras and finishes for a unique modern style.
RIGHT Adding a Japanese vibe, these black fabric panels are simply hung over a pole.
BELOW This aubergine, gray, and pink scheme shows you how to work the tonal trend.

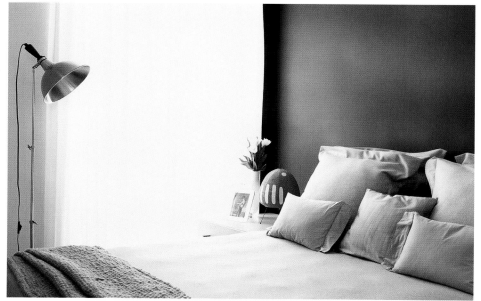

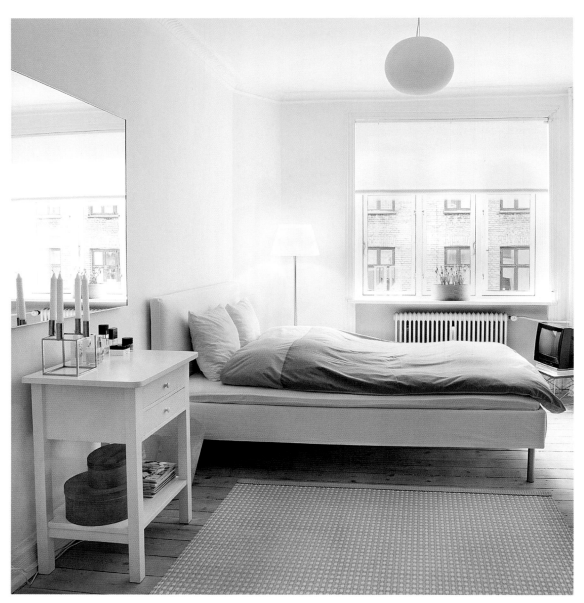

LEFT Hang a mirror on its side to heighten the sense of space. A fabric-covered headboard and rug soften this sparse interior.

RIGHT Get the feeling of five-star luxury with a velvet-covered sofa at the end of your bed.

BELOW Create a soft, fabric-filled haven to relax in. From the heavy curtains to the deep-buttoned headboards, these rooms use layers of fabrics to create a tactile effect.

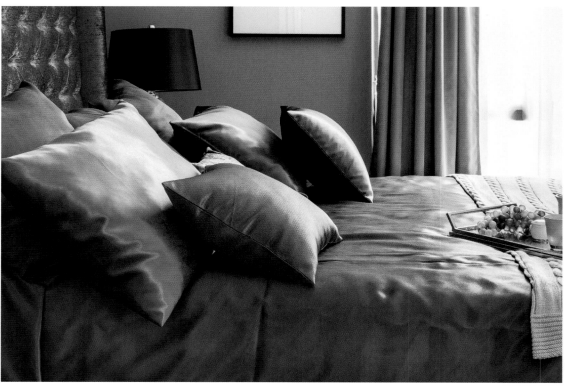

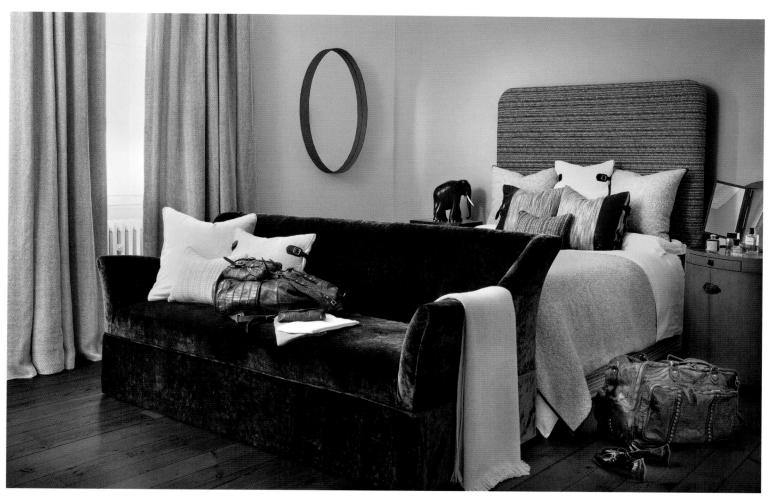

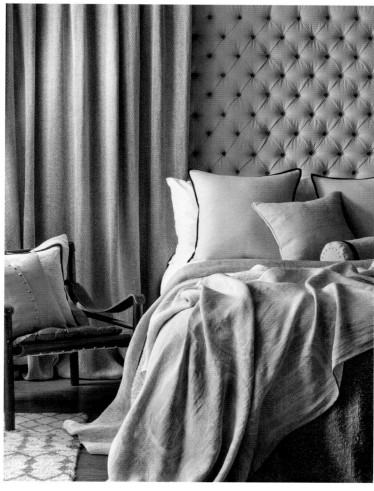

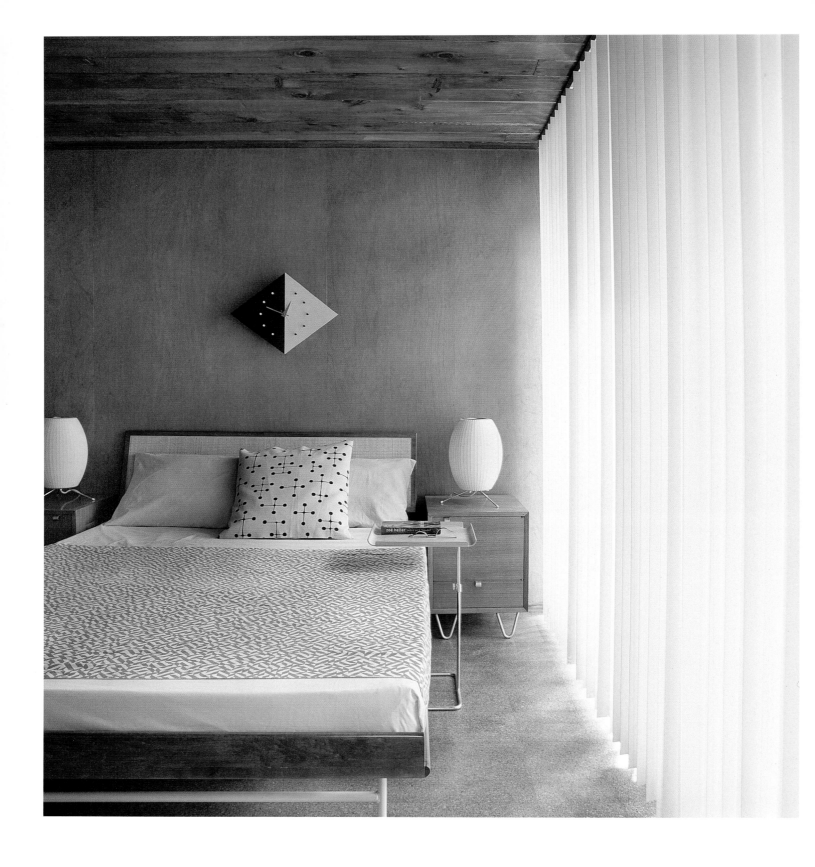

LEFT Mid-century meets a Japanese aesthetic in this bedroom. Orange, black, and white are perfect partners to the wood-paneled walls and cork floor.
RIGHT Stained timber boards have been used as the headboard. A vintage pendant light in the alcove creates a cozy pocket of glow.
BELOW This warm, Japanese aesthetic was created with a mix of wood paneling, raw linen, and a fluffy, quilted throw.

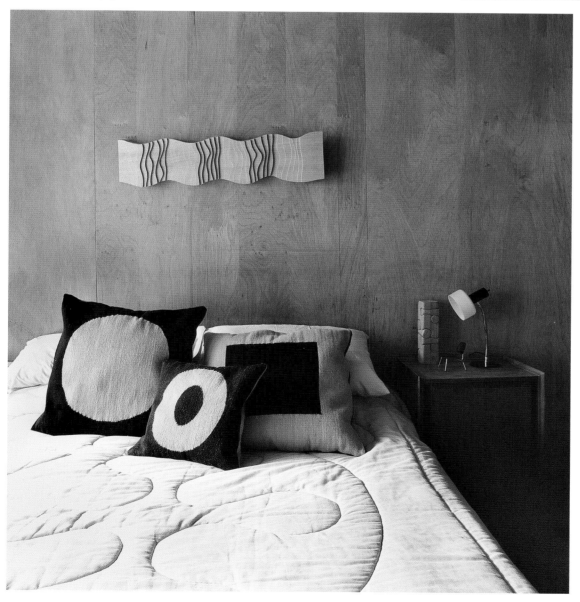

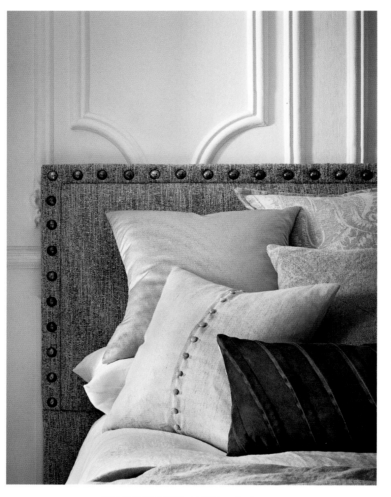

HOW TO MAKE A COOL HEADBOARD

A good headboard can make a room. Treat your bed to a makeover and reupholster a padded headboard with a fabric of your choice. A vintage silk or velvet will make your bed unique. Add studs to a plain linen canvas for a Scandi-style edge. An oversized tapestry or a large, decorative mirror is a great way to dress up the wall behind your bed or for a more rustic feel, use salvaged planks. Also, consider playing around with white, embossed tiles. If you find a range with matching curved corners and dado rails, you can create wonderful patterns. Ornamental wood paneling can be used to similar effect. However, some of the most confident bedrooms don't feature headboards at all. In their place is an eye-catching painting or a sculptural piece of art.

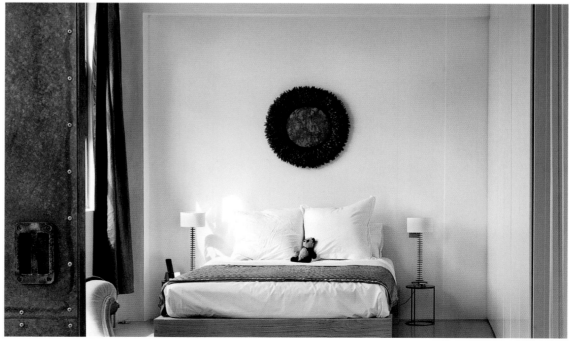

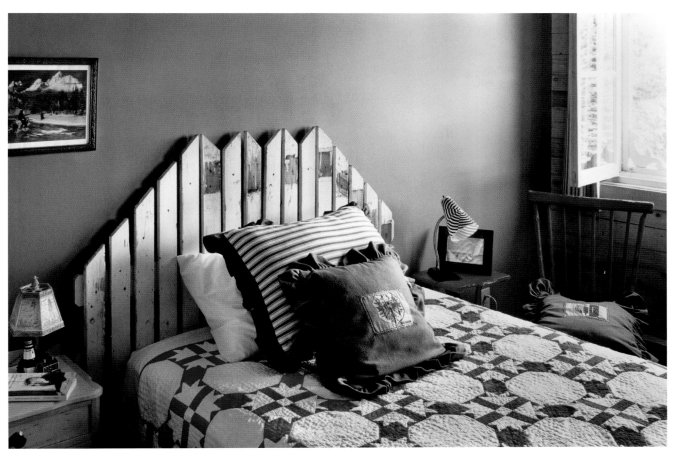

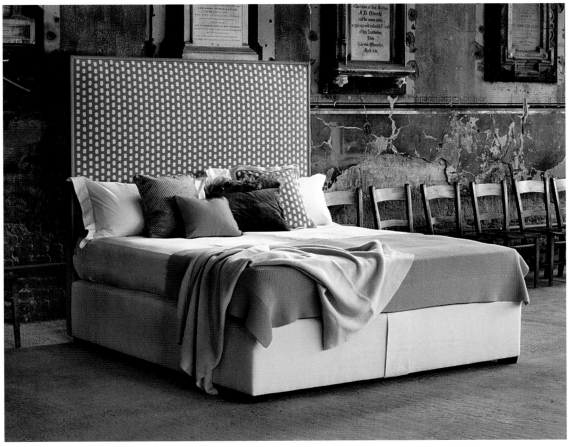

BATHROOMS

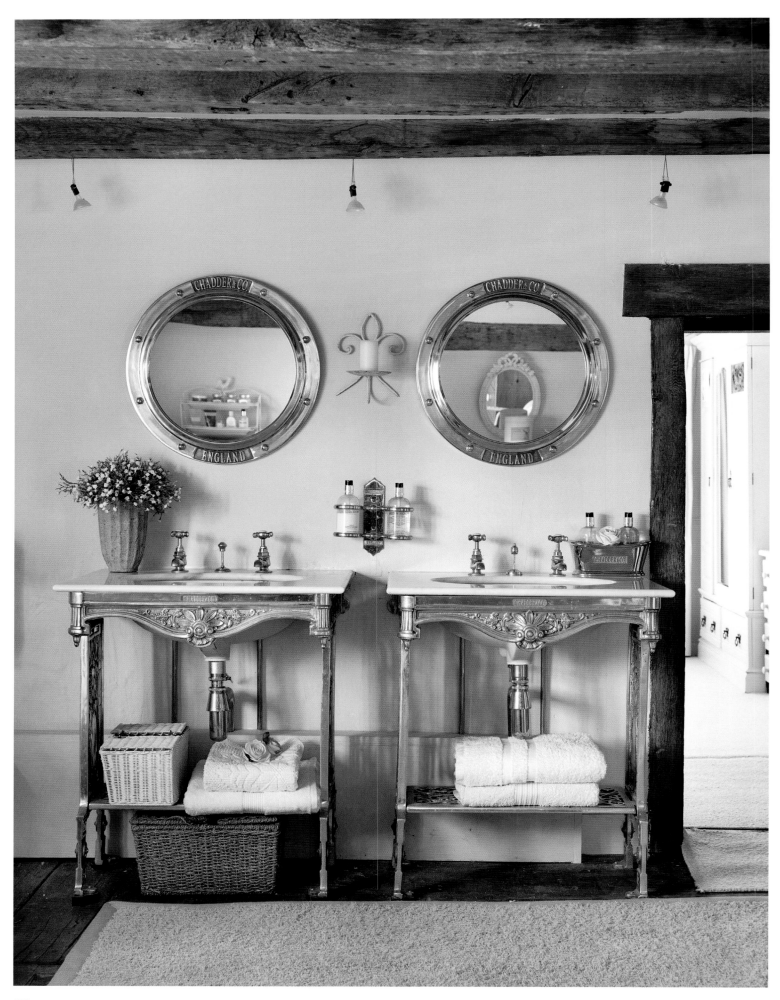

BATHROOMS

What is a bathroom really and truly? Is it a place to get some downtime and read a book? A place to put your make up on, dress up and go? A place to shower, a place to soak, a place to get the kids scrubbed and ready to face the world? It is all of these, and more. While the bathroom needs to be functional with a scheme that works for every person in the house, it should have as much to do with aesthetics and emotional pleasure as it does with hygiene. It's no good trying to cleanse both body and mind, if your bathroom isn't up to scratch. Proper space, good light, and quality surfaces are the saving grace of any bathroom. In no particular order, here are some of the things that I find work really well.

#1 Blue loves white in the bathroom. It's a classic color combo, so fresh and uplifting it conjures up holidays in Santorini—wherever you happen to live. #2 Large bathrooms do well with a softer color. Add some personality with a cool light fitting and some beautiful floor tiles. Pearly mosaic tiles will add a beautiful shimmer. Oversized stone tiles will feel luxurious and grounding. #3 For small spaces, give up the dream of a roll top bath. Here, the bath is better boxed into the end wall and underneath the window. A surround of tiles—mosaic or large sheets—will create a seamless effect, while creating a handy shelf to put a

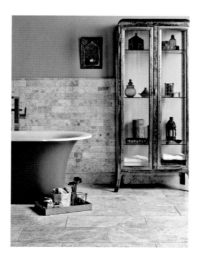

plant and loofah. #4 The ultimate way to achieve a hotel style at home is with a freestanding bath. Keep a tall stool close by for your products and any bath-side refreshments. #5 Consider linoleum on the floor. In a marble or stone effect, it is softer and warmer than tiles underfoot. #6 Think outside the box and put the toilet in a room of its own. It shouldn't really have any place next to the bath. #7 If your toilet and bathtub are in the same room, plan the layout starting with the toilet. The toilet is the most inflexible when it comes to choosing where it can go. I like to position the bath as far away from the door as possible. #8 If you don't have space for a separate shower and bath, enjoy the extra space and just choose one. #9 Have a choice of lighting, from task lighting by the mirror to a more atmospheric, low-level glow. Candles will do. #10 The bathroom is the one room where you are guaranteed to come into daily contact with the surfaces. All the more reason to splash out on the bath, taps, tiles, and floor. You use them every day. #11 Get your plumber to install the shower controls at the door to the shower, rather than under the shower head. It just makes sense. #12 To get the look of a walk-in shower without going to the trouble of sealing the floor and walls, recess the shower tray into the floorboards so it is level with the rest of the floor.

If both your bedroom and bathroom feel short on space, consider combining the two. To connect the two rooms into a single, open-plan room, use materials that work in both areas. The space can be left open or divided with a screen or shelving unit that is open on both sides. It's a decadent idea, but you could always turn your spare room into a bathroom as well. Make the tub the focal point by positioning it in the middle of the room, include some seating—a chaise longue or long bench are both nice—and hang a favorite painting that you can admire while lying back in the bath. Tell your guests they are in the smaller room next door.

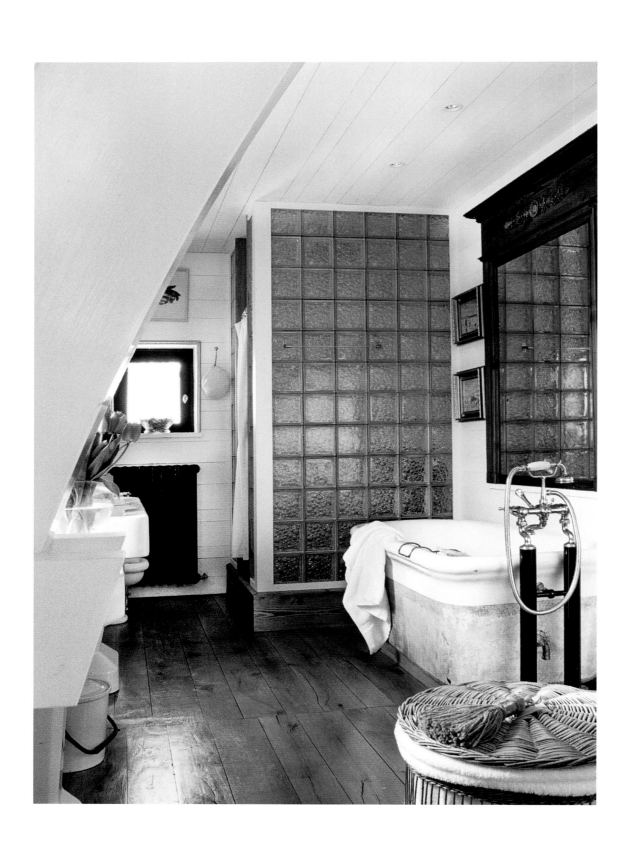

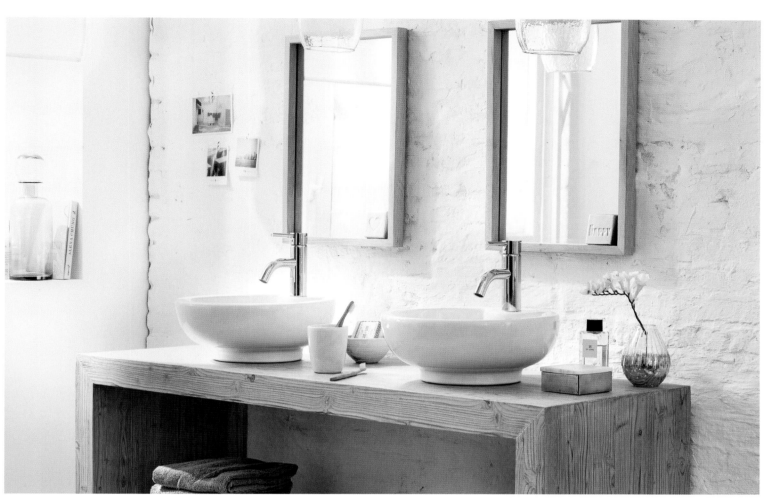

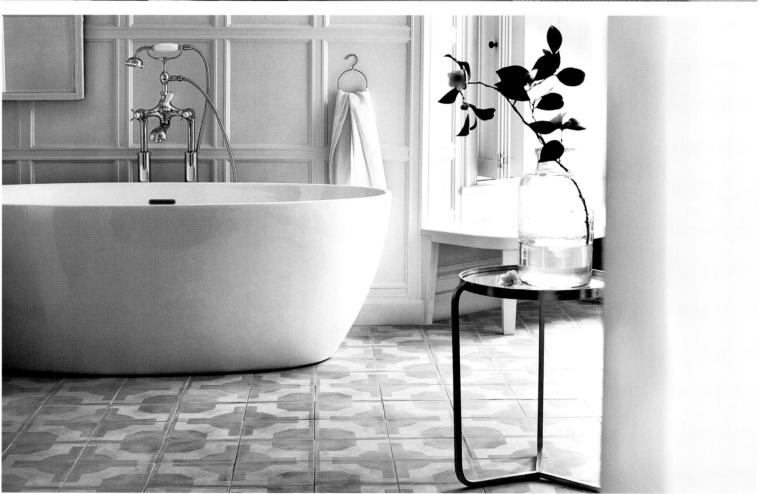

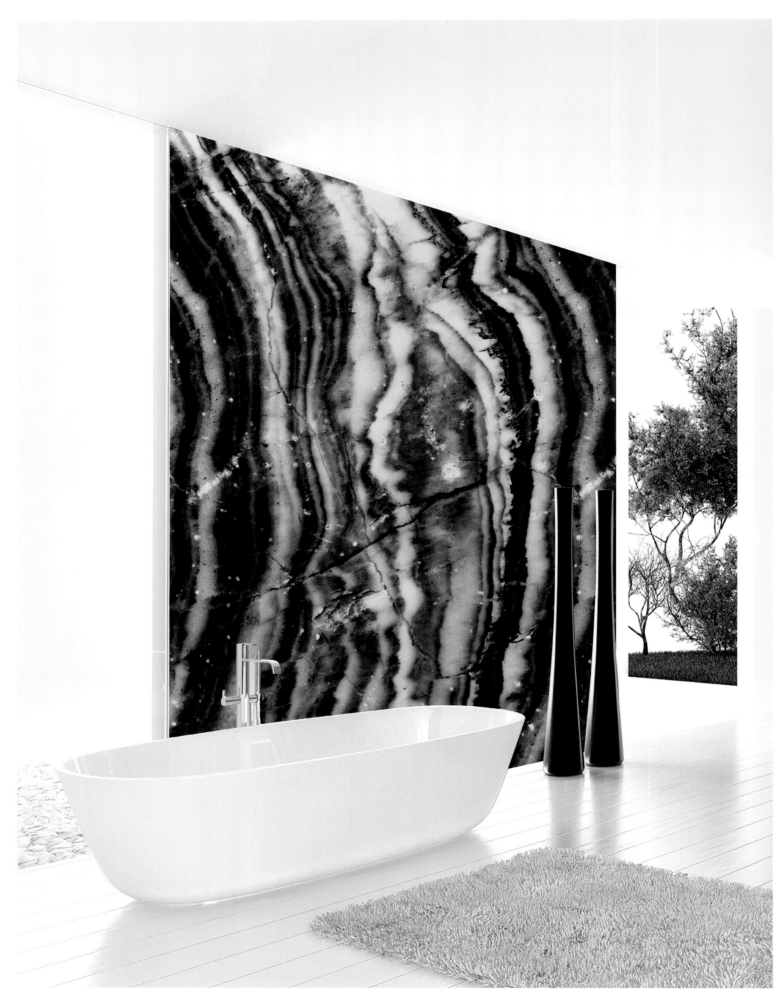

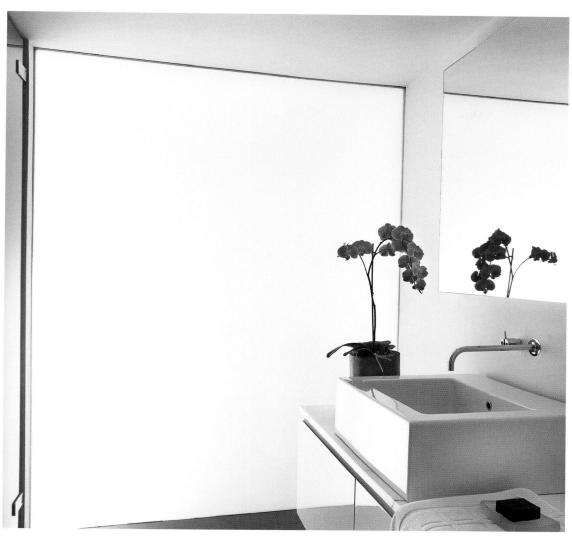

LEFT A "marble" wall adds extreme luxury to this minimal white interior.
ABOVE A mirror fitted flush to the wall bounces light all around for a light and airy space.
RIGHT From basins to countertops, everything looks good in black and white. Here, silver is added for additional luxe.

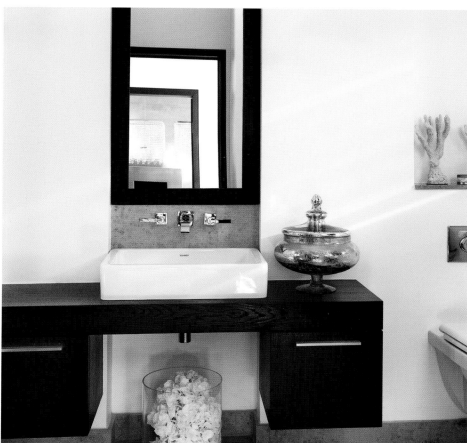

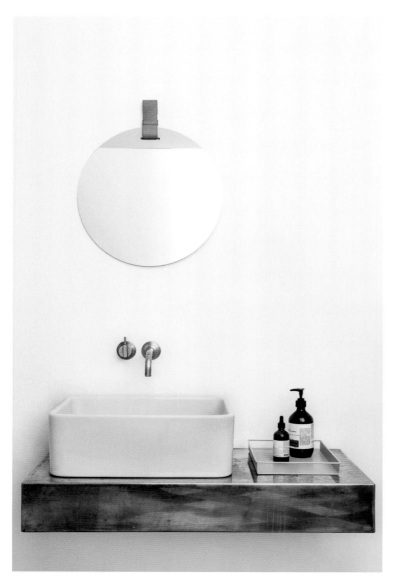

LEFT Grandness and simplicity are combined with a contemporary mirror and burnished brass shelf.
BELOW A dividing wall separates the bath from the rest of this space.
RIGHT Modern bathrooms may be sleek and chic, but this silver shower has heritage appeal.

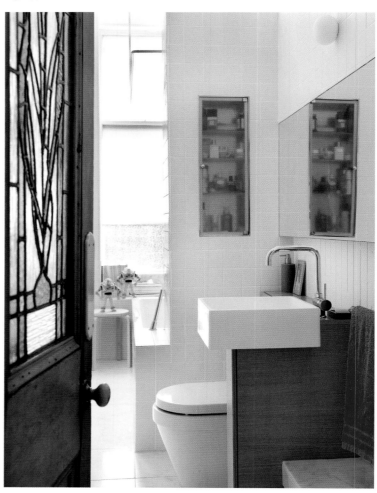

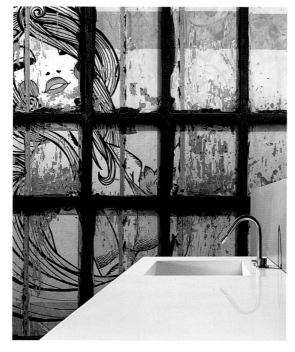

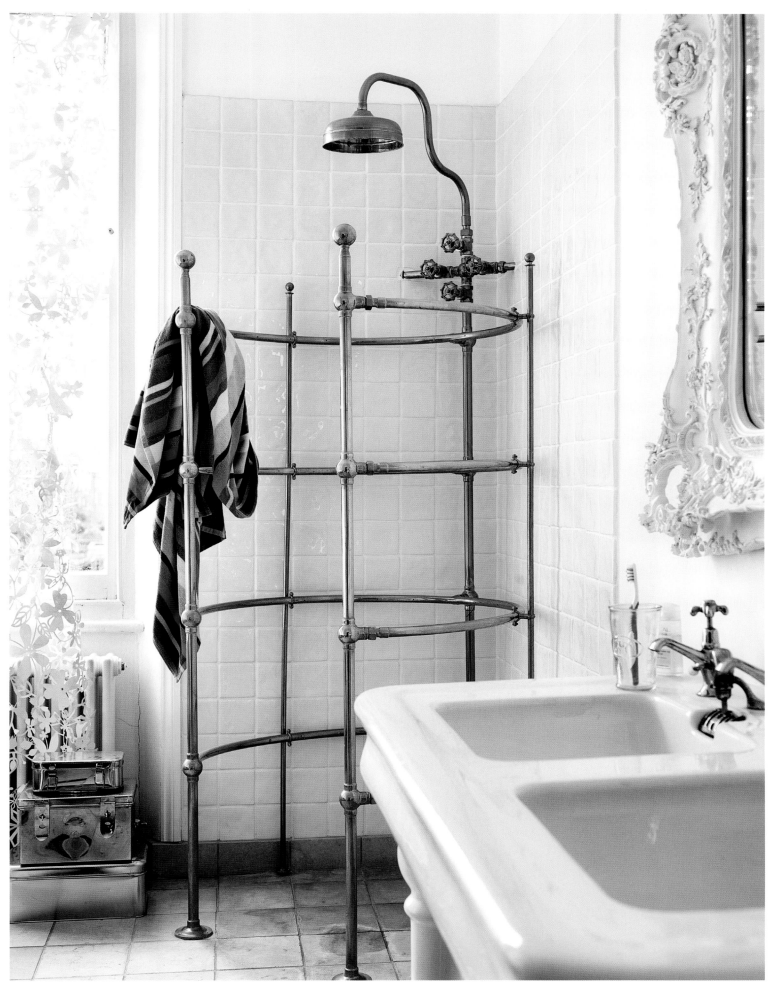

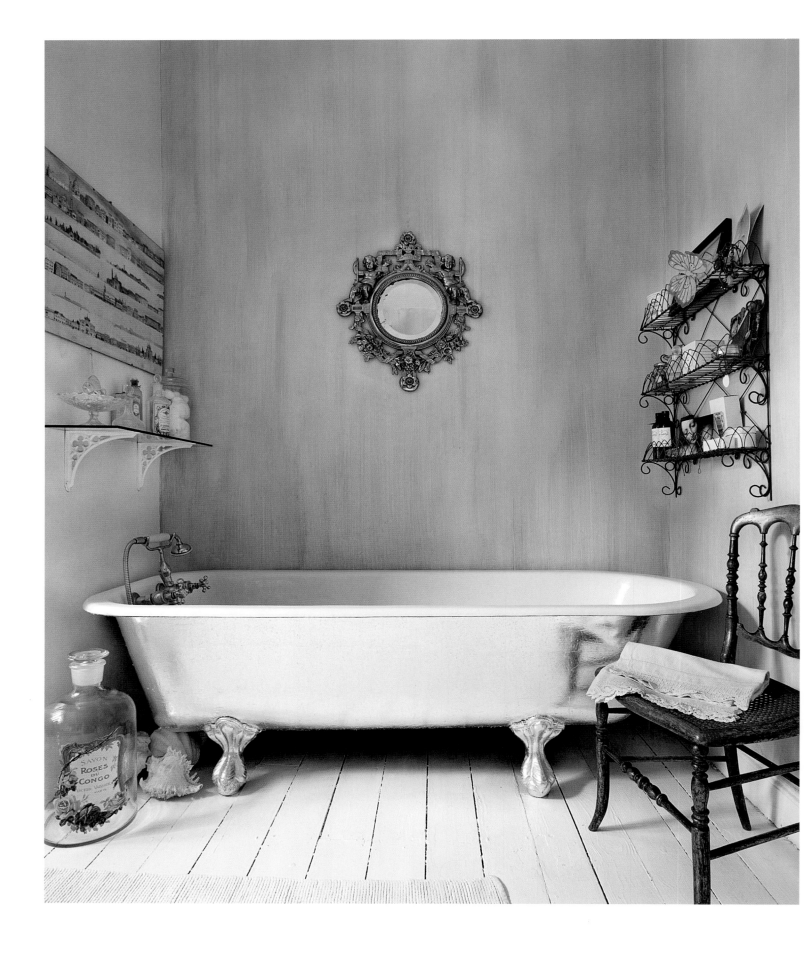

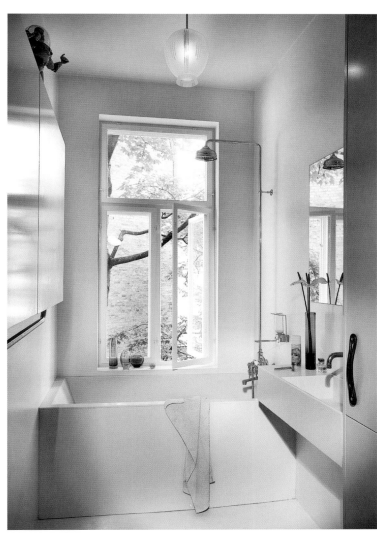

FAR LEFT The aqua-colored wall makes a striking statement in this vintage-inspired space.

LEFT This bathroom makes the most of a small space with a wall-hung basin and combined bath and shower.

BELOW Add a Moroccan flavor to a space with patterned tiles, ornamental mirrors, and decorative fretwork panels.

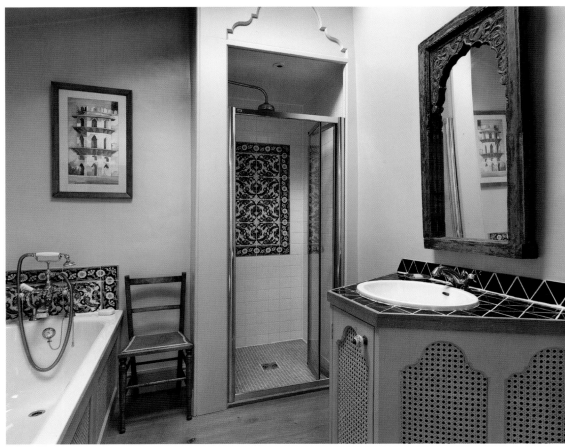

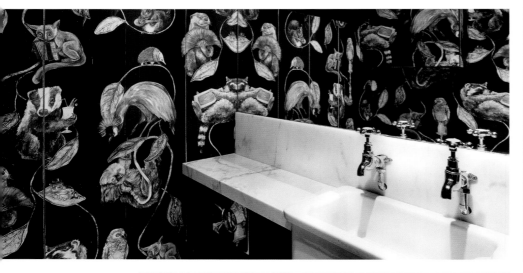

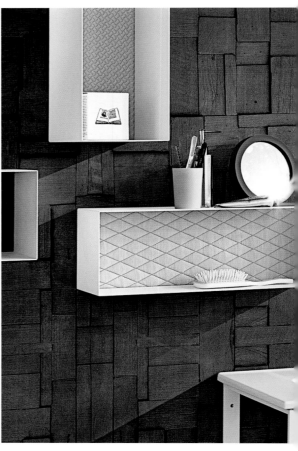

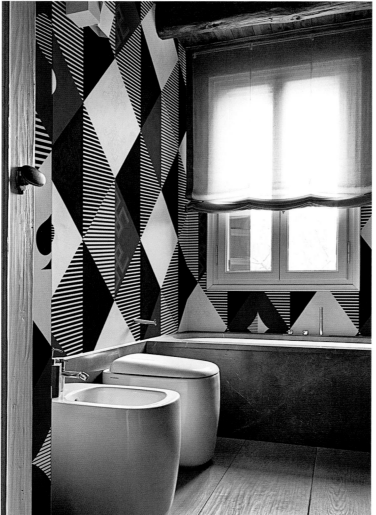

LEFT ABOVE Go to town with decoration in a small space, such as a downstairs cloakroom. Black-patterned walls can look incredibly glam.

ABOVE Rather than sticking to plain walls, add interest to your bathroom by combining different textures across floors and walls.

RIGHT The high-gloss surfaces and graphic pattern of this bathroom are perfect with chrome fittings.

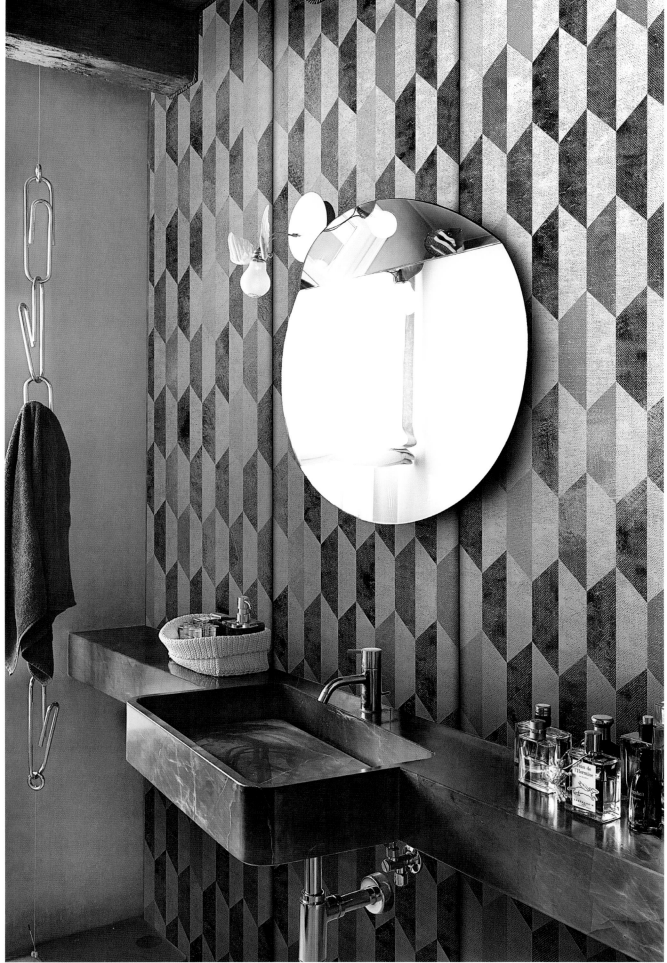

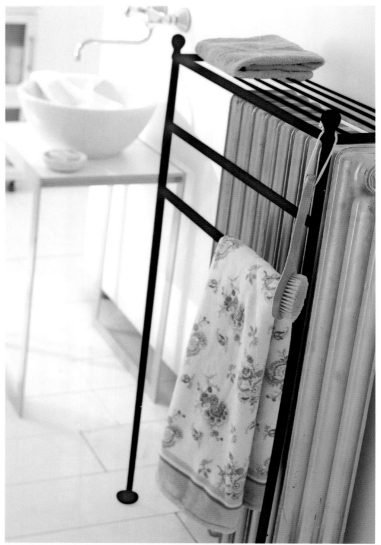

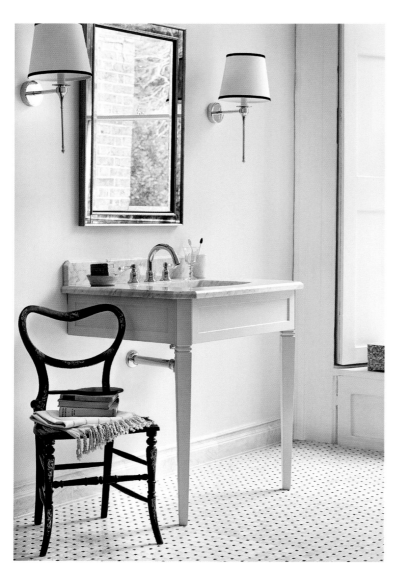

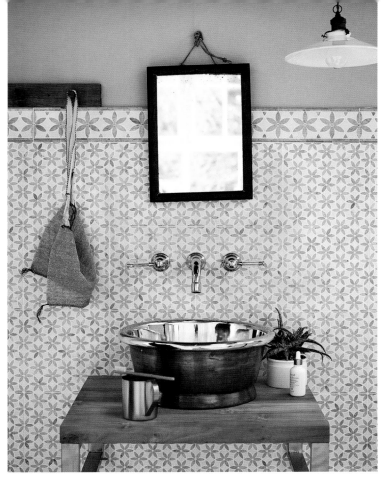

HOW TO SAVE SPACE

An effective way to make the most of small spaces is to swap sinks that sit on floor-standing pedestals for simple wall-hung basins instead. A countertop basin on a vanity unit works wonders in unusual-shaped spaces, such as the eaves of a loft. Look for designs with extended surfaces around the washbasin, useful for holding cosmetics or those that include a drawer. Because it keeps floors clear, it is a fabulous way of making a small room feel bigger. There is also plenty of space underneath for a bench or basket. Mobile trolleys that can be tucked under the countertop or into a corner are good for practicality, too. Heated towel rails are another way to save on space, and provided you have storage elsewhere, a mirror wall above the basin will complete the clutter-free look.

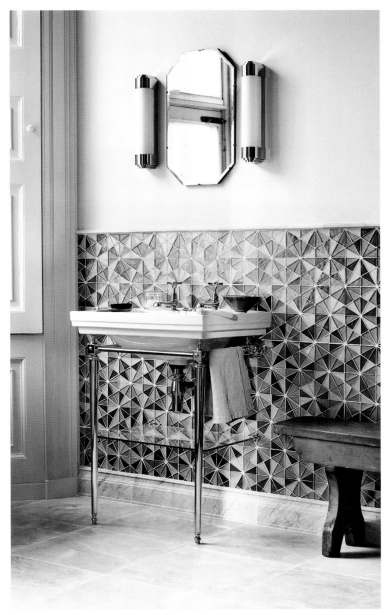

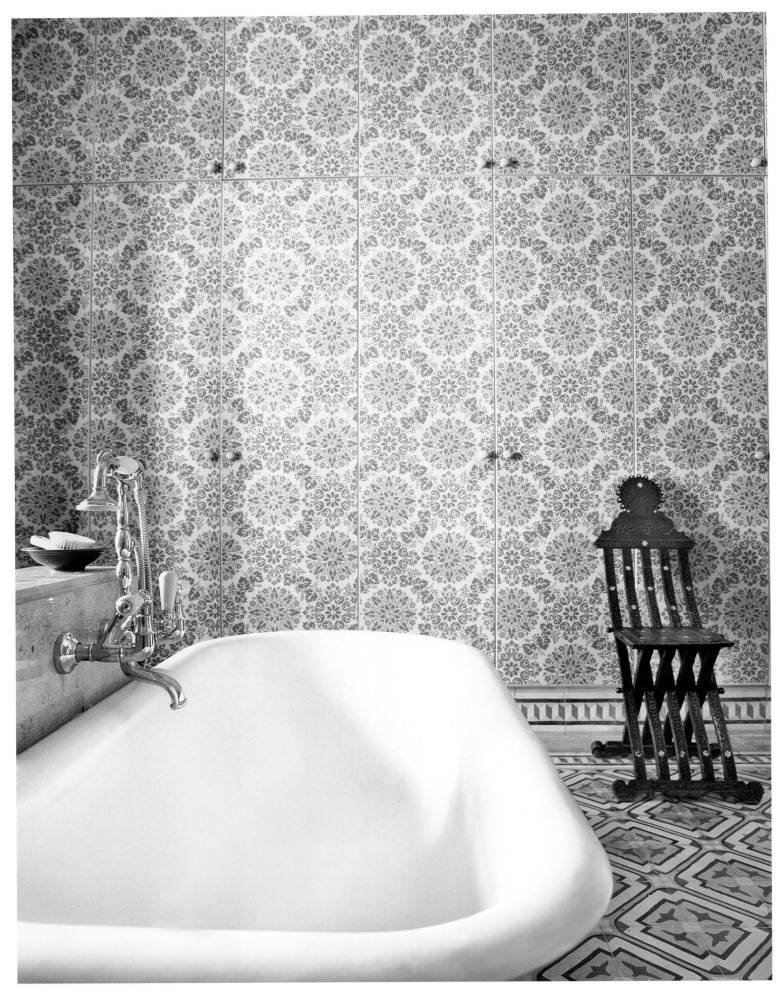

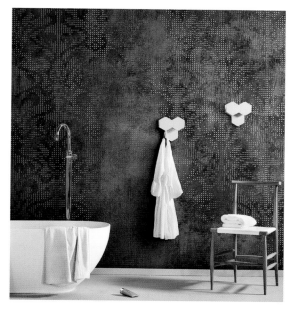

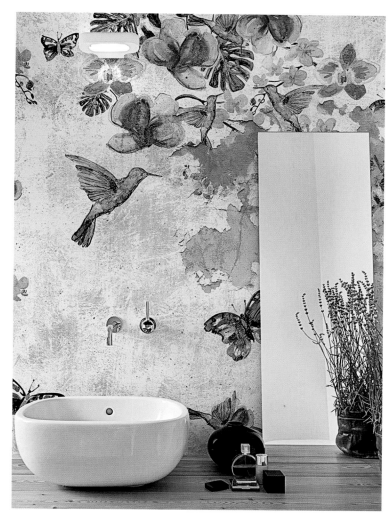

LEFT Be canny with decoration. Here, wallpaper is used to conceal a wall full of cabinets.

ABOVE This "hand-painted" decoration brings character and color to an often over-sanitized space.

RIGHT ABOVE AND BELOW Candlelit bathing will feel all the more decadent in these dramatic, dark-walled schemes.

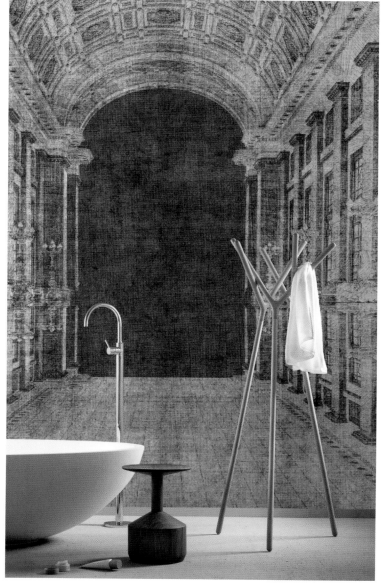

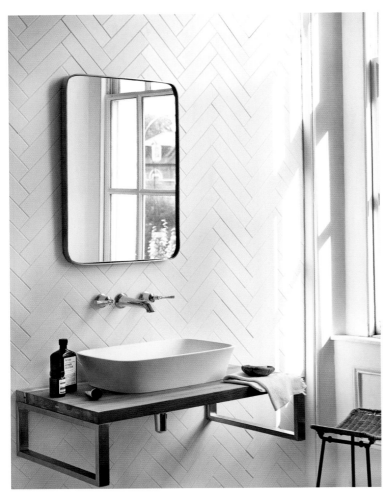

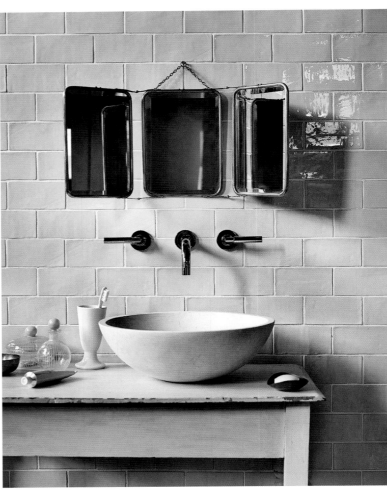

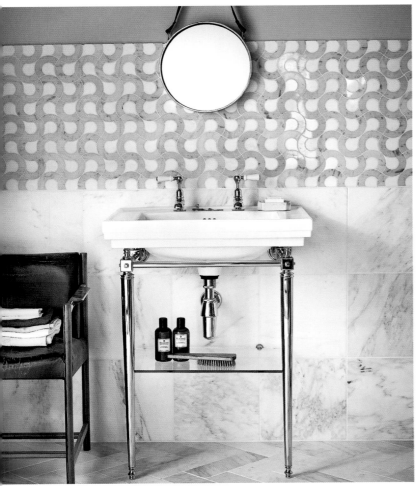

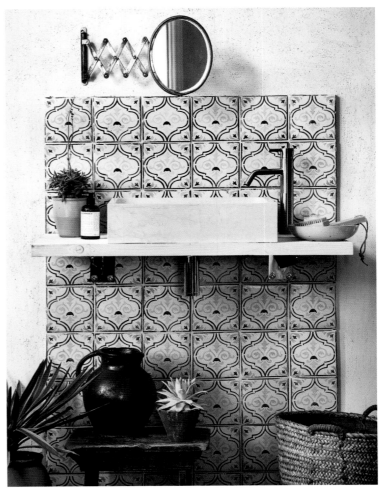

ABOVE LEFT Slim matte tiles arranged in a chic chevron pattern are paving the way in bathroom fashion.
ABOVE RIGHT A converted console is used here as a vanity, the rough texture contrasting with the soft curves of the sink.
BELOW LEFT Mixing elegance with clean lines, this look uses patterned tiles rather than color to add drama.
BELOW RIGHT Beautifully patterned tiles as a splashback for this sink create a focal point and give an eclectic feel to the space.

RIGHT AND BELOW Shades of blue and green or textures of blue and gold are the perfect color combinations for a harmonious bathing space. Tactile materials such as timber and brass add the texture.

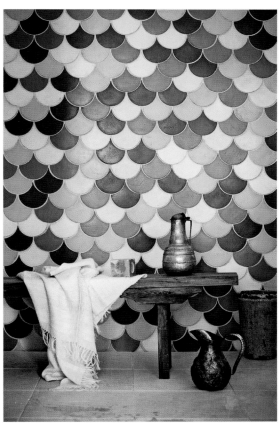

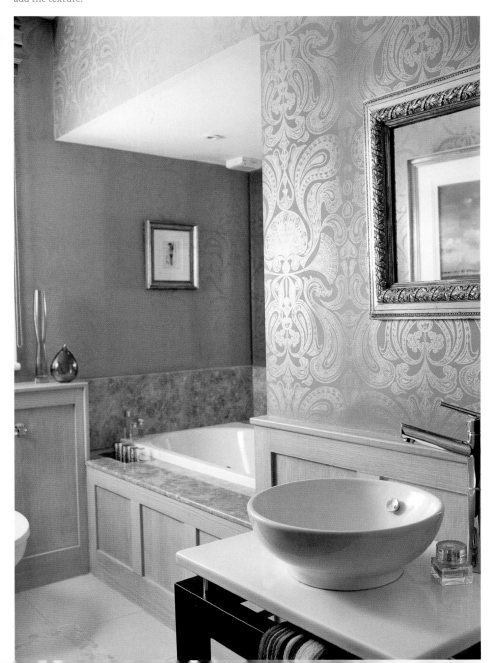

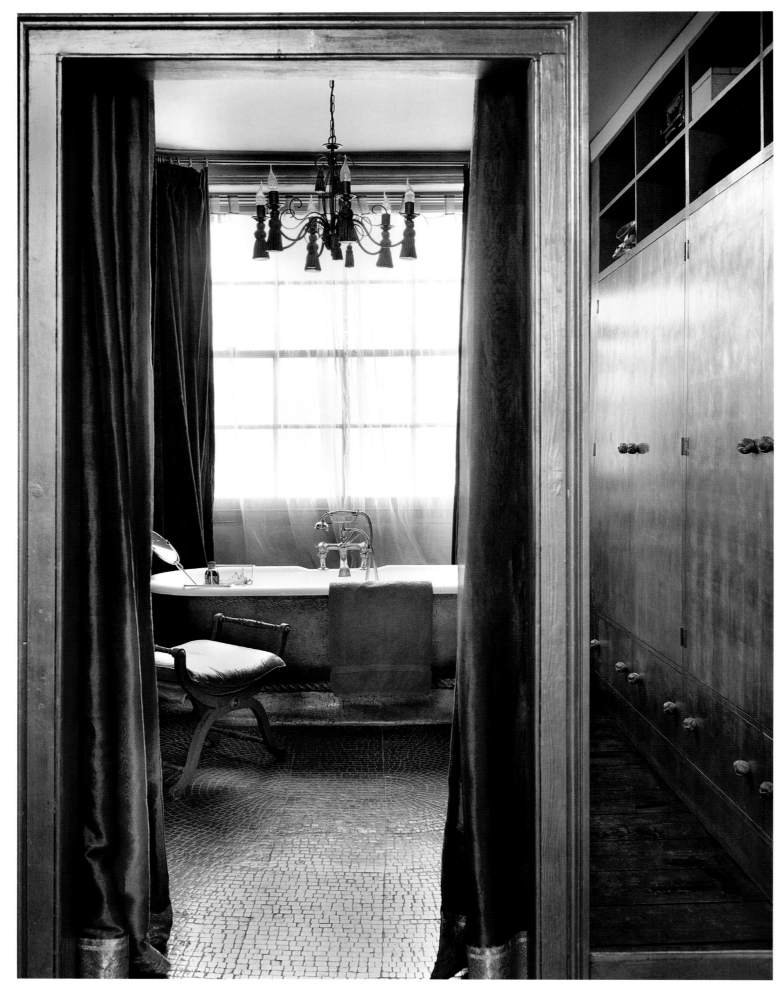

LEFT The gleaming walls of this opulent space will turn your bathroom into a shimmering haven.
RIGHT A curvy design makes the most of this unusually-shaped space.

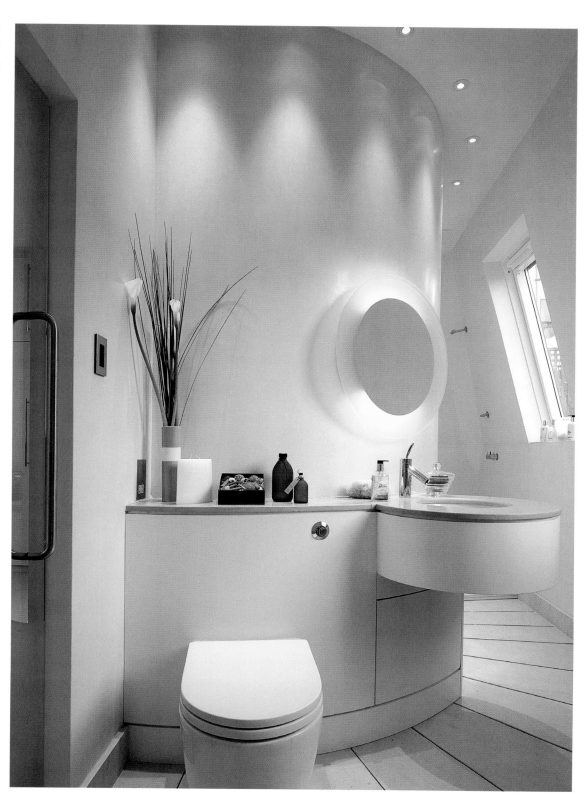

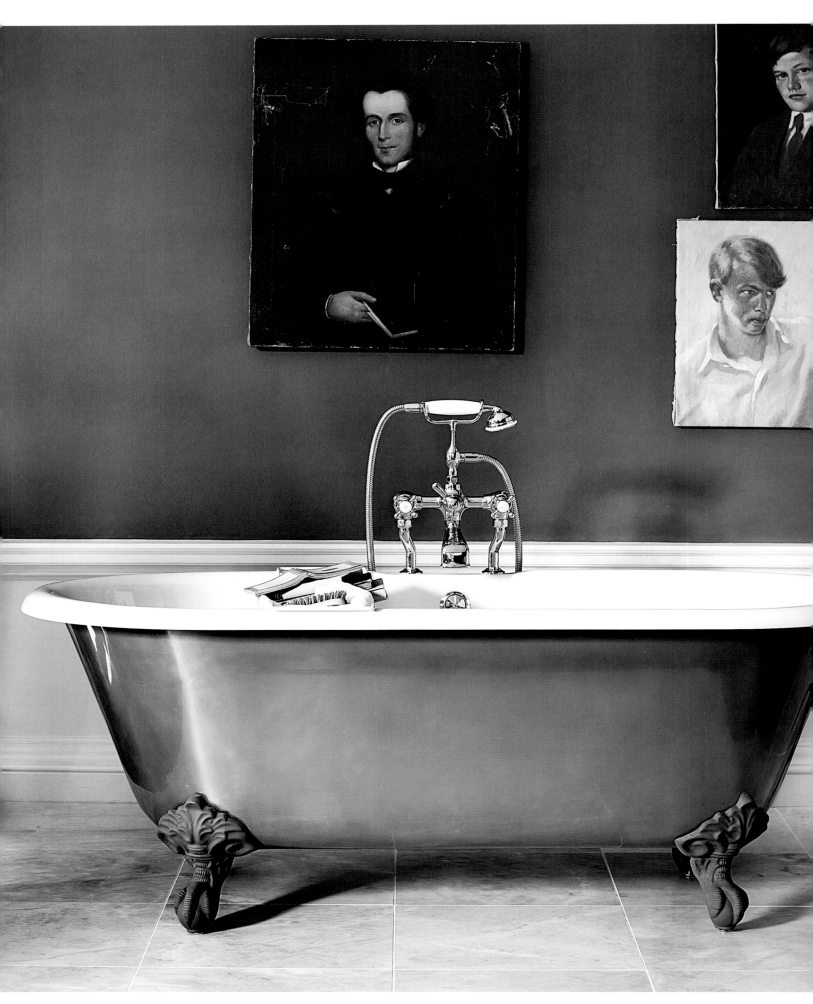

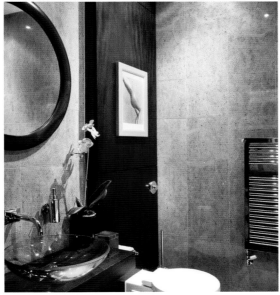

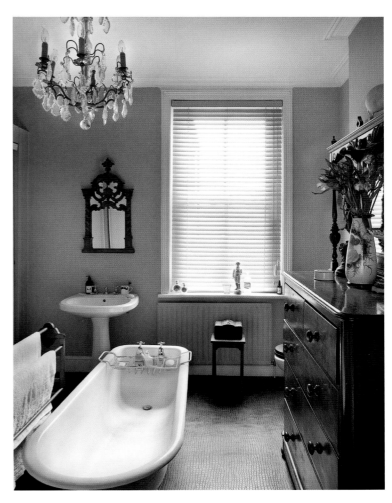

LEFT A free-standing bath with the base painted in a shade to tie in with a pale gray scheme makes it the main feature in a room.

ABOVE Grandness and simplicity come together in this traditional scheme.

ABOVE RIGHT These deep, smoky colors look striking and are beautifully offset by the white ceramics.

RIGHT Dark wood and white combines natural chic with sleek practicality.

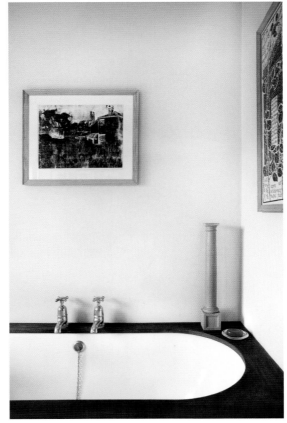

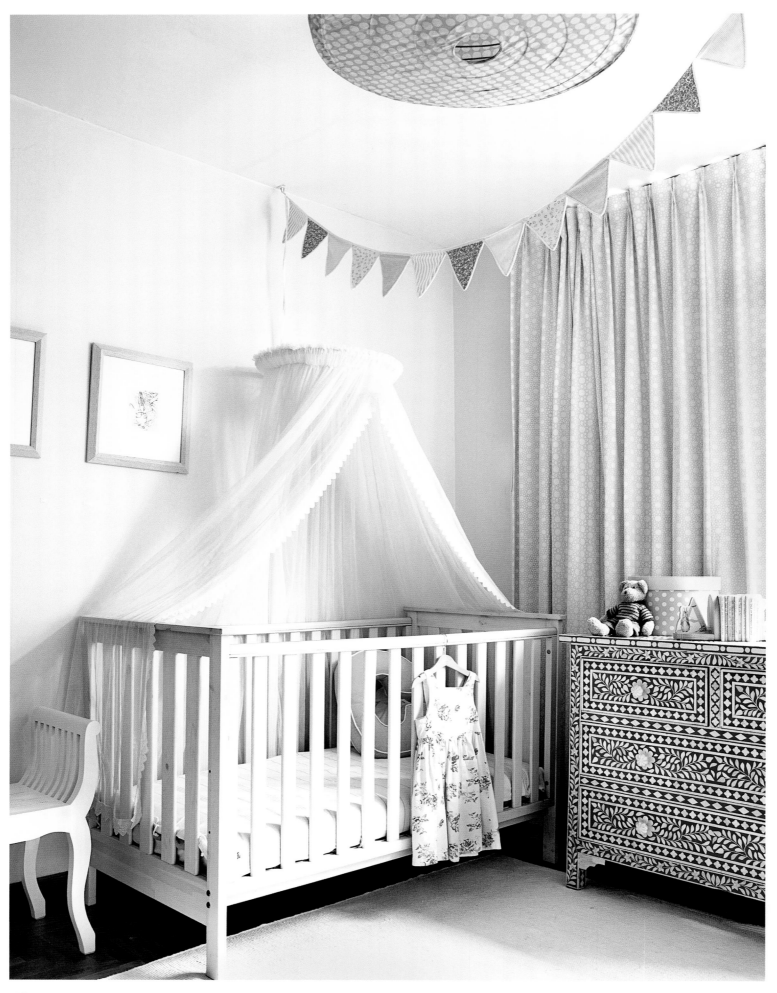

CHILDREN'S ROOMS

I don't know about you, but for anyone who appreciates a quick decorating hit, children's rooms are the perfect opportunity to let the imagination run free. Riding unicorns, chasing rainbows or stretching out beneath fluffy clouds—whatever the vision or inspiration—this is your chance to have fun.

A little space for big ideas, the most captivating kid's rooms are the creative ones: think bold colors and playful patterns. Embrace the happiness that color can bring. A welcoming, sunny yellow will brighten the most sullen of moods, while green is vibrant yet restful, so good for a peaceful night's sleep. A backdrop of brilliant white—white floors, white walls, and white furniture—will make a feature of colorful textiles and toys. The light and airy scheme is easy on the eye and helps create an uncluttered feel even when there is madness all around. Sometimes a bit of sugar in the room is always irresistible. To make a palette of baby pink or powder blue more grown-up and livable, the trick is to combine the pastels with darker, un-child-like shades of maroon or terracotta (for pink), muddy browns and green aqua (for blue). The more muted the shade, the more grown-up it will look. For a less girly variation on pinks and purples, opt for still-feminine reds and oranges instead. Or go unisex with a soft *eau de nil*—because girls like blue too.

For style notes on planning a clever redesign, first empty the room of all contents to determine what's going to go where. Do you need a den to read books? Do you have space for a small table and chair? Use sheets of newspaper to match the size of the furniture so you can see how it all fits. An *Alice in Wonderland* or *Peter Pan*-themed room is lovely, but the decoration has to be relevant to your child's lifestyle. Just as you can't drag a girl around in a party dress all the time, their rooms have to be practical and comfortable. It is a no-brainer. Good storage is top of the list.

I'm a fan of storage beds, as they allow everything to be hidden away and they don't take up extra space. A good chest of drawers also goes a long way. Drawers under the bed, hooks for accessories, glass jars on a desk, cube shelving on the wall, there is literally a place for everything. By keeping a lot of storage open and on view, nothing is hidden at the back of a wardrobe, but easily accessible and enticing to be used. If things get put away in cupboards, they are too quickly forgotten. Likewise, the same applies to clothes. Hooks are brilliant as kids are far more likely to throw a jacket over somewhere they can hang it. Folding is much too hard.

Future-proof investment buys such as wardrobes and drawers by keeping them white and modern—this

way they will work as the child grows and his/her style changes. My criteria for choosing something is "will it last?" "How will it evolve over time?" Also, consider furnishing a child's room with adult-sized furniture rather than pint-size—that way the decoration is integrated with the rest of the house.

While you may want a room to reflect your own taste, it is nice to create an interior that expresses your child's personality as well. The more creative input they have (or feel they have), the more they will feel amazed. Make them into mini decorators! Get them to design a moodboard for their room by cutting out images from magazines and sticking them onto card stock. Then let them paint a piece of old furniture in their chosen moodboard colors. A spray-painted mirror is an effective update. You can also get the kids involved by letting them arrange things how you would both like them to be. By taking the time to find out what bits are important to your child—what they want to look at, along with what storage solutions they need, you will create a room they will want to spend time in, which keeps the rest of the house tidier too.

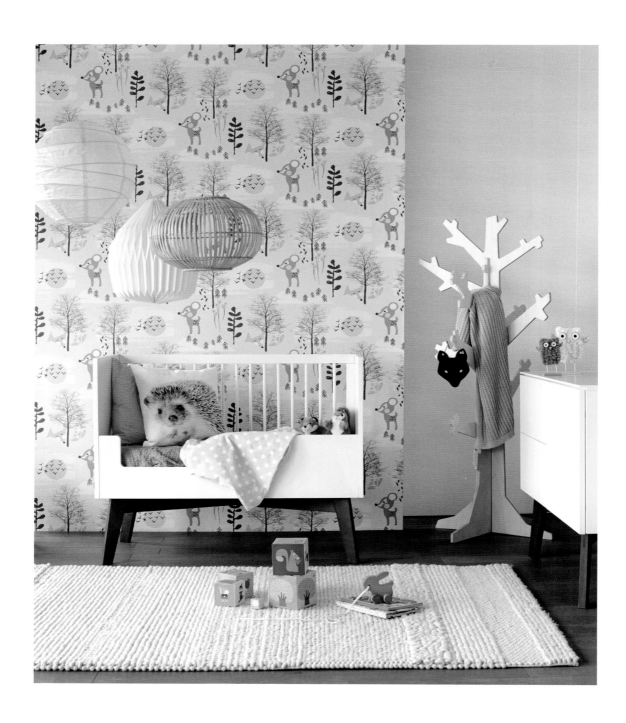

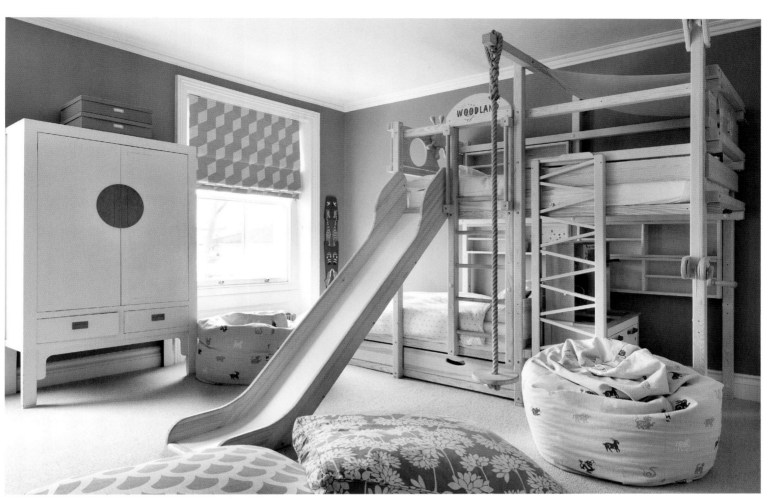

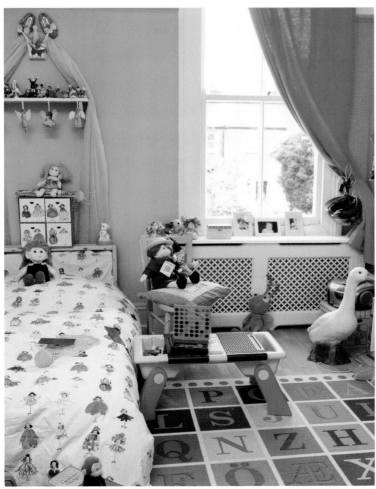

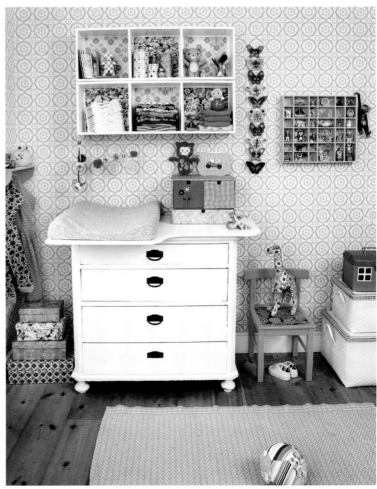

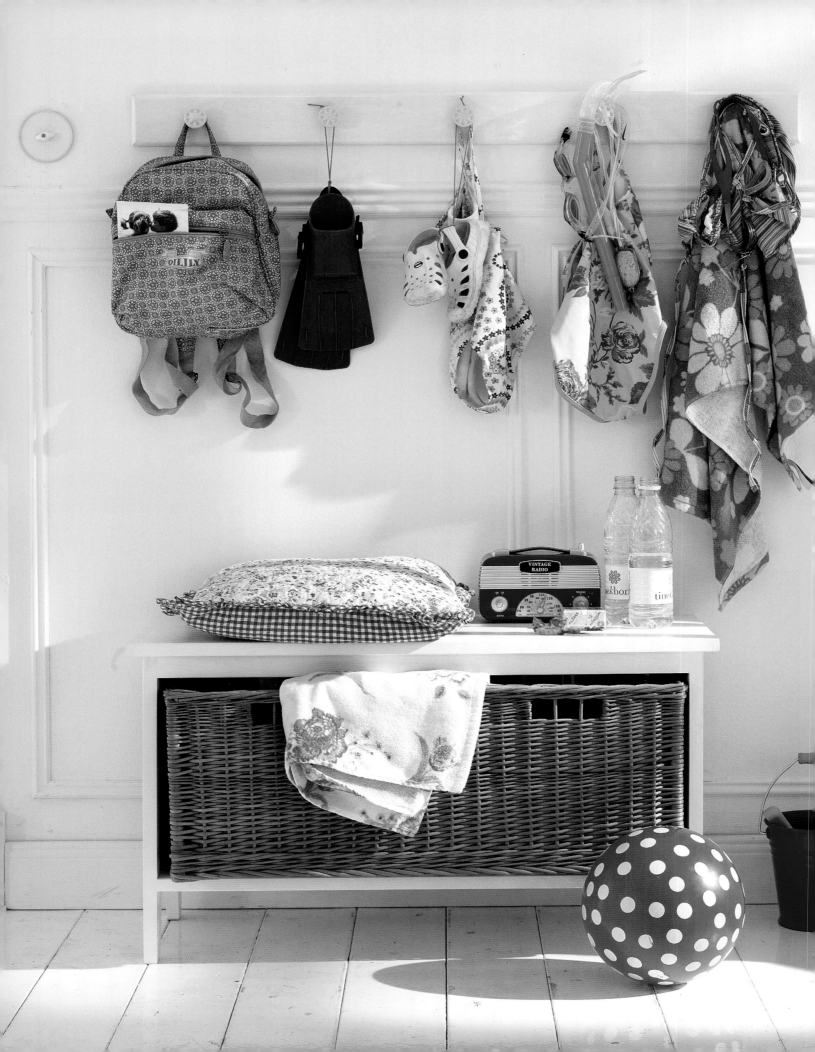

LEFT Storage is essential in a child's room. A combination of boxes and hanging rails makes tidying up quick and easy.
RIGHT Mounted on the wall, these contemporary doll house boxes double up for both play and storage.

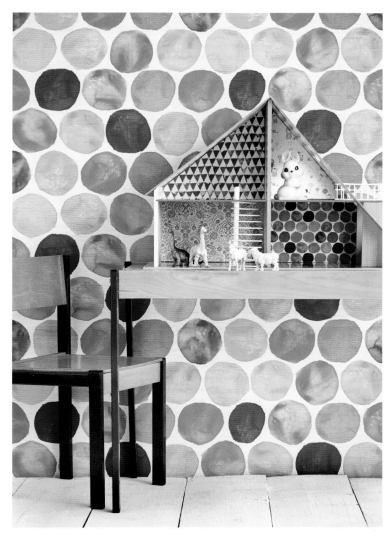

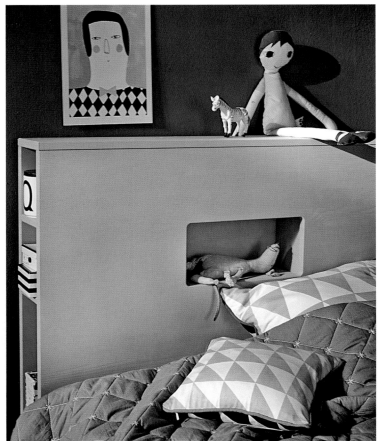

ABOVE Clear plastic containers provide practical storage for Lego that you can see at a glance.
LEFT This clever headboard has built-in shelves for storing precious things close by while they sleep.

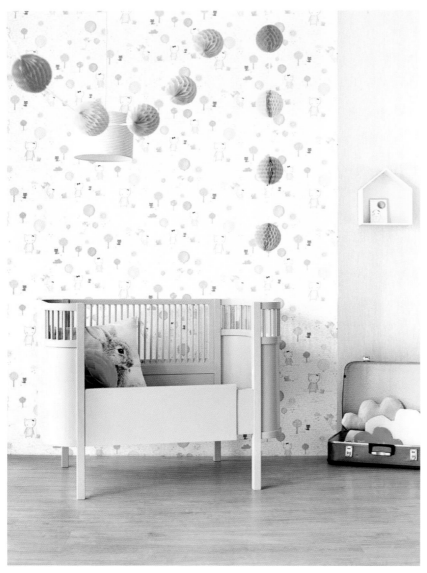

LEFT Garlands, bunting, and pom-poms make pretty additions to a girl's room.
BELOW The vintage charm of these needlework cushions will be loved for years to come.
RIGHT Here, the hot pink of the wardrobes is softened with purple and gray.

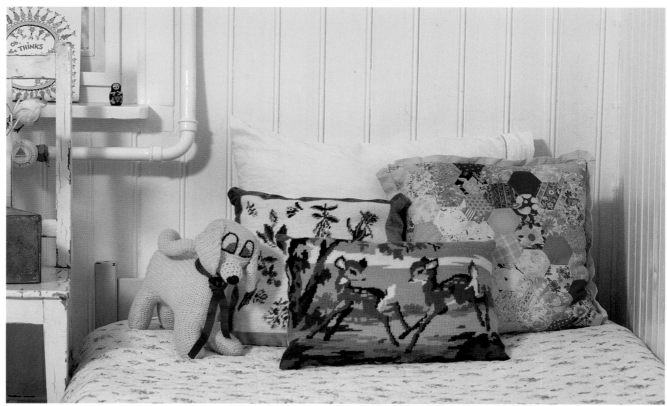

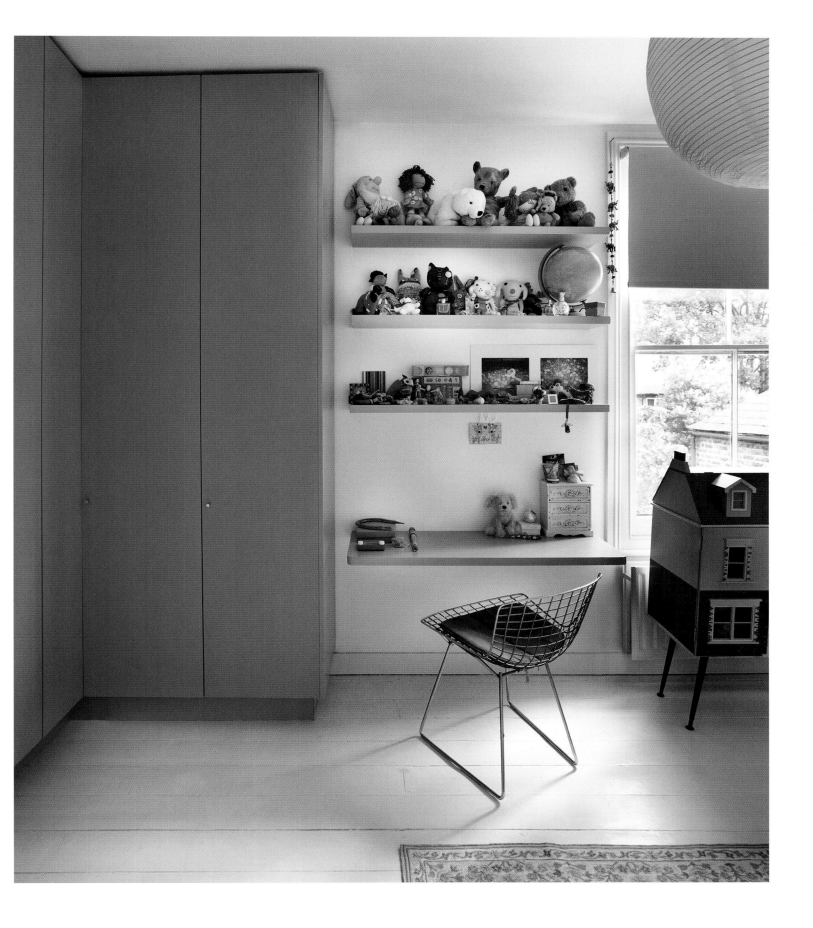

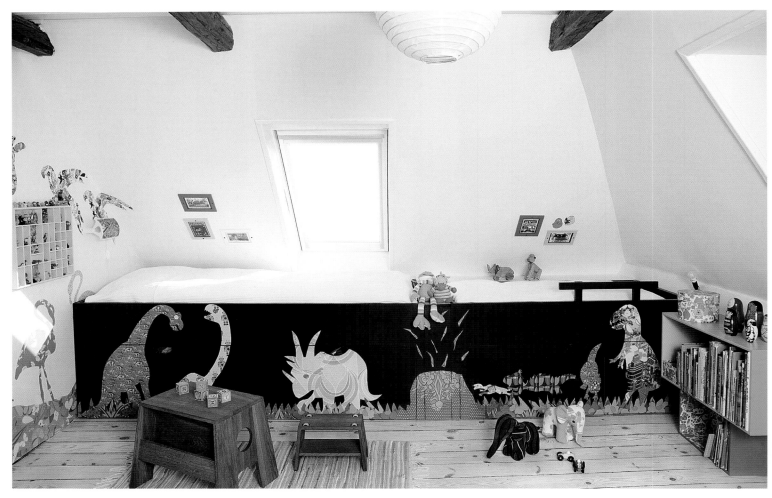

HOW TO CREATE WONDER WALLS

There are all sorts of fun you can have with the walls. From massive flowers made of different pieces of fabric to decal dinosaurs on the base of the bed, wall art is an eye-catching way to bring personality into a room. I love to see art in children's rooms. Images really stick in a child's mind—and like a good story, they help with the imagination. An oversized world map mural looks great as well as being educational. Instagram photos look lovely arranged in a heart pattern over the bed. Or try hanging musical instruments instead. This works brilliantly with guitars, violins, and clarinets—not only are they off the floor not taking up any space, but they are stored safe and instantly accessible should the moment inspire.

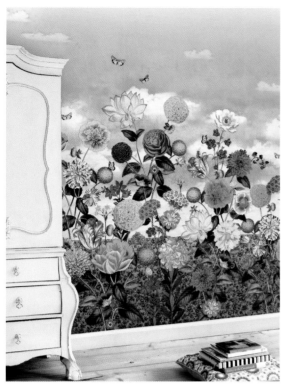

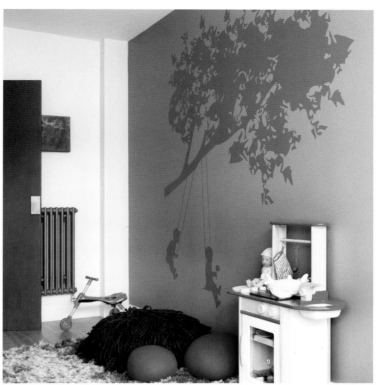

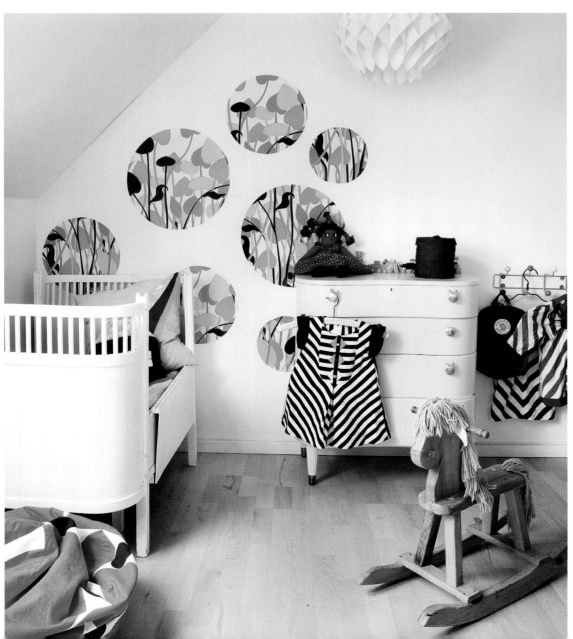

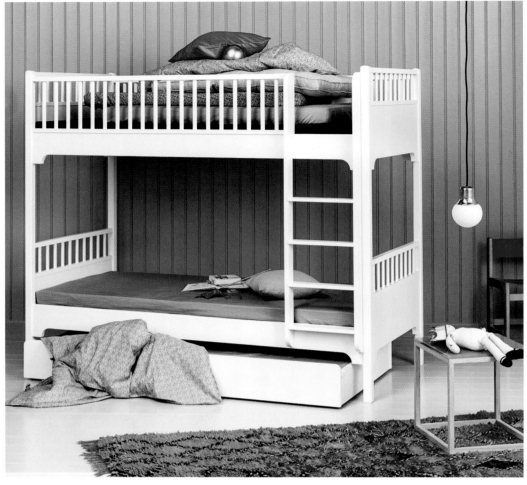

ABOVE It doesn't need to be all primary-colored plastic and kiddie designs. A beautiful textured rug and modern side tables will go the distance in a child's space.

RIGHT A round table is good for children to play at as it is versatile and can be moved anywhere in the room.

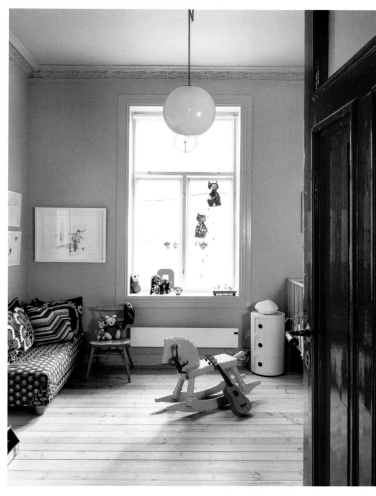

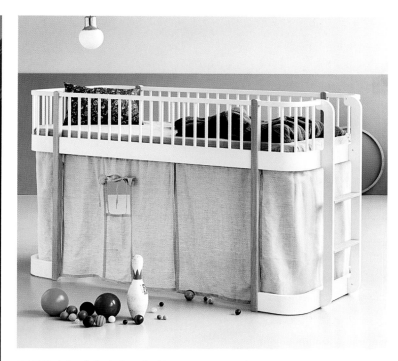

ABOVE A bunk bed that doubles up as a cozy burrow is every child's dream. Fill with cozy cushions and a soothing reading light.
LEFT This eclectic bedroom is a lovely balance of modern, vintage, and practical style.
BELOW LEFT These Butterfly chairs are a design classic—in miniature form.
BELOW These sunshine yellow chairs look striking against the pretty cloud wallpaper.

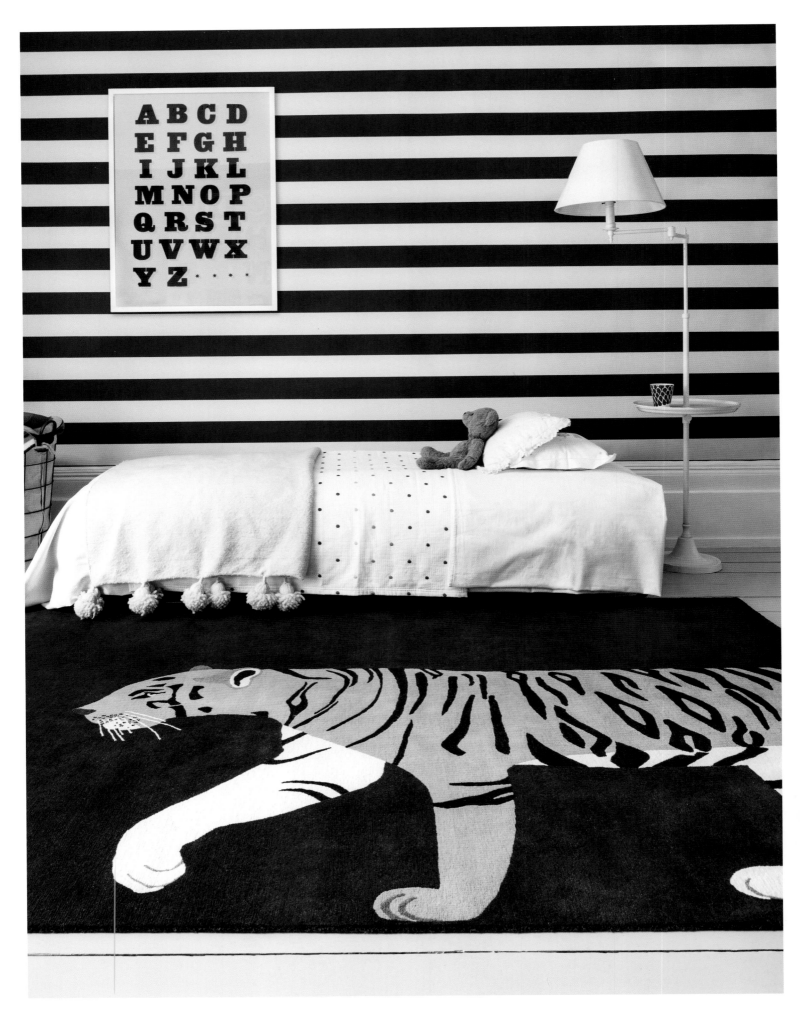

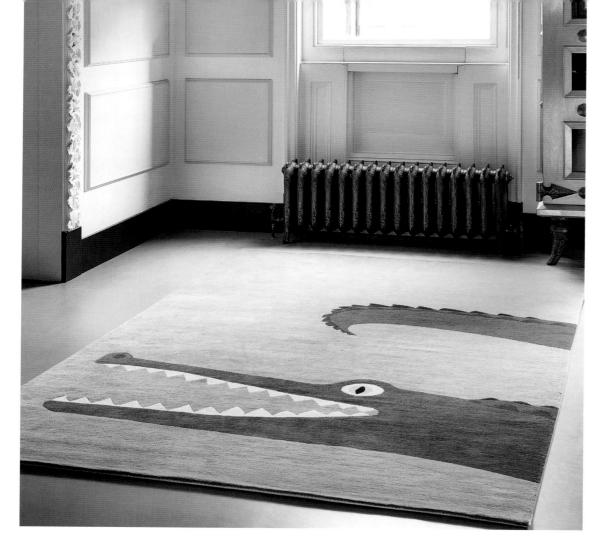

RIGHT, ABOVE, AND BELOW These cheeky stealth-like tiger, crocodile, and peacock rugs are part of a collection of animal rugs, created to thrill both parents and children alike.

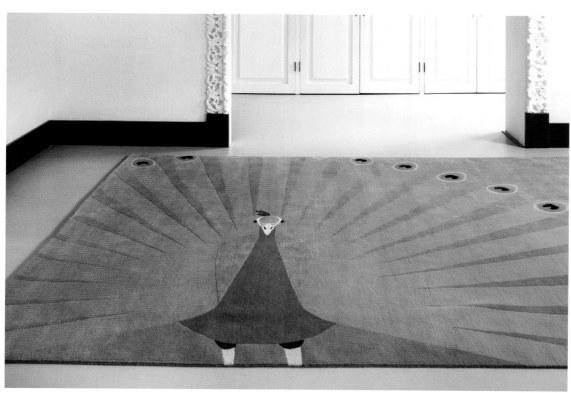

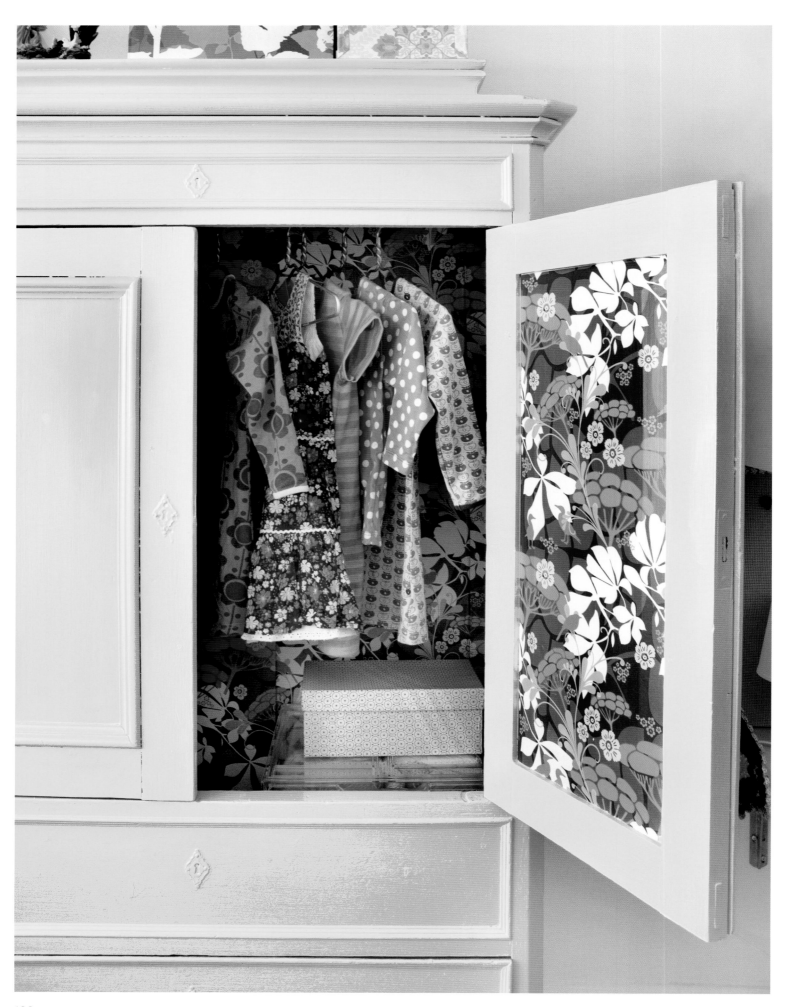

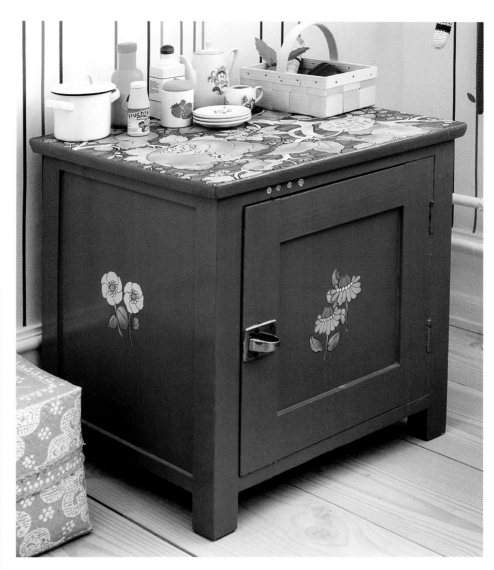

HOW TO UPCYCLE FURNITURE

The beauty of upcycling is that you can give a new lease on life to an old piece of furniture, making it more lovable and all the more you. In my daughter's bedroom, I gave an IKEA wardrobe a unique spin by painting it a similar shade to the room. I used a tough eggshell finish and replaced the handles with bird-shaped ceramic knobs. It makes me happy every time I open the doors. You can go a step further and wallpaper the interior with a vibrant pattern. The same idea can be applied to bedside cabinets and tables. Storage boxes are the mainstay of any bedroom, but to make them look better and tie into a scheme, cover them in a mixture of different floral fabrics.

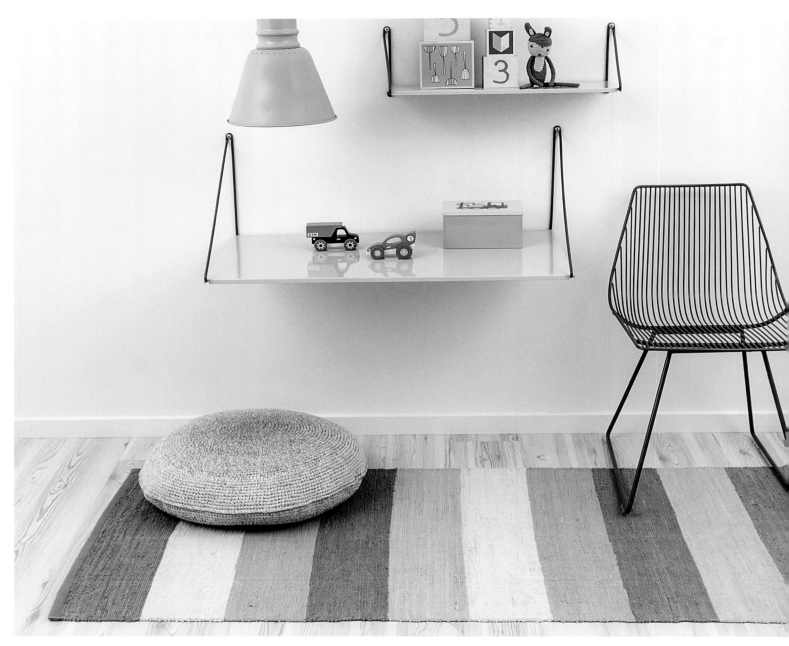

ABOVE Not all kids rooms have to be cute. These simple shelves are great for as they take up so little space and double up as a desk.
ABOVE RIGHT Use illustrations on textiles and walls to give a room lovable appeal.

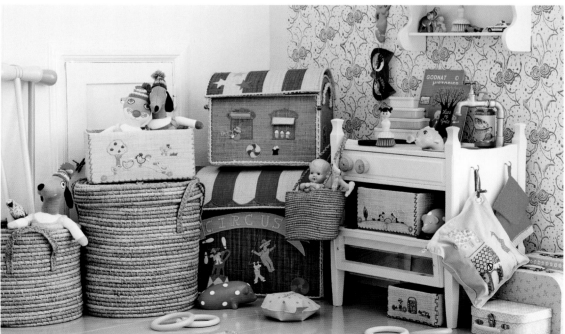

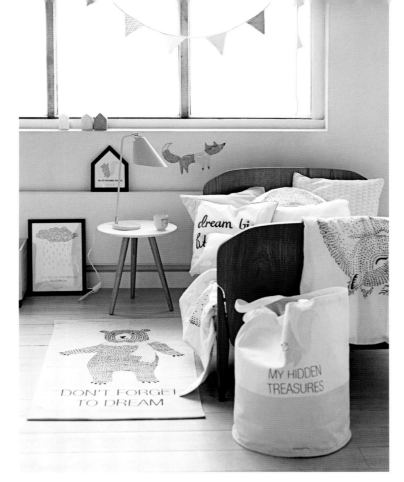

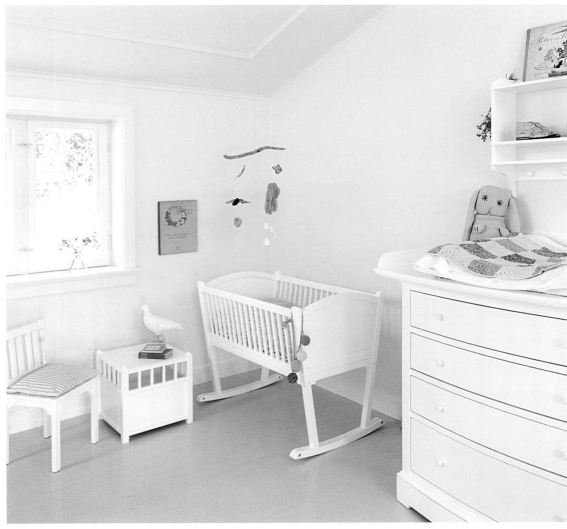

R	Y	A	T	I					R
U	S	B	U	L	U	C	H	O	U
I	U	N	V	C	F	G	K	P	I
A	X	Q	S	T	L	H	O	B	A
U	B	I	H	Z	E	A	R	J	U
N	O	M	O	L	B	R	L	K	N
B	L	X	G	V	Y	U	N	O	B
O	N	E	N	I	T	R	Z	L	O
D	S	Z	C	B	W	E	I	M	D
R	Y	A	T	C	I	N	U	K	
U	S	B	U	L	U	C	H		

A	T	C	T	N	O	K	R	Y	A
B	U	L	U	C	H	O	U	S	B
N	V	C	F	G	K	P	I	U	N
Q	S	T	I	H	O	B	A	X	Q
I	H	Z	E	A	R	J	U	B	I
M	O	L	B			K	N	O	M
X	G	V	Y			D	B	L	X
E	N	I	T	R	Z	L	O	N	E
Z	C	B	W	E	I	M	D	S	Z
			I	N	U	K	R	Y	A
			U	C	H	O	U	S	B

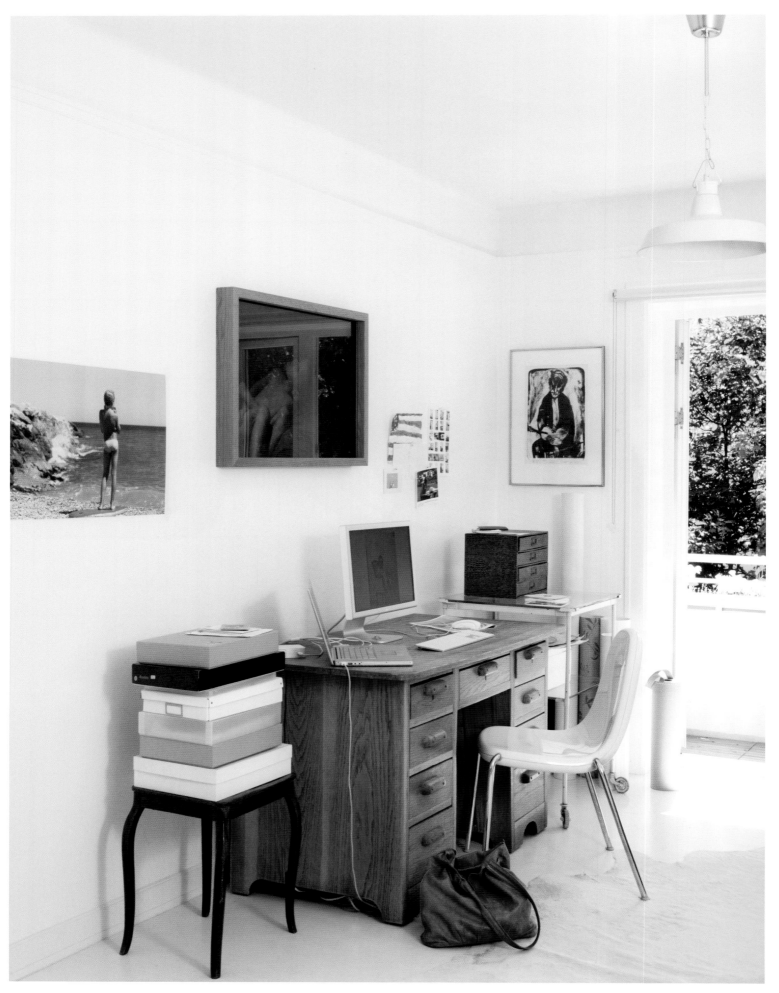

[WORKSPACE]

As the line between work and home continues to blur, our ever-versatile rooms have evolved accordingly. Many of us work from home at least some of the time now. More often than not, the living room doubles as a study. Or the spare bedroom has a designated desk. But considering our sense of being is so closely related to what we do, we should make the experience as pleasurable as possible. Above all, our home office should be an attractive place to be.

My strategy is as follows: clear the dining table of anything unrelated to my work, mark my territory with a few things that inspire me (cut flowers, candle, book), spray a bit of aromatherapy and get in the zone. As a freelancer, I'm lucky as one day I might work from the kitchen or sometimes, in bed. I like to vary the view. Whether you have a room of your own or you are hot-desking from the coffee shop, as long as the space functions and feels good, you're on the right track.

The key challenges interior designers face when designing a home office are blending it into the current surroundings, creating a flexible space, and ensuring it is functional. But that doesn't mean you have to replicate the office aesthetic. My top tip is to create your own space that you can personalize. After all, it's more productive to work in an environment that is warm and inviting.

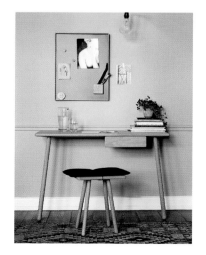

Ideally, your workspace will have a comfy chair, decent shelves, good light, and accessories to get the creative juices flowing. A well-positioned desk lamp will provide focused light for studying. LEDs make superb task lights because they provide bright light instantly and don't heat up. Also, look for adjustable lamps, so the light can be directed exactly where it is needed most. Music is important too. A wireless speaker brings music to any space. If your work demands a lot of reading, sit in a high-backed armchair positioned by the window (you don't always need to be at a desk). Reupholster it in a tactile mohair and you have the ultimate reading chair. All of these things can be moved around, too—so they work with our lifestyle as well as our homes.

Ask yourself these questions before equipping your workspace. Are you tidy? Or do you prefer organized chaos where you can leave things out? Do you need a room where you are completely alone? It's good to forget the world around you when you work. Do you like to have an outside view? Do you like it to be very light? A white desk is always useful as it makes everything stand out. The same applies to atmospheric inky blue schemes too. Light or dark, both color schemes help to focus the mind.

Tidy desk. Tidy mind. You can get more done in an orderly home office. Tablets

and laptops are, of course, the perfect space-saving tech for both browsing and working (wherever that might be). Custom-made shelves with sliding front panels are great for storing files and keeping them out of sight. If you're having bookcases made, it's useful to have a couple of drawers fitted at the base. For home office storage that looks right in the home, sideboards offer lots of space for papers, along with a perfect height top for propping pictures and plants. Your desk accessories should match your décor, so don't be afraid to think outside of the box. A hand-painted tile will make an excellent coaster.

Also, repurposed Portuguese olive oil tins (with those beautiful labels) make great pen holders. I work at a big table most of the time, and I like it in the middle of the room, because who wants to sit facing a blank wall? A leather-topped partner's desk, refectory table, or if you're really lucky, an oval Saarinen dining table—all of these options offer lots of lovely surface area, but when placed center stage, allows you to sit back and admire a favorite picture opposite. A massive beach scene or lakeside view will always keep me in good spirits.

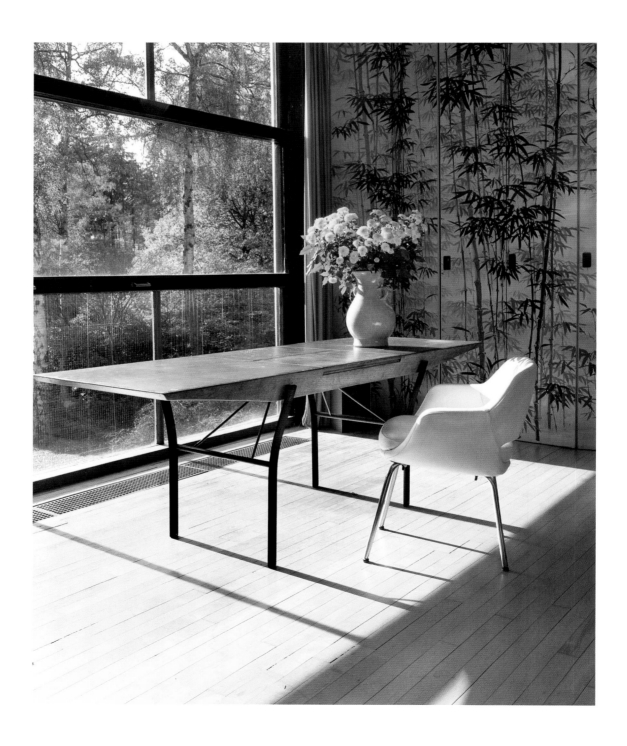

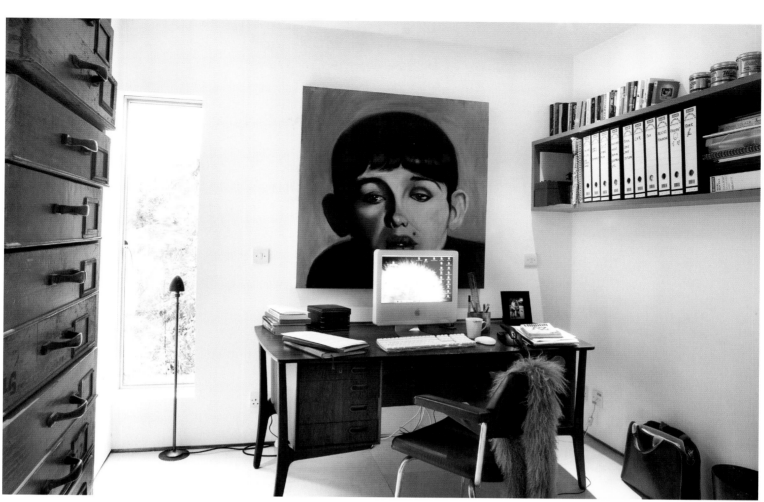

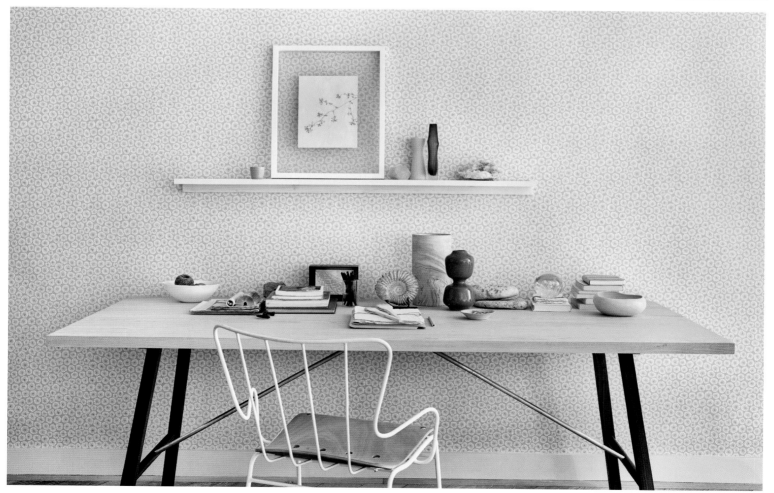

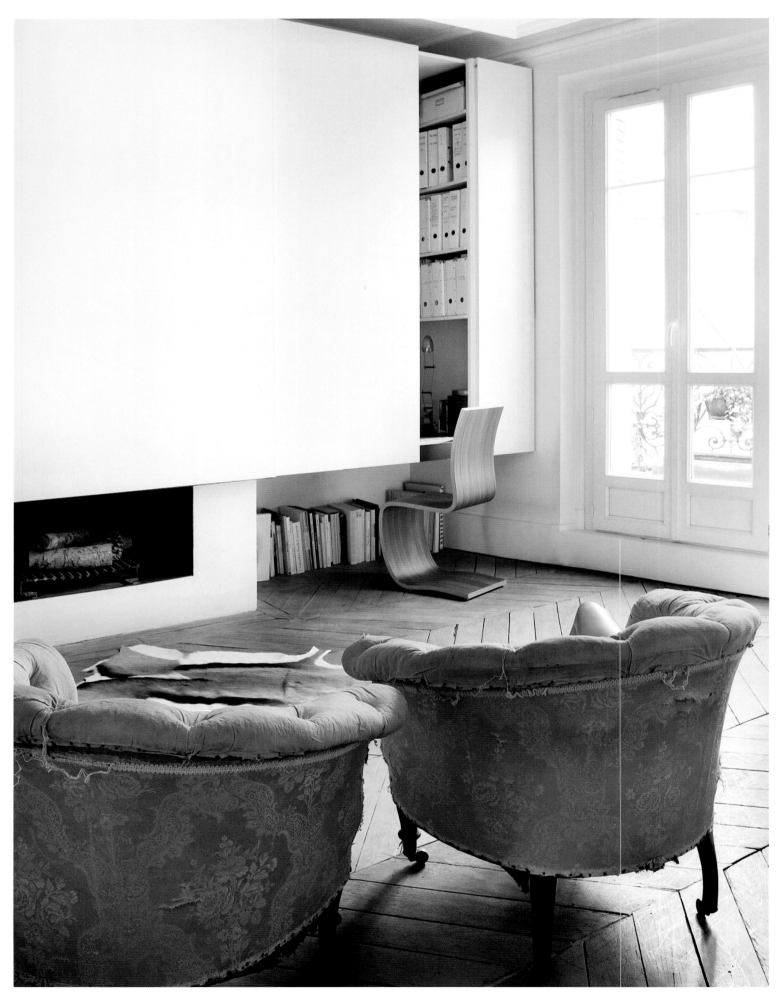

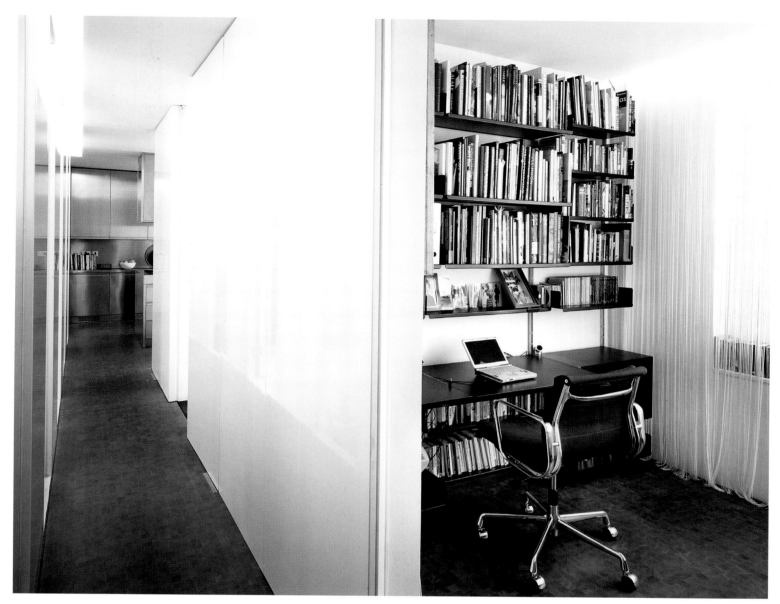

LEFT For the ultimate streamlined space, create an office in the manner of a built-in cupboard. Open it when you need it and close the door when you don't.

ABOVE This black and white scheme maximizes available light. Desk-to-ceiling shelves ensure that every available inch of storage is used.

RIGHT An alcove provides a useful nook for a small desk and shelves.

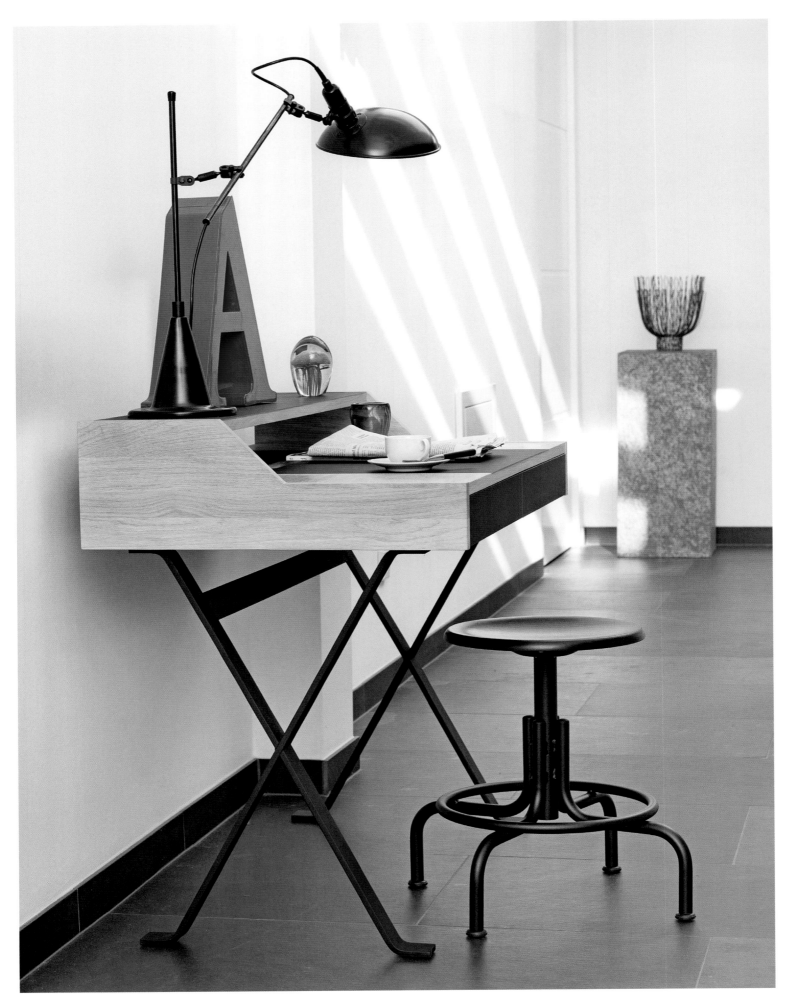

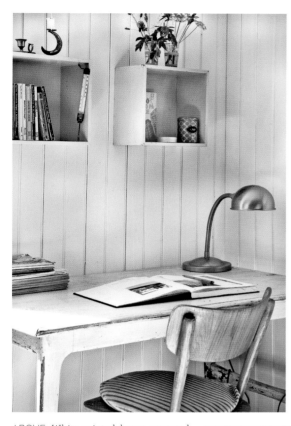

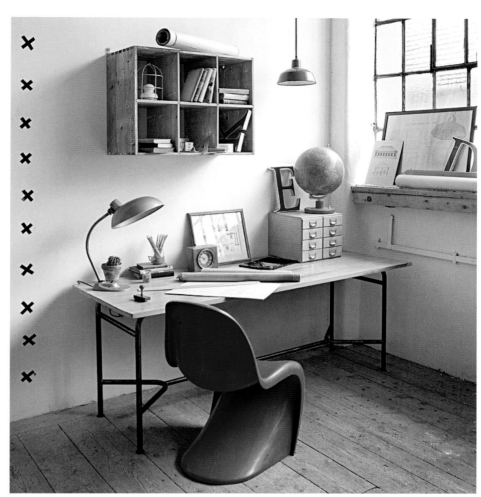

ABOVE White-painted boxes mounted to the wall provide additional storage.

ABOVE RIGHT If there was ever an excuse to indulge in your favorite chair, it's when you have to work from home. This vibrant design provides a brilliant contrast to all the white.

RIGHT An efficient workspace requires a calm, clutter-free area with a well-designed desk, an ergonomic (but good-looking) chair and an adjustable wall or desk lamp providing crisp, white LED light.

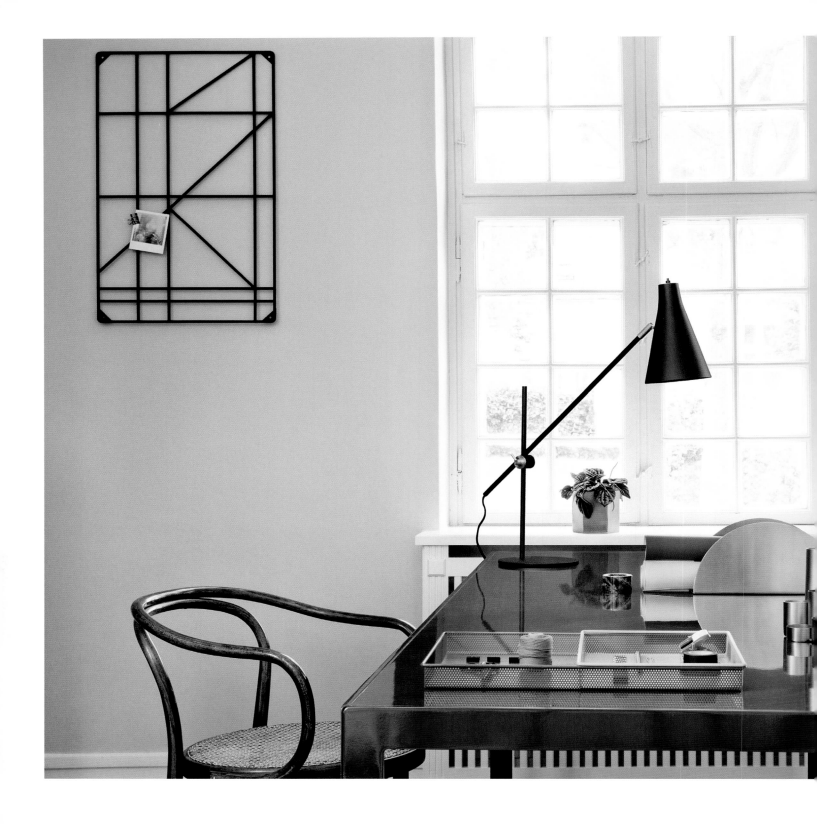

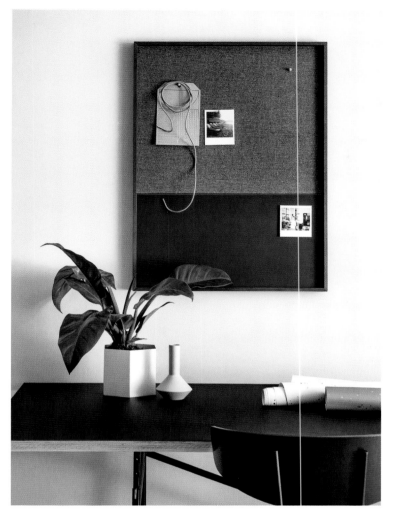

HOW TO CREATE A PINBOARD

If space is tight, a cork wall is a clever way to keep notes and reminders away from the desk. Painted the same color as the walls, it will blend into the rest of the interior and serve as a place to map your inspirations too. For a smaller-scale take on this idea, cover a pre-made corkboard with a piece of canvas using nailheads or thumbtacks to hold it in place. A huge sheet of plywood makes a Scandinavian style memo board. Buy a sheet from your local hardware store and lean it against the wall; simple as that. Use washi tape to secure notes and spruce it up with some cool lighting.

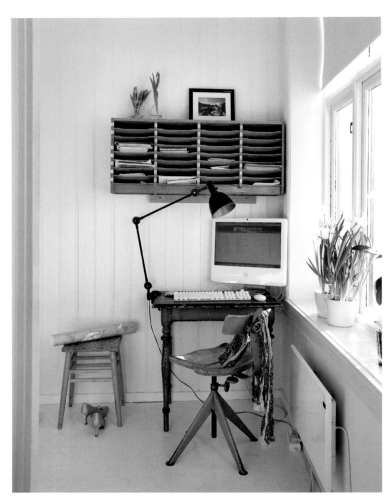

LEFT A desk, a chair, a lamp—and some kind of stationery organizer—you don't need a lot of space for somewhere to work. This set up is positioned next to a window where there is lots of natural light.

BELOW LEFT The minimalistic, slim lines of this desk area are accentuated with flashes of silver.

BELOW The floral stencil and bright accessories create this uniquely pretty office.

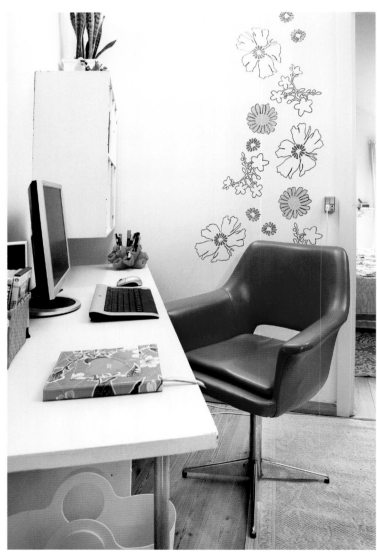

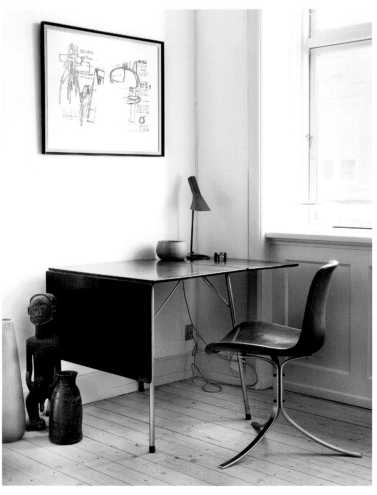

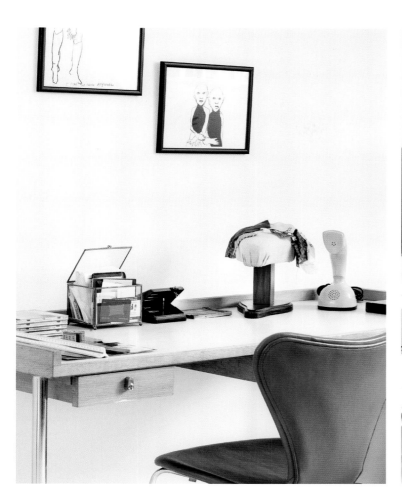

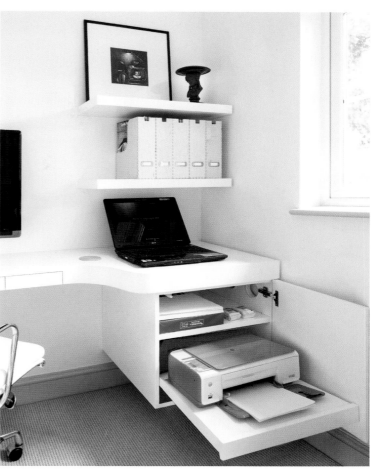

ABOVE LEFT A non-corporate mid-century chair and desk combo suits a bedroom environment.

ABOVE This streamlined office has a custom-made shelf and cabinet to hide away unsightly wires and technology.

LEFT This neat desk is built to an alcove.

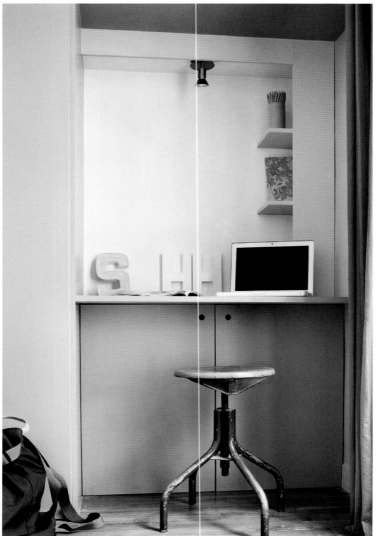

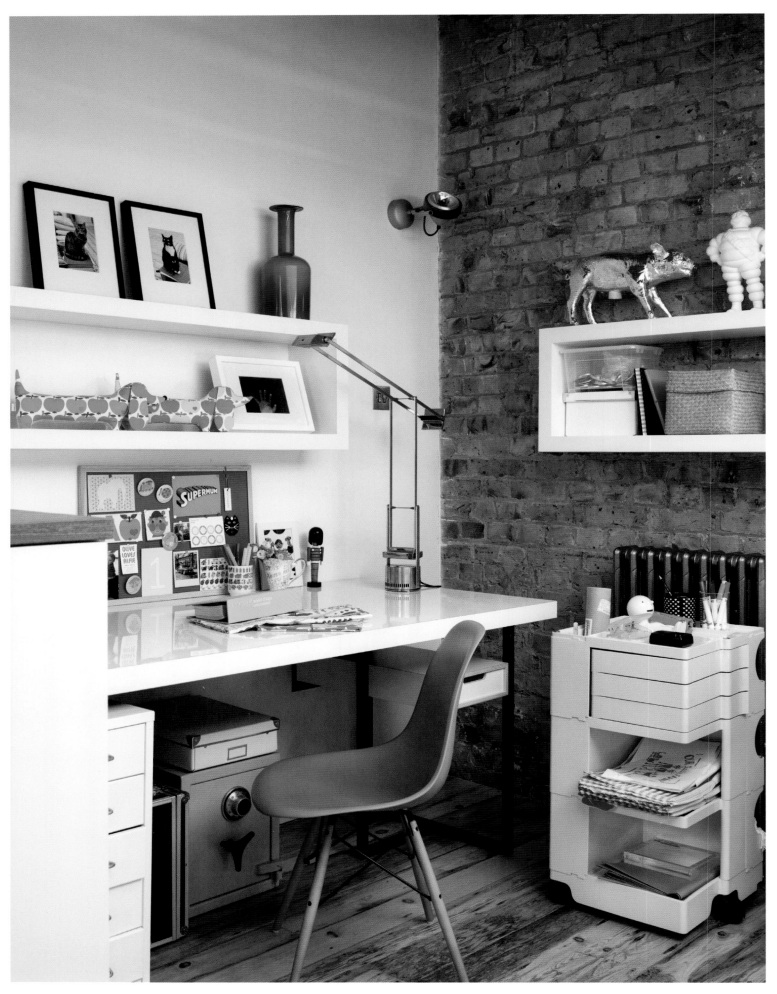

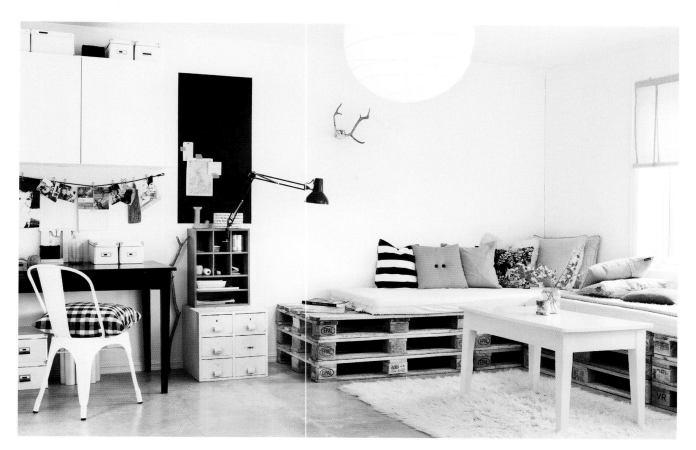

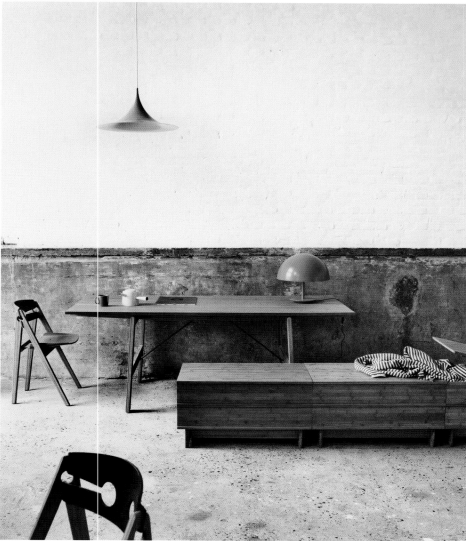

LEFT Trolleys offer a brilliant use of space in an office as they can hold all manner of things from printers to stationary and can be stowed away when not in use.

ABOVE Above this desk, a piece of string holds pictures and artwork that are important to the homeowner.

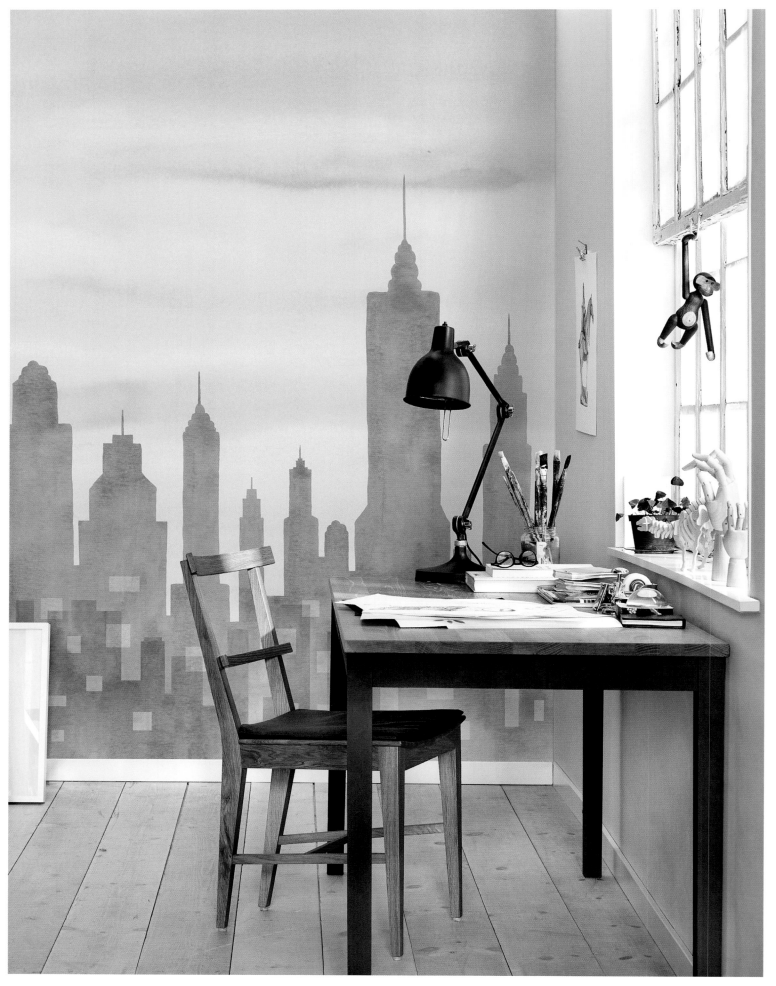

RIGHT Integrate a desk into a living space, anchored by a classically framed piece of art.

BELOW A gorgeous soft rug and leggy mid-century desk look elegant and comfortable in the bedroom. A well-positioned wall sconce provides light.

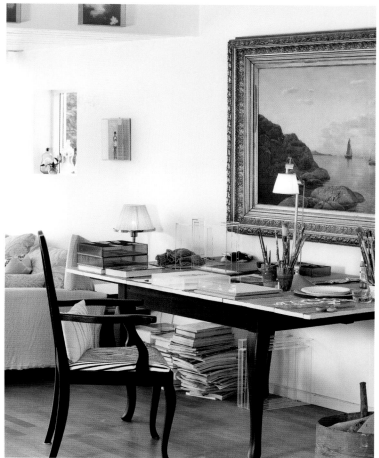

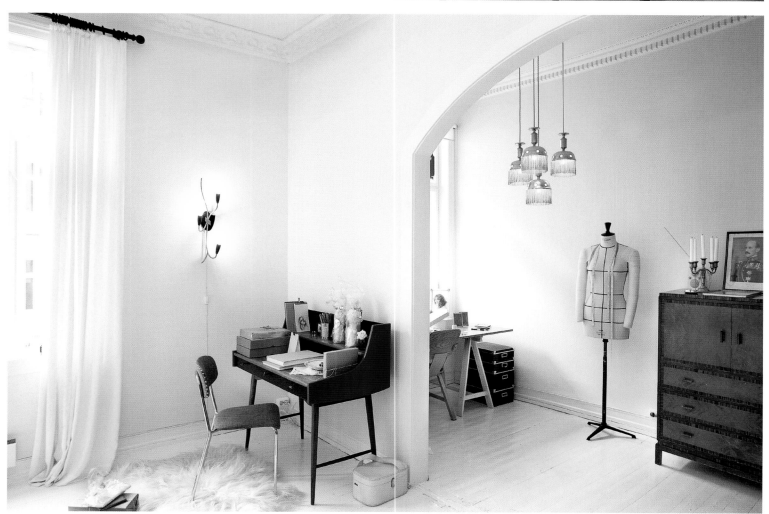

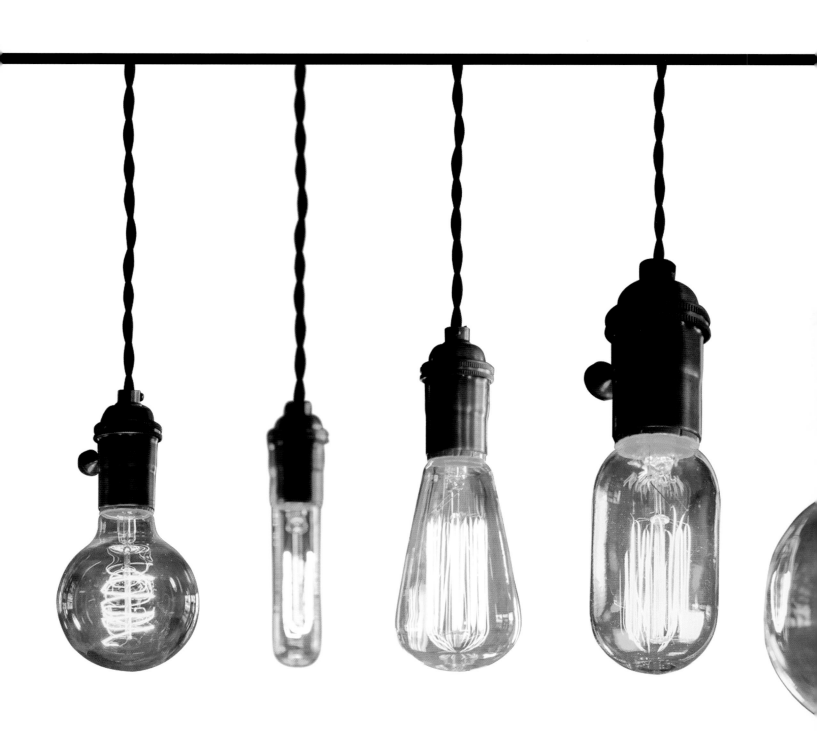

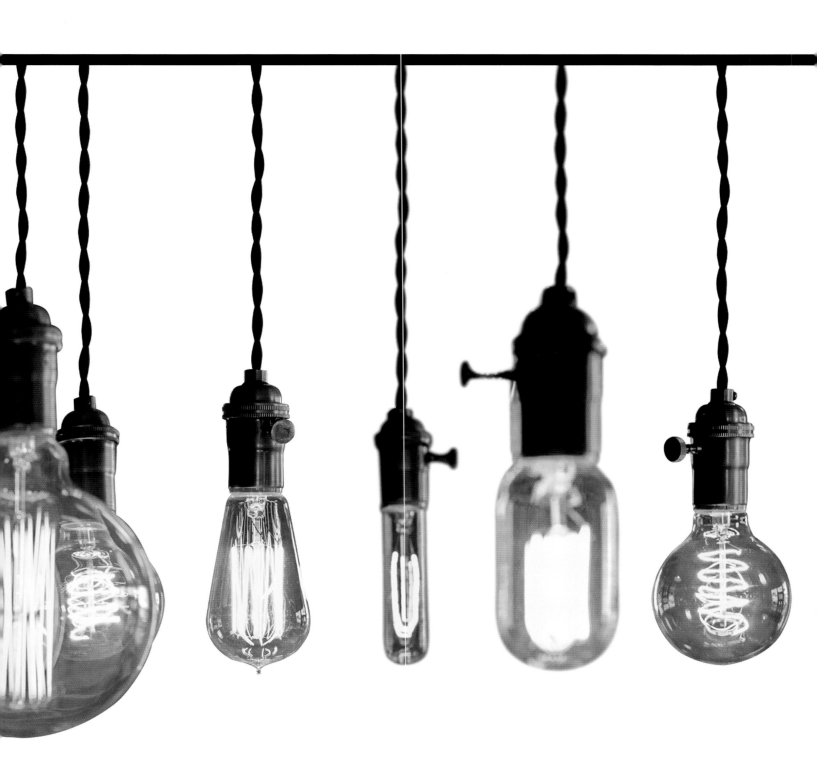

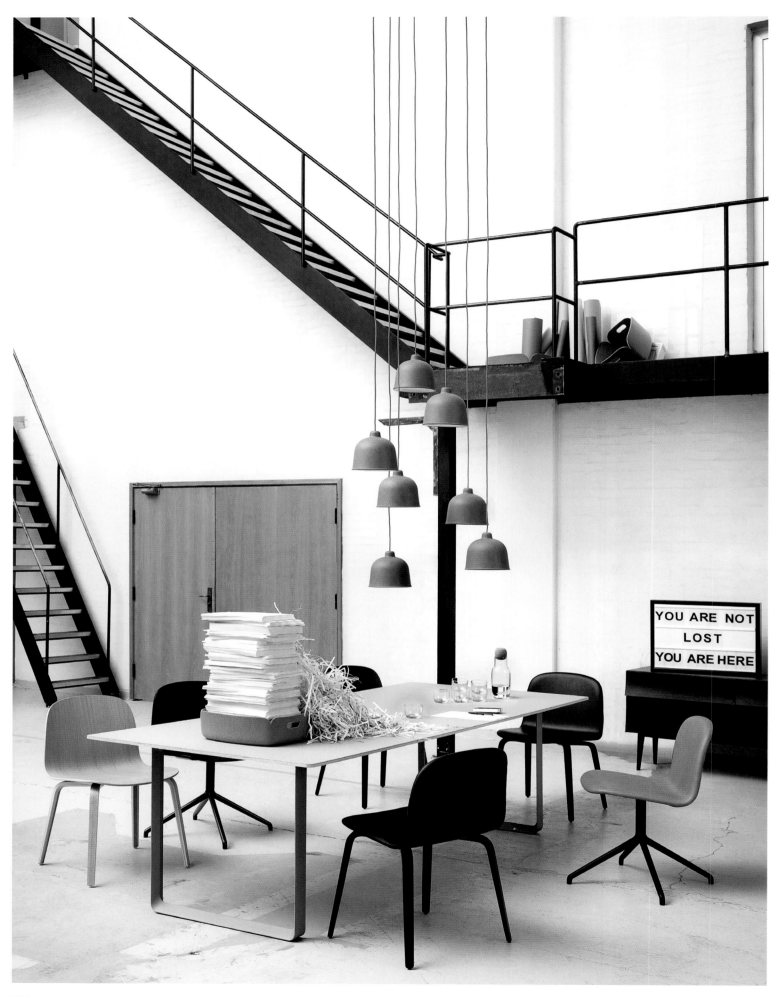

Lighting is one of the biggest game-changers in a home's décor. The little pockets of glow add intrigue and atmosphere to an interior, creating instant coziness, making a room appear larger, drawing the eye to a focal point, and casting magical shadows. Think of it as jewelry for the home. As such, it's important to choose a style that fits your personality. Are you drawn to rustic materials, such as wood, glamourous blown glass, or classical brass? If you're ever stuck for lighting ideas, a bar or restaurant is a good place to head for inspiration. They are often up-to-the-minute when it comes to lighting, and they are professionals at making sure the scene is perfectly set.

Certain rooms do better with different types of lighting. An impressive chandelier will give a living room focus. If it seems bigger than you think it should be, you're on the right track. Pick designs that are not just functional but also have impact when you walk through the door. In contrast, I like to keep lamp fittings simple if there is lots of detailed decoration elsewhere.

To get the lighting right in the kitchen, a good even brightness works well. Recessed ceiling spots have a place here—you get extra style points if they are dimmable in sections, so the light can be controlled with variable depth. It's worth noting that you don't need to go symmetrical when you are planning your spotlights. It is

more pertinent that the spots are positioned where they are needed most. Over a dining table, you can use 1, 2, or 3 pendants (depending on their size). As a minimal alternative, I like a suspended LED tube.

In the bedroom, it is useful to have general light, but my main priority is a flexible bedside lamp that is up to the task of reading at night. As well as being pretty, it needs to be practical. Adjustable wall sconces are currently very fashionable and make a sculptural feature in the room. They work particularly well suspended over a dining table—or on a living room or bedroom wall. In loft bedrooms, LED strip lighting is effective when it can be hidden behind beams or tucked behind voile curtains or a headboard. Just make sure you go for a soft warm light; otherwise, LEDs can feel a bit harsh and soulless.

Warm lighting is my biggest must-have in a home. If it were up to me, I wouldn't have a ceiling light on at all. Floor lamps and table lamps are my go-to—especially in the living room and bedroom. The more the merrier. The aim here is to create accents of light in the space. Suspend pendants to highlight objects or create a corner vignette in a room. Consider clustering a few simple lights together, and don't be afraid to hang them low. Lamps on side tables, on consoles, on a pouf, on the floor, in pairs... To ensure all of your lamps

work together, keep either the color or material consistent, i.e., all brass bases or all white shades. This way you can mix up the shape of the shades or the style of your favorite bases. Just go for low wattage to make sure you have a softer glow. And for an instant shift in mood, change the color of the bulb in a bedside light.

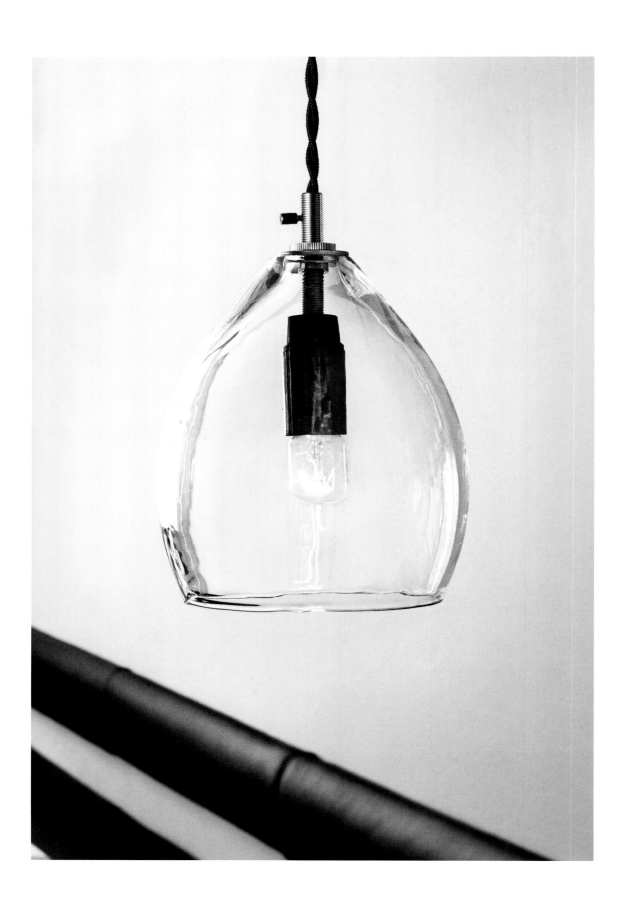

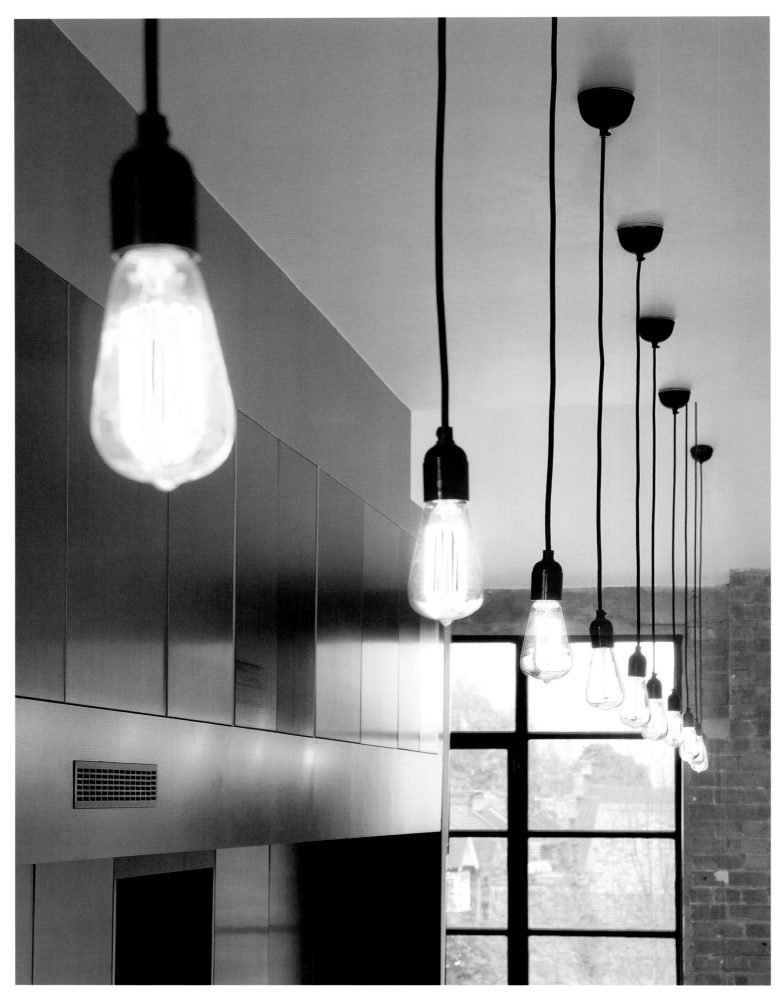

LEFT With a slick industrial aesthetic, these Edison-style bulbs look great lined up above a worktop in a kitchen.
RIGHT A minimal design with the classic silhouette of a traditional bulb, this lamp can be hung as a single feature over a table or mixed in clusters to create a modern Scandinavian-style chandelier.
BELOW While large twin pendants work well over a dining table, for a taller kitchen island, smaller lighting looks lovely in threes.

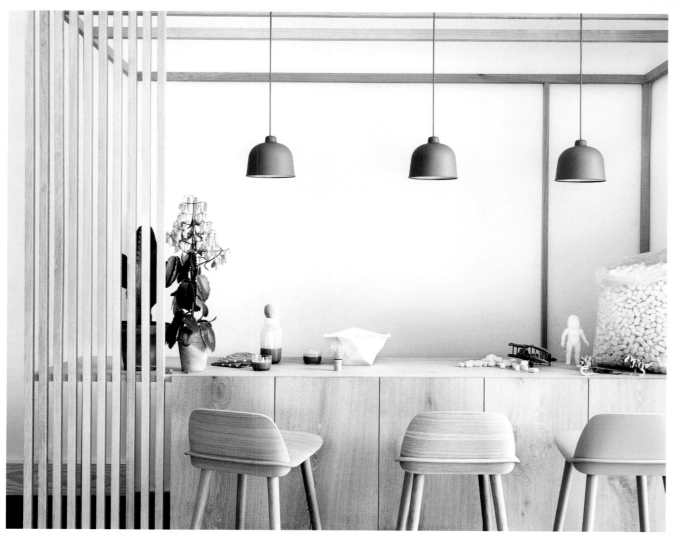

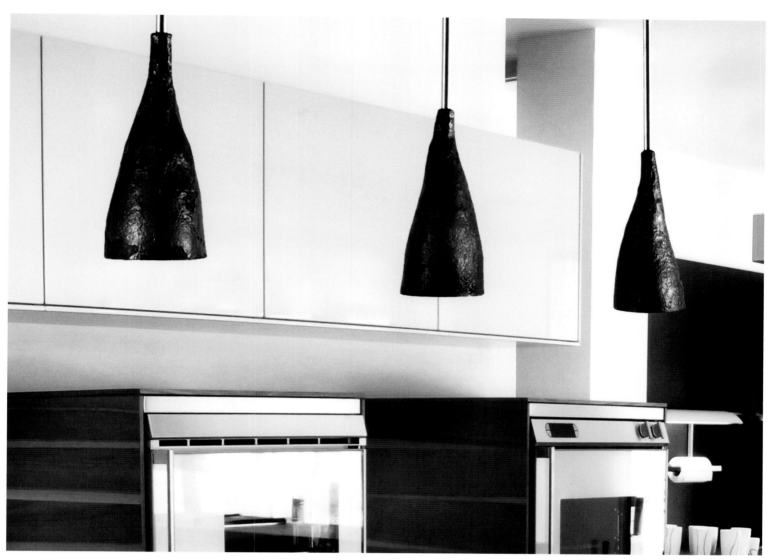

HOW TO DO SALVAGED STYLE

Lighting designers have been toying around with salvaged industrial components for a while, using wire cages, burnished metal, and exposed bulbs to striking effect. These tactile lights give any room an edge. To manufacture lights from scratch, customize light fittings with colored fabric cable, different shaped bulbs and steel hardware. Combine with up-cycled found objects, such as a zinc bucket, fancy patisserie cake tins, and vintage bird cages—flea markets are an excellent source for factory-style shades and recycled finds.

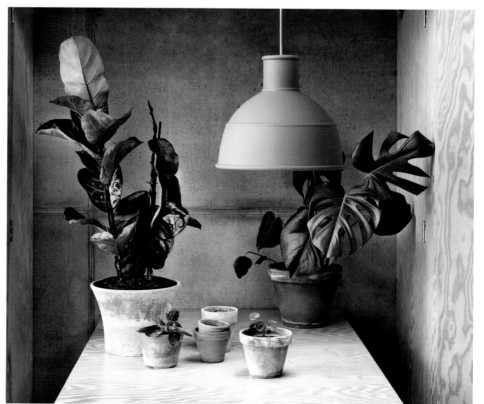

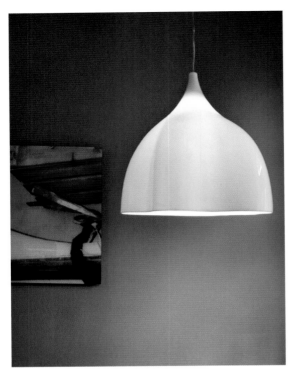

BELOW This room is all about the bold use of color to accentuate curvy shapes. The chrome floor lamp is glammed up with a vintage crystal chandelier.
RIGHT Keep it sleek and simple with an understated glass shade.
FAR RIGHT The bright orange glass shades of these modern retro pendants come to life when set against white walls.

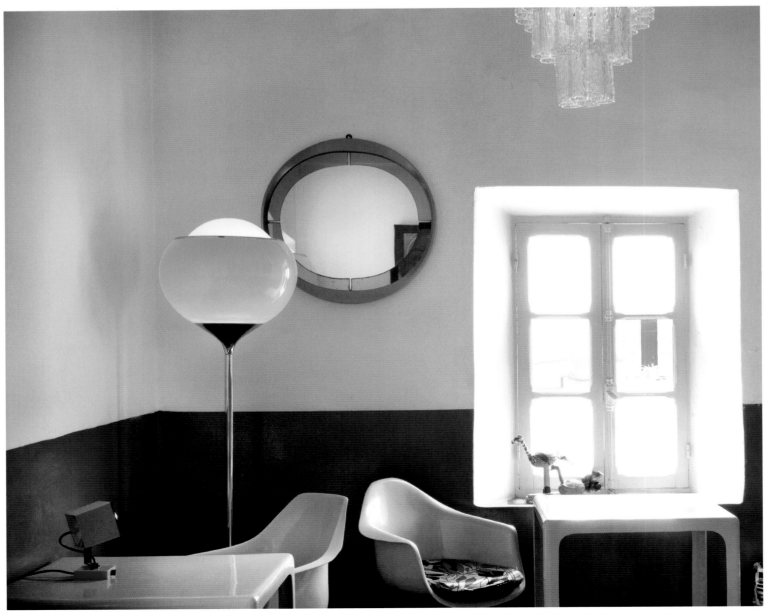

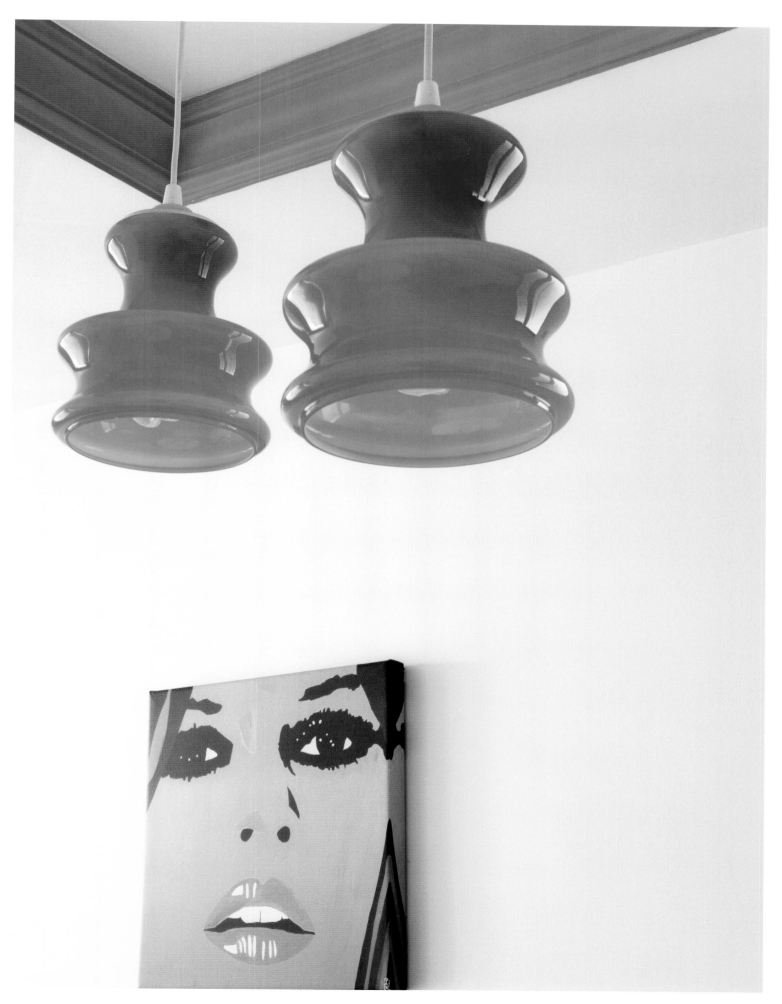

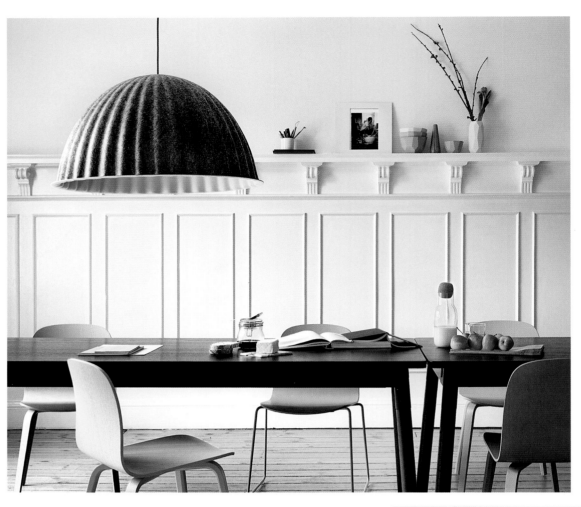

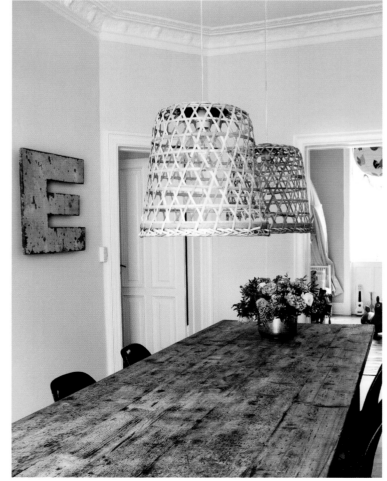

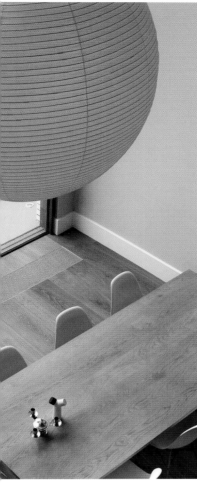

ABOVE LEFT This outsize drum pendant shade, with its elegant fluted design, looks beautiful during the day and casts a gorgeous glow at night.

ABOVE A simple paper pendant looks natural and chic above a dining table.

LEFT When is a basket not a basket? When it is a fabulous pendant shade instead. The open weave will cast elaborate shadows.

RIGHT Twin pendants are effective over a long, refectory-style table. Keep them simple like the soft, round shape of this Fluid lamp to avoid design overload.

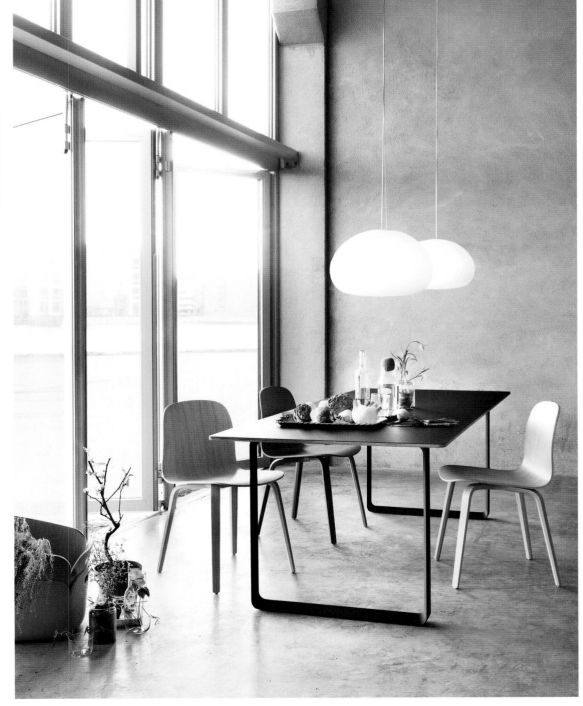

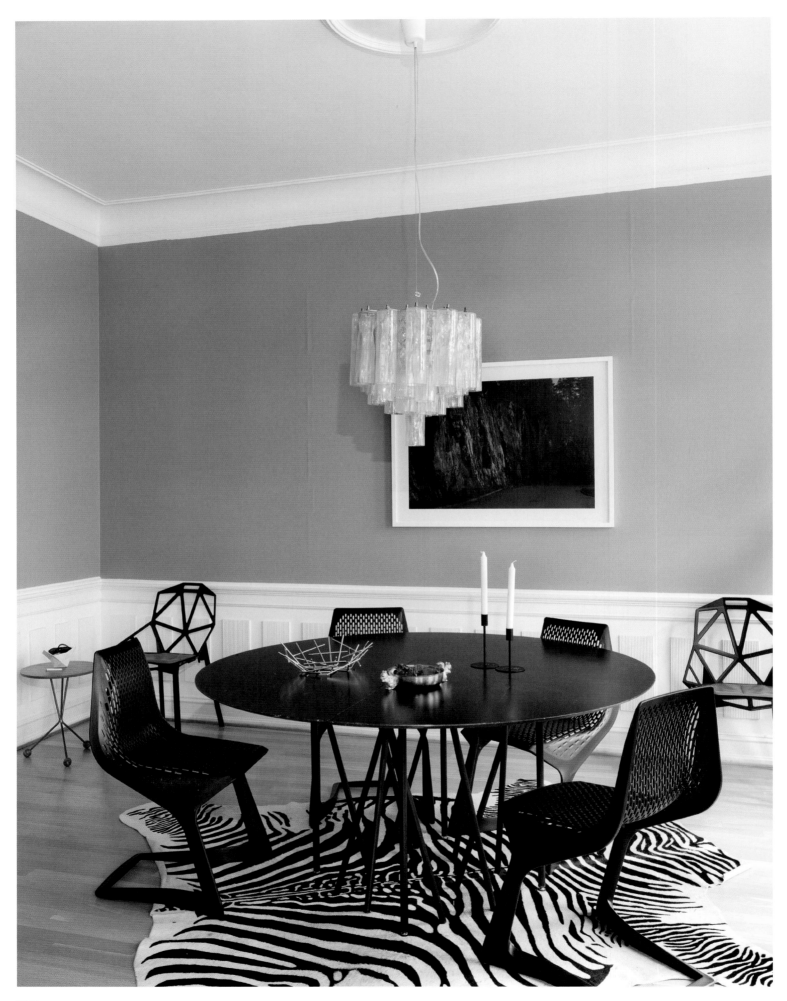

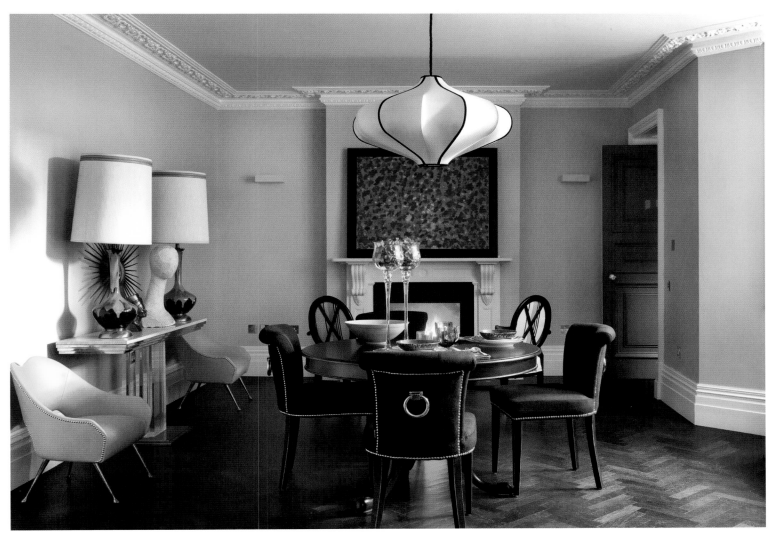

FAR LEFT Lighting is the jewelry of the home and should be chosen with as much consideration. This contemporary opulent look is the equivalent of a black-tie occasion.

ABOVE This east-meets-west fusion looks striking. The Japanese lampshade hangs above a classic English table—joined in the middle by flashes of blood red and a pair of glam yellow leather and brass chairs.

LEFT Play with light and shadow. Combine matte and shiny finishes to add luster and sparkle in a room.

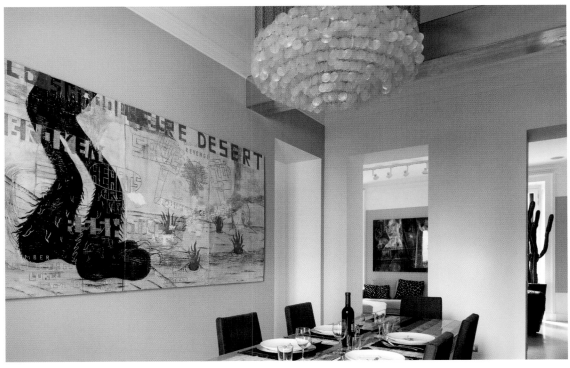

LEFT Lighting looks good in pairs. On a console or either side of the sofa, go symmetrical with table lights for an uptown, chic style.

LEFT BELOW For your very own glamour pad, combine shimmering metallic, shine and sheen.

BELOW Rather than a single, central light source, a variety of lighting dotted around the room will create a seductive mood after dark.

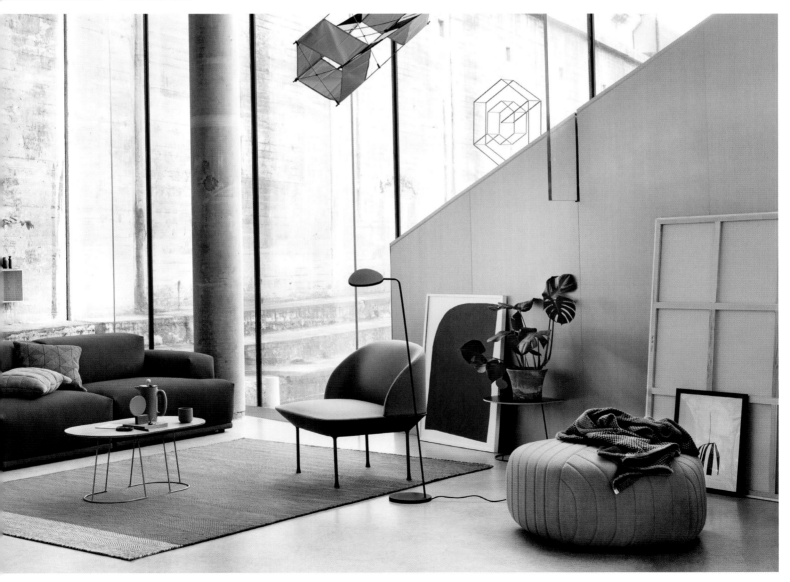

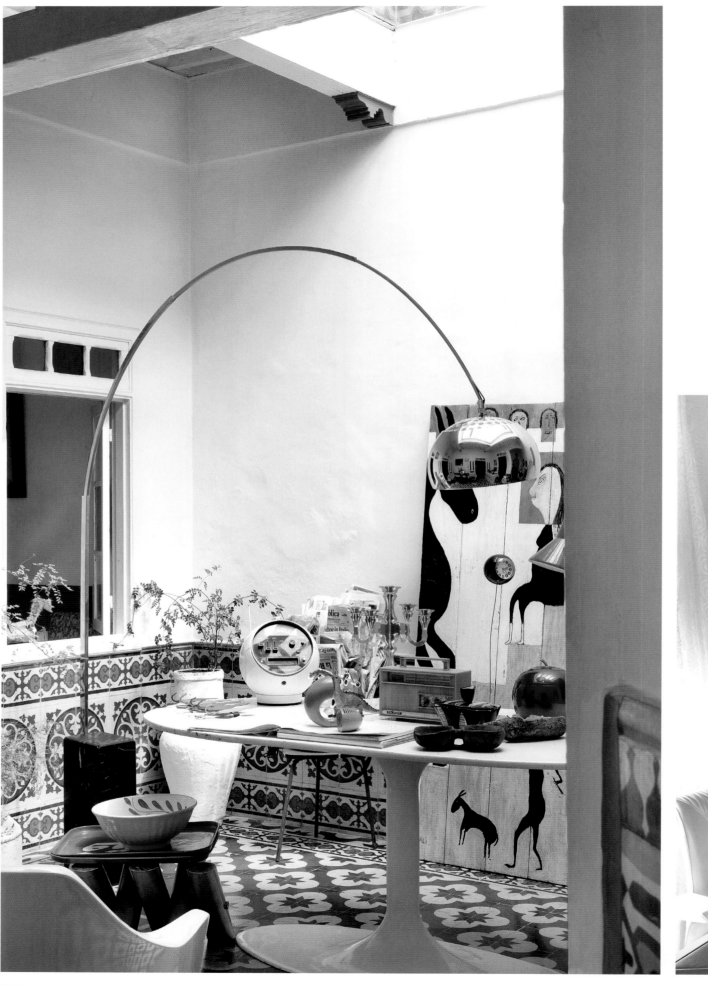

FAR LEFT I love the contrast between this Flos Arco floor lamp, Saarinen table, and Moroccan tiled floor and walls.

LEFT For an open-plan space, these matching pendants link the cooking and dining zones together. An additional Anglepoise lamp turns the table into a versatile place to work.

BELOW A soft pleated shade will add texture to a neutral and monochrome palette.

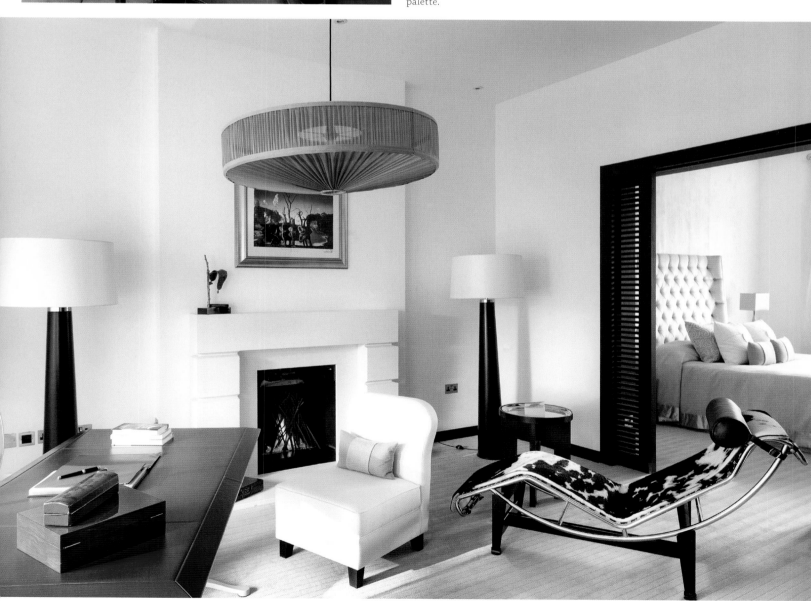

BLOGGERS

Want to achieve a super-stylish home with effortless style? Some of the best interior inspiration is found online. Here, top design bloggers share their favorite decorating tips.

ABIGAIL AHERN

STYLE TIPS ON ADDING DRAMA TO A SPACE

If you have a passion for glamourous homes, Abigail's blog is the place to go for ideas. One of the UK's coolest interior decorators, Abigail blogs about her design tastes, new trends, and interior design tips that have everything to do with confidence and style.

My favorite decorating rule to break: Whenever I'm decorating a room I paint everything, and I mean everything—walls, ceilings, floors, trim, coving, radiators, doors, and built-in cabinetry—all in the same hue. It's so magical because you're effectively removing all the lines that normally break up or stumpify a room. It blurs boundaries and instantly opens up the whole space.

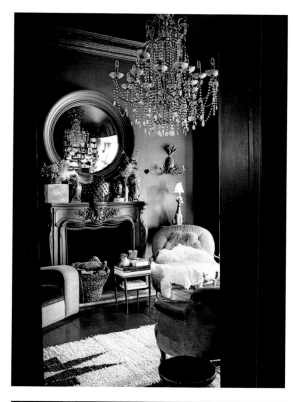

GO DARK. This is always my number one tip to everybody. Everything looks cooler against a dark background.

GO BIG with lighting. A dramatic statement pendant or supersized chandelier will make any space seem instantly grander. I've also put floor lights on tables and consoles to give that extra height. Playing with scale like this creates a sense of *Alice in Wonderland* magic, and is one of the easiest decorating tricks in the book.

ADD MIRRORS. They expand horizons, and add depth and intrigue all at the same time. My personal favorite is to experiment with shape, using giant convex mirrors, or finishes, such as antique blackened effects, or the most luxuriously beautiful bronze mirror.

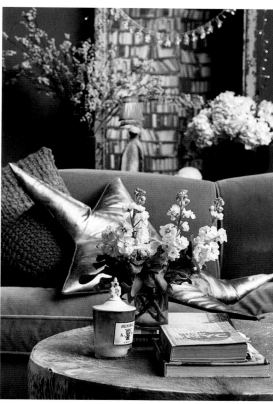

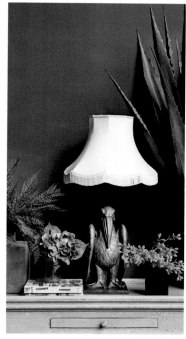

EVERY ROOM needs some shimmering metallic pops. Like magpies, we are drawn to shiny things, so when you plop a beautiful gold mirror, picture frame, or vase in a room it lifts it immediately and enhances the whole space.

MY LATEST DIY PROJECT

The next thing I want to tackle is my bathroom. I have pretty ambitious plans for a Tadelakt plaster spa haven, stunning brass accents, and a lush balcony garden.

Abigail Ahern of
blog.abigailahern.com

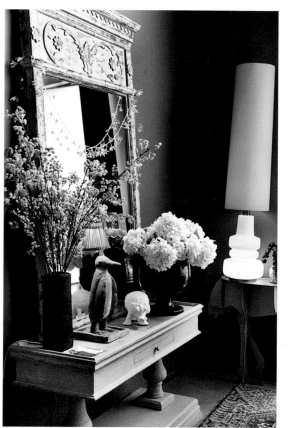

COMBINE TEXTURES to create a tactile, tantalizing, inviting space. Rough, smooth, raw, and soft surfaces all need to mingle up against each other. The trick to keeping the look sophisticated rather than crazy is to stick with a restrained color palette.

LUCY MEEK

STYLE TIPS ON DECORATING WITH PERSONALITY

Lucy started writing Decorenvy as a scrapbook to record her ideas while decorating her own place. It has evolved into a sourcebook for unusual and interesting design—and the place to pick up a cool DIY idea.

My favorite decorating rule to break: All of them! It's your

home, so express yourself and have fun. By all means take inspiration from magazines and blogs, but remember that no decorating rule is set in stone. If you think it looks good, go for it.

WORK WITH your architecture. Trying to force a theme that's completely at odds with the style or shape of your building often winds up looking odd. It's worth compromising on your vision of a dream home in order to create something that sits harmoniously with the architecture.

CHOOSE FUNCTION over form. There's no point in having a beautiful interior if it gets in the way of you enjoying your home. Be wary of purchases such as striking yet uncomfortable sofas or pristine white carpets and consider whether they're worth the impracticality.

DON'T GET STUCK in a theme. You may love Scandinavian style or rustic interiors, but that doesn't mean you have to choose one look and rigidly stick to it. The most effortlessly beautiful homes borrow from all kinds of trends to create something unique.

RESHUFFLE YOUR STUFF. Occasionally changing your furniture layout or swapping decorations between rooms is a great way to keep your home feeling newly decorated without spending any money. I find moving things around helps me to enjoy them more, as I really "see" them in their new location, whereas before they had started to blend into the background.

DO IT YOURSELF. The most rewarding and cherished items in your home will be the ones you created yourself. It's well worth spending time working on DIY projects, whether it's growing your own plants or building your own shelves. Start small and work your way up!

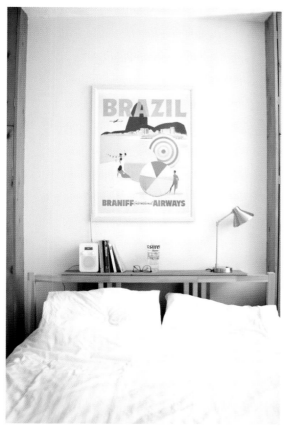

MY LATEST DIY PROJECT

Living in a rented flat means I'm limited in what I can change, but having been inspired by a recent tutorial I saw online, I'm quite tempted to request permission to repaint the terracotta tiles in our kitchen a nice glossy white. Longer term, the goal is to buy my own place, gut it, and decorate it from scratch.

Lucy Meek of
decorenvy.co.uk

KARINE CANDICE

STYLE TIPS FOR ADDING FRENCH CHIC

Regarded as the "little black book of style" when it comes to decorating, Karine's blog brings together her love for white interiors and French chic.

My favorite decorating rule to break: That's a tough one... I don't really follow rules when decorating. I follow my instinct. If I like it, it goes in the room. If I think it's visually pleasing and inspiring, I keep it.

PERSONALIZE YOUR HOME with black and white family photos. I like to create happy corners around our home with photos of the people I love, smiling.

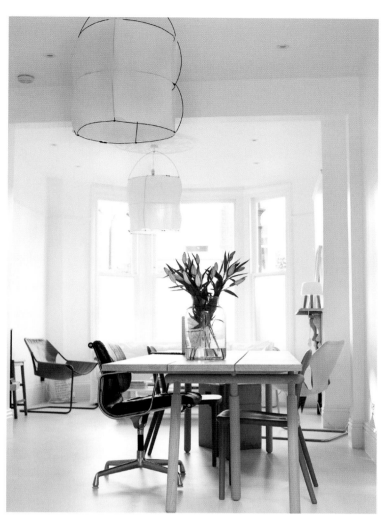

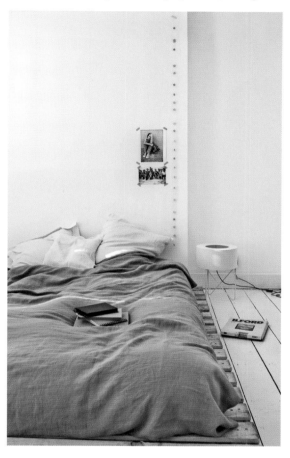

USE STONEWASHED LINEN rather than crisp white sheets in the bedroom for an effortless, feel-good vacation vibe.
TO KEEP YOUR HOME uncluttered, aim to get rid of two or three of the same item when you buy a new one, i.e., one new t-shirt in, three old t-shirts out!

TREAT YOURSELF to fresh flowers from the market as often as you can. It doesn't have to be expensive, but it will perfume your home and uplift your mood.
PAINT AT LEAST ONE WALL in the kid's bedroom light gray to add a stylish Parisian effect.

MY LATEST DIY PROJECT

We are currently revamping our vacation home in France and I'm replacing the sisal floor with a concrete one painted with gray parking paint, which is hardwearing.

Karine Candice of
bodieandfou.com

HOLLY BECKER

STYLE TIPS ON GETTING STARTED

An expert in decorating know-how, American journalist and interior stylist Holly began her blog in 2006 and is ideal for anyone on the hunt for design inspiration.

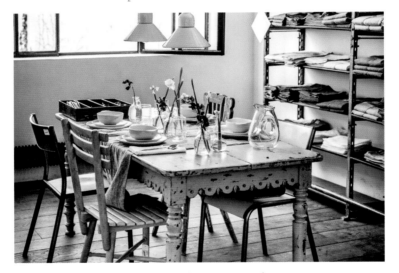

My favorite decorating rule to break: I like to add something to a room that competes with the focal point—like a lamp that is out of scale in the opposite corner, or a chair off to the side in a wild, totally bonkers pattern. Healthy tension can be good.

SEEK INSPIRATION. Knowing what's out there is key to finding ideas that you respond to positively. Create a Pinterest board, moodboard, fill a notebook or folder… Collect your ideas.

FIND YOUR personal style. Look at your photos for recurring themes and hone in on what you see standing out. This could be specific patterns, colors, etc.
IDENTIFY your project. Which room is screaming the loudest for help? Take it one room at a time. Don't decorate the entire house in a month!

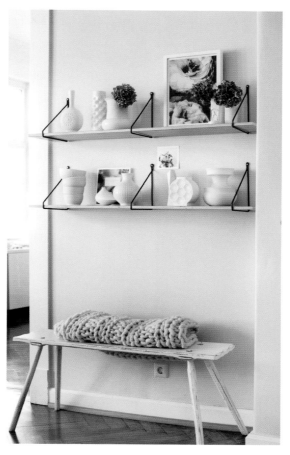

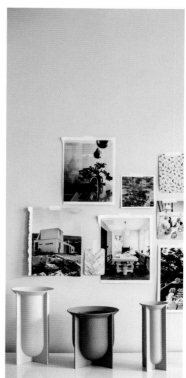

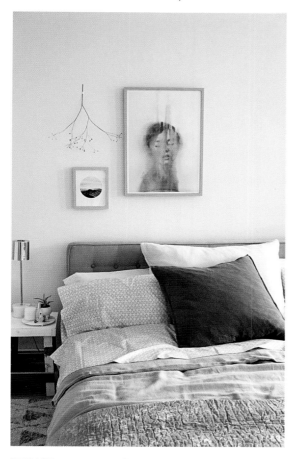

PREPARE your space. Gather everything up an adjacent room and write out your inventory. What do you want to bring back into the room? What do you wish to get rid of? What do you need to replace? Then photograph the empty space and measure it. Next, sketch out your space so you know where windows are, doorways, etc. It's easy to forget when you are out shopping.
FINALIZE your scheme. A sofa choice, the chairs you found, fabric—compare shopping finds with your Pinterest images and see how well they match up. Does the furniture all work together? Look at paint colors and wallpaper. How about flooring? Once some decisions are made, the rest of the scheme will follow.

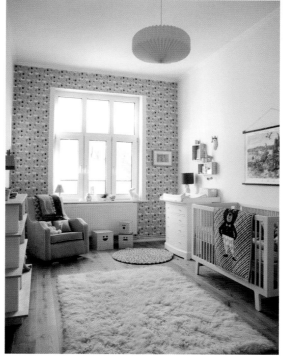

MY LATEST DIY PROJECT

I am currently turning the nursery into a toddler room. I'm looking for a new rug, toddler bed, window treatment, storage and a fun teepee to set up in the corner so he can go inside to play and read books—I think he'll really enjoy that.

Holly Becker of
decor8blog.com

MANUFACTURERS & SUPPLIERS

ALESSANDRA SCARFÒ is an up-and-coming designer on the contemporary international scene. Her work encompasses many different services including interior, product, graphic, and exhibit design. Her broad-based skill set allows her to take a cross-disciplinary approach to her design work, starting from contemporary design models and focusing on sustainability. She is committed to examining new materials, pursuing customized solutions and creating quality in every detail. She has worked as a freelance designer for companies including UCA (San Carlo Square in Turin), Dreamweave (Singapore), and Guido Gobino (Turin). She has her own line of products under the brand *Merci di Culto*. Her products are available in leading contemporary art bookshops as well as concept stores and showrooms.
Alessandra Scarfò Design, Via Andrea Provana 5/c, 10123 Turin, Italy.
www.alessandrascarfo.com

Founded in 1978, ANDREW MARTIN is a UK brand with global authority within the world of interior design. Offering a wide range of fabrics, wallpapers, furniture, and home accessories inspired by a unique mix of cultures, nostalgia, and decades, Andrew Martin is the go-to place for tastemakers in search of individual interiors with a twist.
Andrew Martin International, 190 Walton Street, London SW3 2JL, UK.
Tel.: +44 (0)207 225 5100 (general number). www.andrewmartin.co.uk

ARTKRAFT Authentic chairs, lamps, and tables. The furniture and accessories breathe new life into industrial and agricultural items from the 20th century. artKraft redefines furniture; for example, they can turn a horse carriage bench into an armchair, a bench vise into a bar counter, or a cable reel into a smokers' table. Their one-of-a-kind handcrafted pieces, which are a great look for lofts, apartments, and homes as well as offices and businesses, are never "just furniture!"
artKraft, Budafoki út 70, 1111 Budapest, Hungary. Tel.: +36 30 317 9463.
info@artkraft.hu; www.loftdesign.hu

BOBO KIDS is a luxury boutique for designer kids furniture, homewares, accessories, interiors and artwork located in London. The boutique and online shop stock an eclectic mix of modern, vintage and designer homewares for children and babies, including contemporary furniture from European and American designers, art, furnishings, toys, and gifts, many of which are exclusive to the UK. bobo kids also offers an interior design service.
bobo kids, 29 Elystan Street, SW3 3NT London, UK.
Tel.: +44 (0)20 7838 1020. www.bobokids.co.uk

BUNTER WOHNEN. was founded in 2014. Its goal is to combine design and craftsmanship. The focus is on timeless products that win you over with their quality and make their own statement. Bunter Wohnen. is bringing lampshades out of Grandma's attic and back into people's homes. They emphasize high-quality materials, perfect craftsmanship, and cooperation with regional partners whenever possible. The lampshades are made by hand in Dresden. Have something special in mind? Bunter Wohnen. can create almost anything you can imagine.
info@bunterwohnen.com. www.bunterwohnen.com

CANVAS HOME™ is a collection of modern, sustainable home goods inspired by hand-crafted objects. The pieces are timeless in their design and useful in their purpose.
www.canvashomestore.com

CAR-MÖBEL: For 50 years, car-Selbstbaumöbel has been working with various magazine editors to design timeless, unique furniture that you can put together yourself in the comfort of your own home! Car-Möbel sells direct to the customer with no middleman. Metal, wood, and woven furniture pieces are handmade from natural materials and generally shipped unfinished.
Car-Möbel, Gutenbergstraße 9a, 24558 Henstedt-Ulzburg, Germany.
www.car-moebel.de

DE LE CUONA is a purveyor of unique fabrics and accessories, loved for its refined and rugged linen, sublime velvet, soft cashmere, and woven paisley. The unique texture, handle and colors of these artisan weaves make them the preferred choice of sophisticates worldwide. The custom design service works with the same dedication to quality and detail. Projects include residential and commercial interiors and feature highly personal commissions for prestigious hotels, yachts, and palaces. Details of the UK and USA flagship showrooms and partners' showrooms worldwide are on the website www.delecuona.com

EMILY KATZ is a multi media designer from Portland, Oregon focusing on interior design and macrame installations and workshops.
www.emilykatz.com; modernmacrame.com

EMMA HARDICKER is a printmaker and painter producing beautiful, pattern based, floral artworks and fabrics. Her work is inspired by the seasons in gardens, along with the vibrant culture of living in a city. This gives her work a fresh and stylized look. She uses traditional silk-screen printing methods to produce these contemporary designs and can often be found covered in paint. Working by hand, she sketches out ideas, produces stencils for each layer of color and then hand prints using silkscreens. Working at her studio in The Old Birds Custard Factory Emma will bring inspiration

for collections together from found objects, plants, colors, and photos, focusing on creating patterns and mixing nature with urban shapes.
Emma Hardicker Designs, 319 Scott House, The Custard Factory, Gibb Street, Birmingham B9 2DT, UK. www.emmahardicker.com

ETSY.COM is a marketplace where people around the world connect, both online and offline, to make, sell and buy unique goods. Etsy was founded in 2005 in Brooklyn, New York to fill a need for an online community where crafters, artists and makers could sell their handmade and vintage goods and craft supplies.
www.etsy.com

FARROW & BALL makes incomparable paints and wallpapers. Ever since the company was founded by paint pioneers John Farrow und Richard Ball, the passion has always been to create paints using only the finest components and proven traditional production methods. The luxurious paints are made using original formulas that employ the richest pigments. The wallpapers are handmade using traditional printing processes and are designed to complement the paint colors. Each batch is subjected to meticulous testing to ensure that Elephant's Breath is not Dead Salmon and that the wallpapers retain their unique palpable structure. Farrow & Ball products are available in their showrooms, at specialty stores worldwide, and at www.farrow-ball.com.
Farrow & Ball, 21/22 Chepstow Corner, Notting Hill, London W2 4XE, UK, showroom@farrow-ball.com. www.farrow-ball.com

FERM LIVING is a Danish company that designs and manufactures interior products with a graphic touch. Their products include furniture, textiles, interior objects, wallpaper, designs for the kitchen, bathroom, and office as well as a large collection for kids; the designs are available in a wide range of materials: organic cotton, recycled paper, wool, wood, porcelain, and metals.
ferm LIVING ApS, Laplandsgade 11, 2300 Copenhagen S, Denmark. Tel.: +45 (0)7022 7523. www.fermliving.com

FIRED EARTH is renowned for its beautiful tiles, paints, wallpapers, and wood flooring as well as for contemporary and classic kitchens and bathrooms. From hand-decorated wall tiles, luxurious marble, and stylish yet practical porcelain flooring to freestanding kitchens and timeless roll-top baths—an inspiring range of products for every type of home.
Fired Earth, 3, Twyford Mill, Oxford Road, Adderbury, Oxfordshire OX17 3SX, UK. Retailer's number: +44 (0)845 366 0400. www.firedearth.com

The wrought iron lighting from FMB LEUCHTEN has its roots in the Finke Company, a family company in Borken, Germany near the Dutch border. The company was founded by brothers Heinrich and Bernhard Finke in 1967, beginning with steel coating for high-end wrought iron items. Each lamp was a unique piece—a renaissance of tradition using the purest materials. And that is still what we do today: build a bridge between the time-honored traditions of craftsmanship and the expressions of that craftsmanship that enable timeless living and furnishing.
FMB Leuchten Schmiedeeisen GmbH, Dunkerstraße 41, 46325 Borken-Burlo, Germany. Tel.: +49 (0)28 62 90 97-0, Fax: +49(0) 28 62 90 97-50. www.fmb-leuchten.de

FRAMEBRIDGE makes it easy to custom frame the things you love. Customers can easily place their order at framebridge.com by selecting from a curated collection of stylish frames and uploading or mailing in their art in prepaid packaging. Each frame is built by Framebridge experts using the best materials and delivered straight to customers, ready-to-hang.
www.framebridge.com

HOTEL4HOME.COM is Germany's first premium on-line shop for beautiful products from the world's leading hotels. Exclusive, high-end brands and lines give both hotel guests and on-line shoppers the opportunity to purchase items they enjoyed during a previous stay, or have special items from the hotel environment delivered right to their door—without ever having visited the hotel in question.
Tel.: +49 (0)5521 85 53 58, service@hotel4home.com. www.hotel4home.com

KORLA is a contemporary heritage design brand creating 100% British fabrics for homes with personality. The geometric and painterly collections are kaleidoscope of pattern and color intended to be mixed and matched across the range. All fabrics are suitable for soft furnishings and upholstery. Tel.: +44 (0)207 603 7498. www.korlahome.com

KSL LIVING specializes in furniture design, lighting, and decorative items. Look here for selected designers from all over Europe. They place a special focus on a large selection, contemporary design, originality, and quality. If you're looking for something for your home, whether it's for inside or outside, decorations for your child's room, or linens and towels in lovely neutral colors, KSL LIVING is the right place for you.
www.ksl-living.fr

Lifestyle company LAMBERT has amassed tremendous expertise in craftsmanship, shapes, and materials, and the products have a corresponding one-of-a-kind vibe. The collection includes accessories, furnishings, lighting, and textiles, with a special focus on handmade accessories. Lambert has a total of eleven flagship stores in Germany, Austria, and Switzerland. At the stores, you can immerse yourself completely in the Lambert world, but individuality is still the central focus here—the Lambert products are freely combined and staged. This stands for the company philosophy of not offering whole-home living concepts, but rather individual pieces that allow everyone to develop his or her own style.
Lambert GmbH, Konstantinstraße 303, 41238 Mönchengladbach, Germany. Tel.: +49 (0)2166 86 83-0.
www.lambert-home.de
www.shop-lambert-home.de

Brit-brand **LOAF** makes laid-back furniture for people to kick off their shoes and lead happier, more relaxed lives. Having lost a whole Saturday trying to buy a bed, founder Charlie Marshall saw an opportunity to make the home shopping experience as quick and hassle-free as possible. Today Loaf offers hundreds of handmade designs for every room of the home and is a champion of serious quality and good old British manufacturing.
Loaf Shack, 255–259 Queenstown Road, London SW8 3NP, UK.
Tel.: +49 (0)845 459 9937. www.loaf.com

LOST ART SALON is a San Francisco-based gallery that specializes in the rediscovery of historically significant artists and the curation of fine art collections reflecting the major styles and movements of the Modern Era. Open to the public, the gallery's showroom offers over 5,000 paintings, drawings, prints, photographs, and objects from the late 19th century through the present, with a strong emphasis on 20th century modernism.
www.lostartsalon.com

LUMAS has works from more than 1,800 artists in its portfolio, including both established artists and talented newcomers. Original works of art are hand-signed and available in limited editions of 75 to 150 units. Lumas now has more than 40 galleries worldwide that employ a unique concept. instead of presenting works in a neutral setting, each piece is displayed as though it were in a friend's home. The effect of each piece of art is heightened by the room in which it is displayed. The artist and/or gallery can make recommendations to the customer on how best to frame and display each work.
LUMAS New York – Soho, 474 West Broadway, New York, NY 10012, USA.
Tel.: +1 212 219 9497, Hotline USA (212) 219 9497. www.lumas.com

MUUTO is rooted in the Scandinavian design tradition characterized by enduring aesthetics, functionality, craftsmanship and an honest expression. By expanding this heritage with forward-looking materials, techniques, and bold creative thinking, Muuto's ambition is to deliver a new perspective on Scandinavian design. The name Muuto comes from *muutos*, meaning "new perspective" in Finnish. Handpicked leading contemporary designers, who are strong interpreters of Muuto's philosophy, combine their talent with the passionate Muuto creative team. You will know the design because it has *muutos*. Objects made sublime through new perspectives, enjoyed across the world, representing the best of Scandinavian design today.
www.muuto.com

MY LAMP With a love for handmade craftsmanship, they produce unique lampshades, hanging lamps, and floor lamps to your custom specifications. Elegant, simple designs and the many available patterns make each lamp a one-of-a-kind treasure. 100% handmade in Hamburg.
My lamp, Schlankreye 45+47, 20144 Hamburg, Germany.
Tel.: +49 (0)40 41 34 64 70. www.my-lamp-hamburg.de

NOSTALGIE IM KINDERZIMMER [Nostalgic Kids' Rooms] is about more than just adding a note of nostalgia to your little one's room. There's something for everyone: unusual favorites for hobby interior designers, a large selection of dishes and kitchenware, great finds for nature lovers, and even bags and accessories for trendsetters both big and small!
NIK Online GmbH, Maria-Lehner-Straße 1, 81671 München, Germany.
Tel.: +49 (0)89 23 51 35 27-0, kontakt@nostalgieimkinderzimmer.de.
www.nostalgieimkinderzimmer.de

OFICINA INGLESA has been making custom handmade furniture for over 30 years. Specialists in French reproductions and classic pieces, the company provides its clients with easy online access to its 600 plus furniture collections via its website, and it is represented in the UK through a showroom in London. Skillfully hand-crafted at Oficina Inglesa's workshop in Europe, the range includes handmade French dining tables and dining chairs, chests of drawers and armchairs, desks and secretaires, bookcases, sideboard buffets, occasional and coffee tables, bedside tables, and more.
Oficina Inglesa, Business Design Centre 329, 52 Upper Street,
London N1 0QH, UK. www.oficinainglesa.com

OLIVER FURNITURE creates wooden furniture for the modern family. Born from a proud Scandinavian tradition of wood making, the products are time-tested and thoroughly contemporary—designed to last for generations. Based on a simple aesthetic, high quality craftsmanship, and function specific design, the Nordic tradition is the brand's attitude. It was founded in 2003 by cabinetmaker and designer Søren Rørbæk. The company is based just north of Copenhagen.
Oliver Furniture A/S, Ndr. Strandvej 119 A, 3150 Hellebæk, Denmark.
Tel.: +45 (0)4970 7317. www.oliverfurniture.com

ROSENTHAL may have one of the longest traditions of the world's premium lifestyle companies, but it is also one of the most modern. It comprises the brands Rosenthal, Rosenthal meets Versace, Hutschenreuther, Thomas, Arzberg and Sambonet. Just as it did when it was originally founded over 135 years ago, Rosenthal develops products that stand out with exceptional form, function, quality, and craftsmanship and represent a cultural asset "made in Germany," combining consistent innovation and creativity to constantly raise the bar for modern tableware and aesthetics.
Rosenthal GmbH, Philip-Rosenthal-Platz 1, 95100 Selb, Germany.
Tel.: +49 (0)92 87 72-0. www.rosenthal.de

SAVOIR BEDS is widely regarded as the world's most luxurious sleeping system. First created for The Savoy Hotel in London in 1905, the tailormade beds have become almost as legendary as the stars who have slept in them. A Savoir bed can be made to any size or shape, stand alone or sport a bespoke headboard, be beautifully upholstered, or made to fit into an existing frame. It is built in all your personal requirements so you can enjoy the

perfect combination of support, comfort and design. The Savoir experience starts at one of their showrooms, where a member of staff can literally take your measure, as well as advising on fabrics and styling for your dream bed. Savoir Beds Great Britain & international, Charley Bray, ress@savoirbeds.co.uk. Tel. +44 (0) 20 8453 6470. www.savoirbeds.com

Feel welcome—that's the motto here at **SCHÖNBUCH**. The company is specialized in creative, functional solutions and design concepts for your entryway or foyer. Whether it's a big-city loft, a single-family home, a country cottage, a business, or any property with special requirements— Schönbuch has the right interior design solution to meet your needs. Schönbuch GmbH, Industriestraße 11, 97631 Bad Königshofen, Germany. Tel.: +49 (0)9761 39 62-0, Fax: +49 (0)9761 39 62-22. www.schoenbuch.com

SKAGERAK creates indoor and outdoor furniture and accessories that are ensured a long lifespan by virtue of their aesthetic and functional qualities. The Danish design brand has an extensive selection of contemporary products in a wide range of materials, brought to life by established designers as well as up-and-coming talents. Visit Skagerak at www.skagerak.dk for more inspiration.

TAPETEN UND UHREN [Wallpaper and Clocks] Hanging wallpaper, mounting wall clocks and setting bells and chimes: whether it's designer wallpaper or just something with stripes, an oversize wall clock or an unusual cuckoo clock—you'll find everything to grace your four walls here. The selection of wallpaper and clocks is second to none, thanks to a wide variety of styles and outstanding quality. The online shop has more than 5,000 different wallpapers, including designer wallpaper, wallpaper for children's rooms, historic motifs, and many different variations of the classic striped wallpaper. The company also offers more than 400 different clocks—beautiful mantelpiece clocks like Grandpa had, designer clocks in all colors and shapes, nostalgic wall clocks, and even silent alarm clocks. The company's wide variety of products are great not just for your home or apartment, but also excellent for stage backdrops and film sets. Tapeten und Uhren GbR, Könneritzstr. 7, 01067 Dresden, Germany. Tel.: +49 (0)351 4 97 76 45-0, Fax: +49 (0)351 4 97 76 45-2. info@tapetenunduhren.de, post@tapetenunduhren.de. www.tapetenunduhren.de

TAPPAN COLLECTIVE is a platform for discovering and collecting original work and limited edition prints by today's best emerging artists. Offering a wide range of prices and types of work, Tappan's online platform supports careers of emerging artists and helps you build your art collection. www.tappancollective.com

TEA AND KATE is a small emporium selling the best sourced collections from around the world, many of whom manufacture their goods in the traditional way and to their original designs. A bit eccentric, sometimes indulgent and always charming, but mostly inspirational. Tea and Kate, 10a Victoria Street, Felixstowe, Suffolk IP11 7ER, UK. www.teaandkate.co.uk

THE GRAPHICS FAIRY is a resource for home decorators and crafters. Find over 5,000 free vintage stock images, illustrations, old pictures, antique graphics, vintage printables, to make craft projects, collage, scrapbooking, etc.! DIY and craft tutorials and home decorating ideas are offered as well. www.thegraphicsfairy.com

THE RUG COMPANY is one of the world's leading luxury brands for hand-knotted, modern rugs. Along with their own line, The Rug Company works with some of the world's most talented designers like Paul Smith, Vivienne Westwood, Alexander McQueen, and Tom Dixon. The product portfolio includes rugs, hanging rugs, and pillows. The Rug Company, 119b Portland Road, London W11 4LN, UK. www.therugcompany.com

VITRA is a furniture maker dedicated to creating healthy, intelligent, inspiring and long-lasting solutions for offices, homes, and public spaces. Vitra's products and concepts are developed in Switzerland using a meticulous process that combines the company's engineering expertise with the creative spirit of leading international designers. The goal is to develop products with a long functional and aesthetic service life. The architecture of the Vitra campus, the Vitra design museum, the design workshops, publications, and archives are all integral parts of the Vitra project. They open up new perspectives for the company and establish the necessary depth to support all of its creative activities. www.vitra.com

WE DO WOOD was founded in Copenhagen in 2011 and is based on the vision that eminent design and strict sustainability principles should go hand in hand. www.wedowood.dk

YELLOWKORNER's ambition is to democratize art photography and make it accessible to a greater number of collectors. YellowKorner galleries are sites of exchange between the public and the artists, exhibiting and commercializing the art photographs of more than 250 artists, provided in limited editions and accompanied by a certificate of authenticity. La Hune Saint-Germain, 16 rue de l'abbaye, 75006 Paris; Paris Francs Bourgeois, 8 rue des Francs-Bourgeois, 75003 Paris, France. www.yellowkorner.com

CLAIRE BINGHAM is an interiors journalist who writes about architecture, design and style for several publications worldwide. Before becoming an author with her first book *Modern Living* she was Homes Editor on UK *Elle Decoration* and creative partner at TBWA\Manchester writing all manner of copy for advertising clients, along with creating custom publishing for luxury global brands. Ultimately, she writes about the design and decoration of people's homes (and hotels) and how they live in them. "There's nothing I like more than a good nosy around other people's homes. I also like a good studio and factory—I love to see how things are made and discovering the talents behind the scenes."
www.clairebingham.com

FAY MARKO began working in real estate in 1999. Because she had originally studied interior design, she also started designing kitchens, bathrooms, and furniture. Soon, Fay expanded her work to include every room in the home. In 2007, she moved from Greece to London, where her firm, Fay Marko Ltd., now offers a wide range of interior design services from planning to the final decorating touches.
www.faymarko.com

WE EXTEND OUR THANKS to all of the manufacturers, suppliers, and dealers who allowed us to use their photographs in *Modern Living*.

CREDITS Cover: © Fay Marko; Back Cover: top: © Lambert GmbH; right: © Mainstream Images / Paul Massey; center: © Farrow & Ball; left: © Mainstream Images / Elisabeth Aarhus; below: © Mainstream Images / Darren Chung; p. 222 © Ellie Cotton
p. 2 © Fay Marko; p. 4 © Mainstream Images / Darren Chung; p. 5 © Schönbuch; p. 6-8 © Fay Marko; p. 9 © Rosenthal GmbH; p. 10 above: © fermliving; top left and below: © KSL Living, fauteuil à bascule design Keinu 4 & fauteuil à lacier Houssen; center below: chairs by Nordal, available from car-moebel; below right: © We Do Wood; p. 11 top: © car-moebel; center left: © Artkraft; center right and below: © Mainstream Images / Ray Main; p. 12 left: © Rob Delamater / Lost Art Salon; top right: © Mainstream Images / Pernille Enoch; center right: © Artkraft; bottom left: © Emily Katz / Photo: Leela Cyd, bottom right: © Mainstream Images / Adam Butler; p. 13 top: courtesy Fired Earth; center left © Emma Hardicker Designs; center: © car-moebel; center right: © Mainstream Images / Elisabeth Aarhus, below: © Oliver Furniture; p. 14 top: © Mainstream Images / Elisabeth Aarhus; center left: © Mainstream Images / Darren Chung; Middle right: courtesy Fired Earth; below left: © Wallpaper by BN, available from Tapeten und Uhren; below right © Mainstream Images / Ray Main; p. 15 top right: © Mainstream Images / Anitta Behrendt; top left: © Mainstream Images / Elisabeth Aarhus; below left: © Wallpaper by Eijffinger, available from Tapeten und Uhren; below right © Mainstream Images / Christine Besson; p. 16 top left and right below © Mainstream Images / Elizabeth Aarhus; top right: © The Rug Company; below left: © hotel4home; below right: Mainstream Images / Elisabeth Aarhus; p. 17 top left: © Mainstream Images / Adam Butler; right: © Artkraft; below left: © fmb Leuchten; below right: © Muuto; p. 18/19 © Fay Marko; p. 20/21 © Wallpaper by Sanderson, available from Tapeten und Uhren; p. 22 © Mainstream Images / Ray Main; p. 23 © Mainstream Images / Darren Chung; p. 24 © fermliving; p. 25 top © Mainstream Images / Ray Main; below © Mainstream Images / Adam Butler; p. 26 © Schönbuch; p. 27 © Oficina Inglesa; p. 28 top: © Mainstream Images / Elisabeth Aarhus; below left: © Wallpaper by Zoffany, available from Tapeten

und Uhren; right: © Mainstream Images / Philippe Saharoff; p. 29 © Mainstream Images / Anitta Behrendt; p. 30 © The Rug Company; p. 31 top: © Artkraft; below: © Mainstream Images / Ray Main; p. 32 top: © Skagerak; left: © car-moebel; right: © KSL Living lampe mural e porte manteau, Bellila; p. 33 © We Do Wood; p. 34 top: © Mainstream Images / Adam Butler; below: © BMW / Schramke; p. 35 © car-moebel; p. 36 top left: © House Doctor available from car-moebel; top right: © Farrow & Ball; below right: KSL Living porte manteau blanc; left below: © Mainstream Images / Elisabeth Aarhus; p. 37 top left: © car-moebel; top right: © We Do Wood; below right: © Skagerak; below left: © Schönbuch; p. 38 © Alessandra Scarfò Design – Merci di Culto, Turin, Italien, www.mercidiculto.com, info@mercidiculto.com; top: Installation, Palazzo Villa (1600, Piazza San Carlo Torino). Alessandra Scarfò Design for UCA spa, 2015-2016 - Interieur und Produkte; below: table lamp *Pantarei*; p. 39 top: © Rob Delamater / Lost Art Salon; below: courtesy Fired Earth; p. 40 top left : © The Rug Company; right: © Mainstream Images / Darren Chung; below © Mainstream Images / Philippe Saharoff; p. 41 © Mainstream Images / Adam Butler; p. 42/43 Shutterstock / Alex Roz; p. 44 © Rob Delamater / Lost Art Salon; p. 45 © Fay Marko; p. 46 © Mainstream Images / Elisabeth Aarhus; p. 47 top: © Mainstream Images / Darren Chung; below: © Fay Marko; p. 48/49 © Lambert GmbH; p. 50 top left: © Wallpaper by Harlequin, available from Tapeten und Uhren; top right: © Mainstream Images / Darren Chung; below: © Mainstream Images / Ray Main; p. 51 top: © Mainstream Images / Adam Butler; below left: © Abigail Ahern; top right: © Lambert GmbH; below right: © The Rug Company; p. 52 top: © Wallpaper by Sandberg available from Tapeten und Uhren; below: © de Le Cuona; p. 53 © KSL Living, Bellila; p. 54 top left: fermliving; top right: We Do Wood; below: © The Rug Company; p. 55 top left: © Skagerak; top right: Lambert GmbH; below: © Mainstream Images / Adam Butler; p. 56 © Wallpaper by London Art, available from Tapeten und Uhren; p. 57 top: © Mainstream Images / Elisabeth Aarhus; below right: © Wallpaper by London Art, available from Tapeten und Uhren; below left: © Wallpaper by Masureel, available from Tapeten und Uhren;

Published by teNeues Publishing Group

teNeues Media GmbH & Co. KG
Am Selder 37, 47906 Kempen, Germany
Phone: +49-(0)2152-916-0
Fax: +49-(0)2152-916-111
e-mail: books@teneues.com

Press department: Andrea Rehn
Phone: +49-(0)2152-916-202
e-mail: arehn@teneues.com

teNeues Publishing Company
7 West 18th Street, New York, NY 10011, USA
Phone: +1-212-627-9090
Fax: +1-212-627-9511

teNeues Publishing UK Ltd.
12 Ferndene Road, London SE24 0AQ, UK
Phone: +44-(0)20-3542-8997

teNeues France S.A.R.L.
39, rue des Billets, 18250 Henrichemont, France
Phone: +33-(0)2-4826-9348
Fax: +33-(0)1-7072-3482

www.teneues.com

teNeues Publishing Group
Kempen
Berlin
London
Munich
New York
Paris

teNeues